SPECTACULAR HOMES

of Chicago

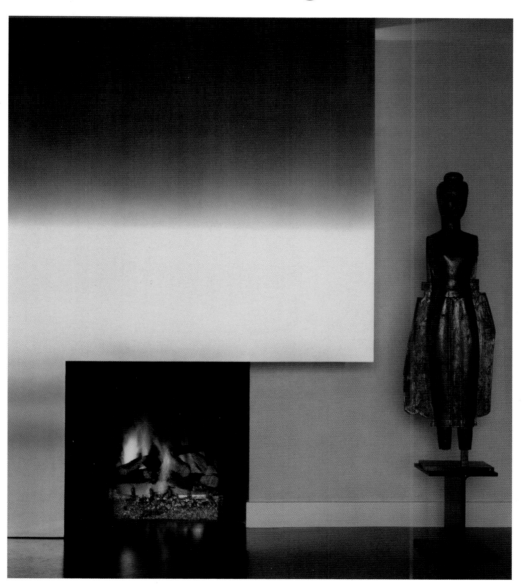

AN EXCLUSIVE SHOWCASE OF CHICAGO'S FINEST DESIGNERS

Published by

13747 Montfort Drive, Suite 100
Dallas, Texas 75240
972.661.9884
972.661.2743
www.panache.com

Publishers: Brian G. Carabet and John A. Shand
Executive Publisher: Phil Reavis
Associate Publisher: Chris Miller
Art Director: Michele Cunningham-Scott
Editor: Rosalie Wilson

Printed in Malaysia

Distributed by Gibbs Smith, Publisher
800.748.5439

PUBLISHER'S DATA

Spectacular Homes of Chicago

Library of Congress Control Number: 2006929739

ISBN - 13: 978-1-933415-21-5
ISBN - 10: 1-933415-21-5

First Printing 2006

10 9 8 7 6 5 4 3 2 1

Previous Page: Janet Schirn Design Group
See page 187 Photograph by Nathan Kirkman

This Page: Cannon Frank A Design Corporation PC
See page 41 Photograph by Tony Soluri

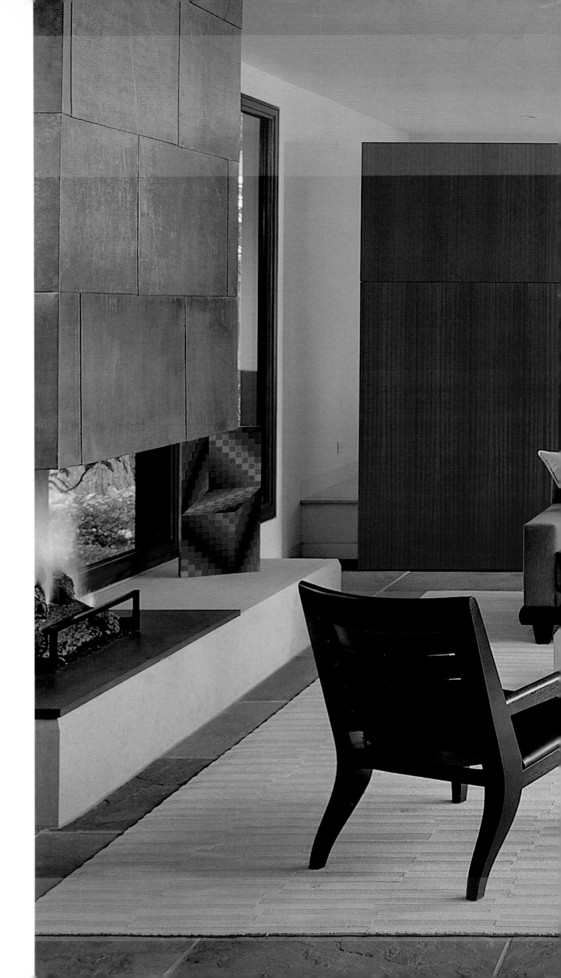

SPECTACULAR HOMES
of Chicago

AN EXCLUSIVE SHOWCASE OF CHICAGO'S FINEST DESIGNERS

introduction

A melding of people, culture and design, it is no wonder that millions have chosen to call Chicago home. The idyllically perched city features a wide array of residential options, from chic lofts that were originally factories, to historical brownstones along Michigan Avenue, up and coming transitional neighborhoods, and well-established communities such as Gold Coast and Lincoln Park.

There's a profusion of creativity in the Chicagoland area as the city draws talent from across the country to attend design school, be near the world's largest and oldest design center, the Merchandise Mart, or just enjoy the life in the Midwest. Some of the principal designers and decorators featured in *Spectacular Homes* have established collaborative interior design firms with showrooms, while others have chosen to remain sole proprietors. A select group of them work with staff architects and a few even design textiles or custom furniture. All are dedicated to designing spaces that truly echo their clients' tastes and lifestyles.

Whether you're drawn to traditional décor, prefer to be surrounded by the clean lines of contemporary design, appreciate a mixture of styles or haven't quite decided, these designers are experts at guiding you through the entire process.

As you immerse yourself in the pages of *Spectacular Homes of Chicago*, the beautiful work of the designers comes to life through breathtaking photography. Let them inspire you and your family with exquisite design.

Genuinely,

Phil Reavis

PHIL REAVIS
EXECUTIVE PUBLISHER

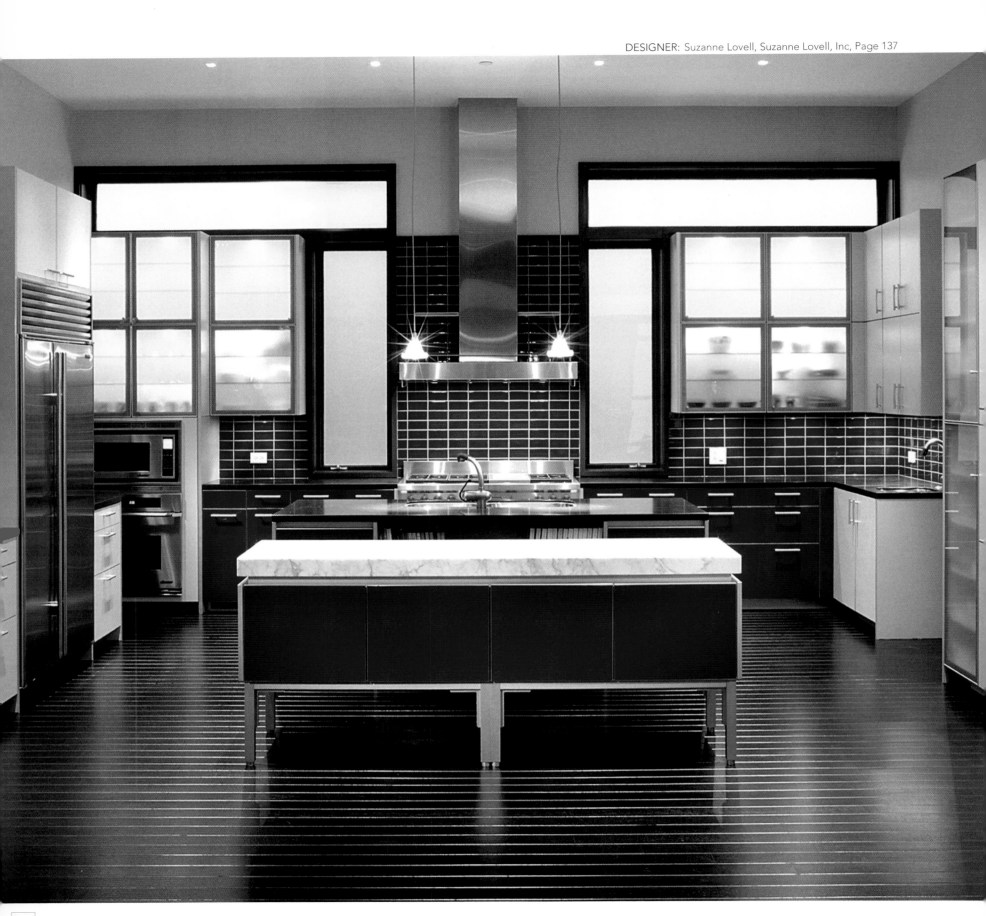

table of contents

"Thoughtful design has the potential to change people's lives."

MARY SUSAN BICICCHI

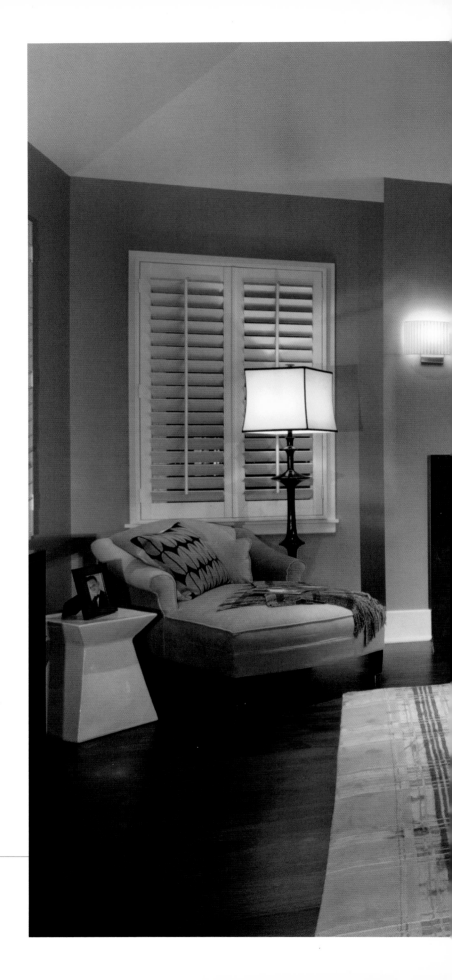

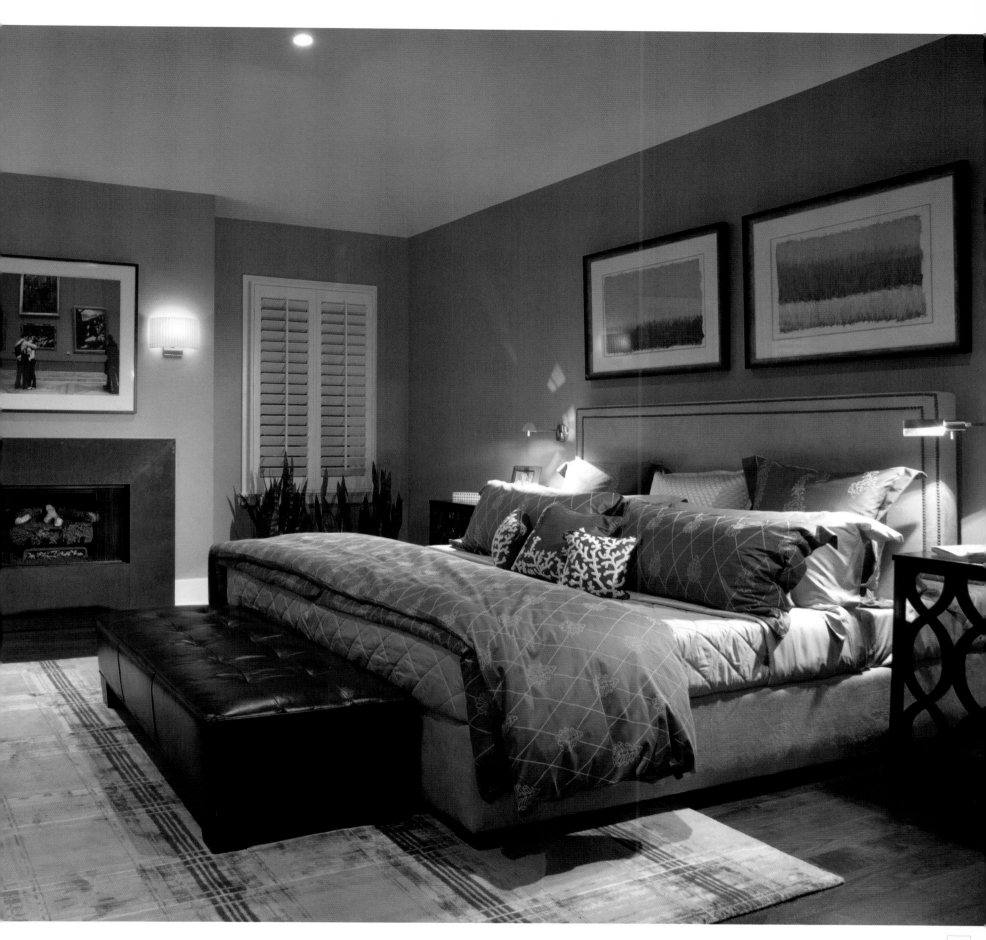

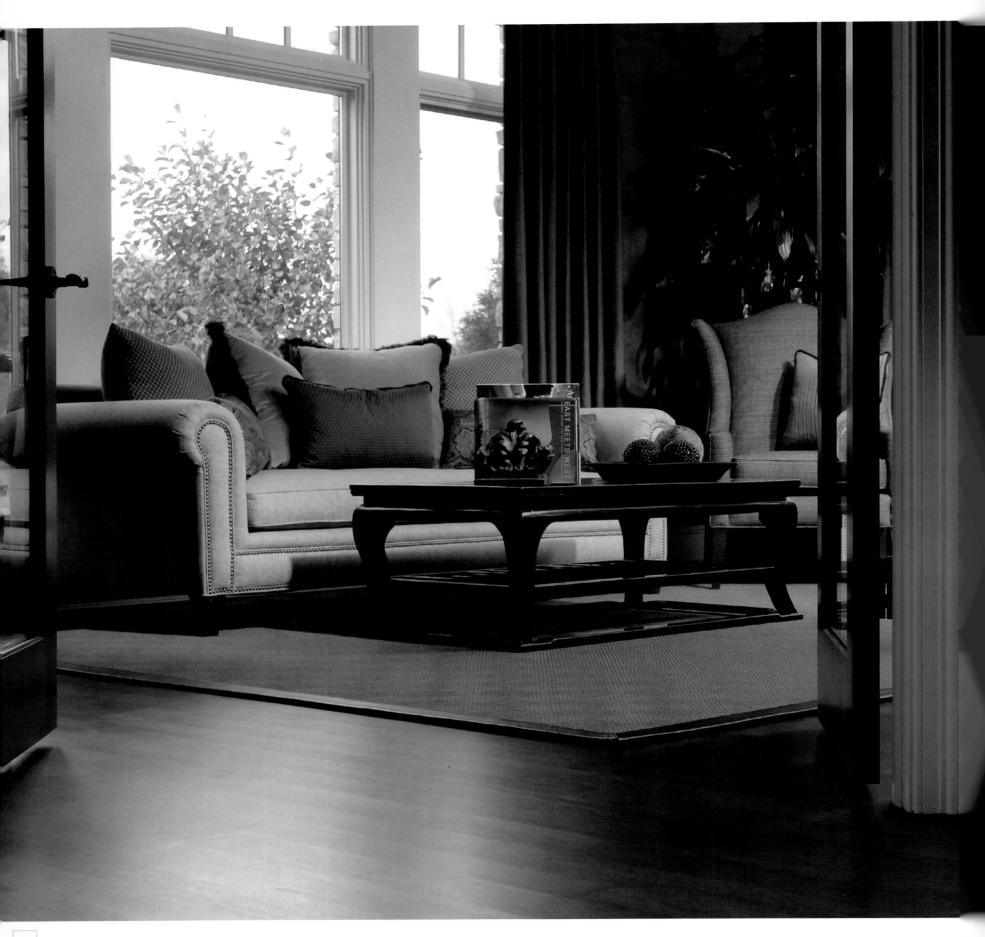

"Interiors should be the reflection of many conversations and an extensive exchange of ideas between client and designer."

SUSAN FREDMAN

DESIGNER: Barbara Theile, Susan Fredman & Associates, Page 69

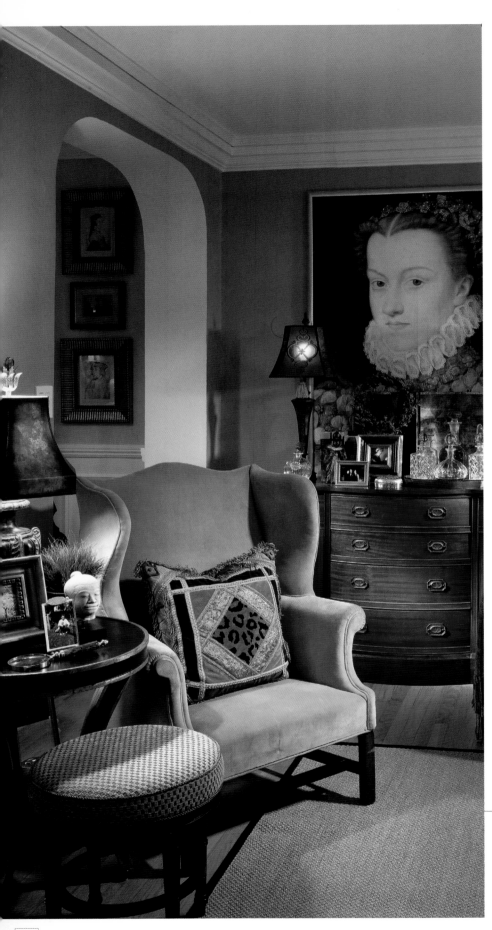

"Interior design is a creative process that combines the client's style the designer's expertise."

MARSHA JONES

LEFT/DESIGNER: Greg Jennings, Graystone Home, Page 105
FACING PAGE/DESIGNER: John Cannon, Cannon Frank A Design Corporation PC, Page 41

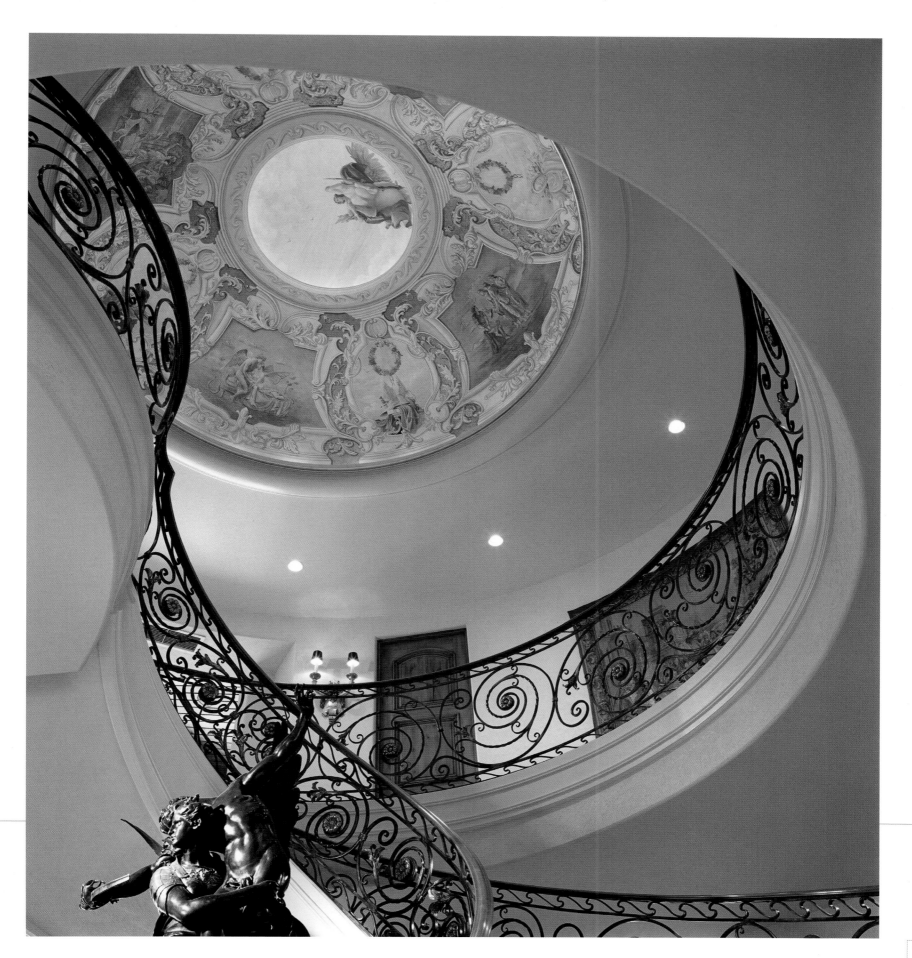

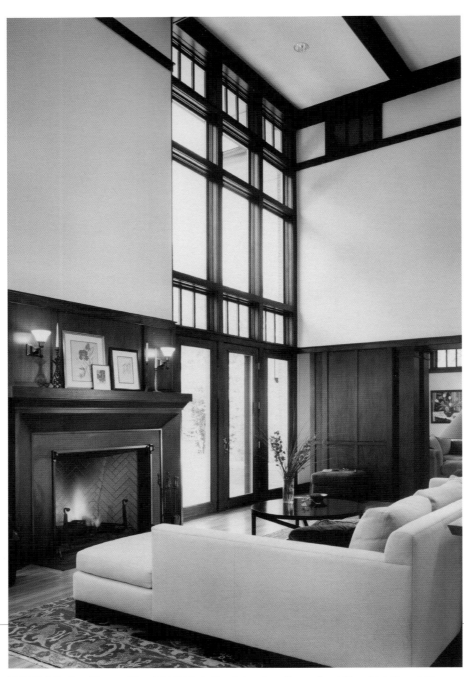

DESIGNER: Ann Frances Blossfeld & Linda Searl, Interiors Group Searl Blossfeld, Page 197

CHICAGO

AN EXCLUSIVE SHOWCASE OF CHICAGO'S FINEST DESIGNERS

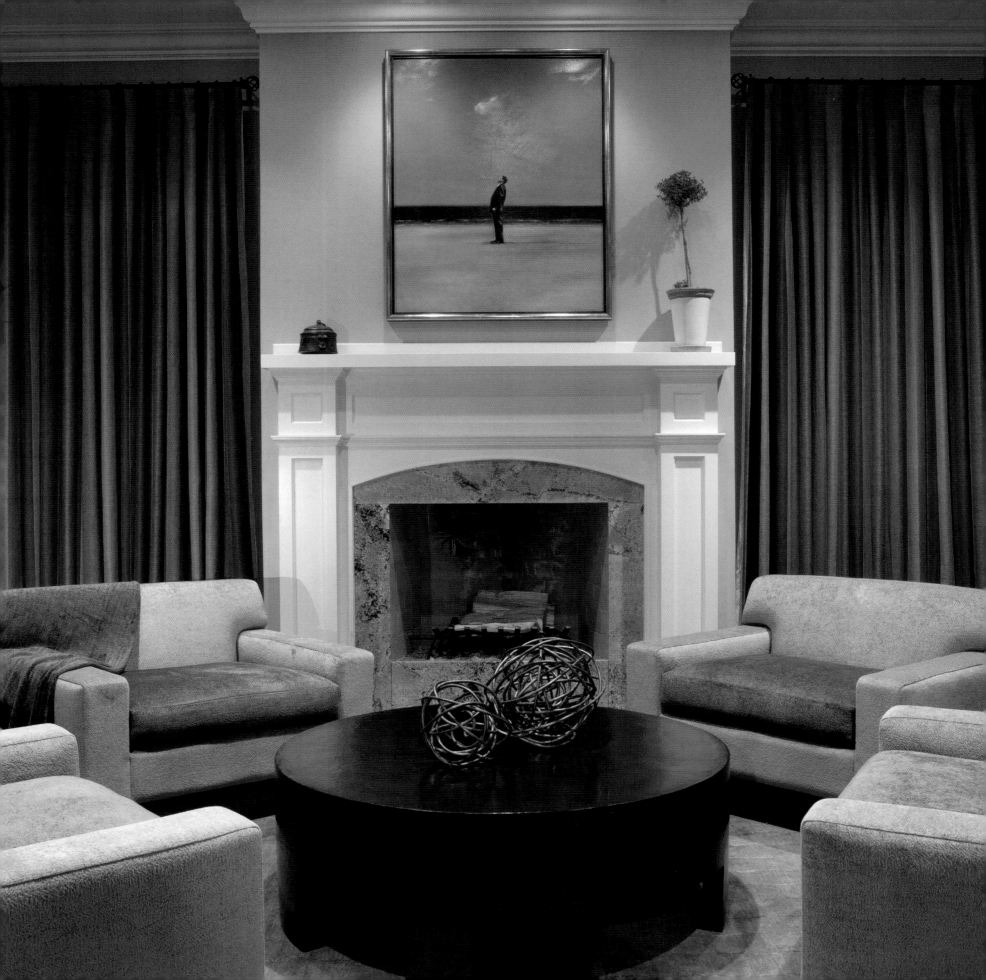

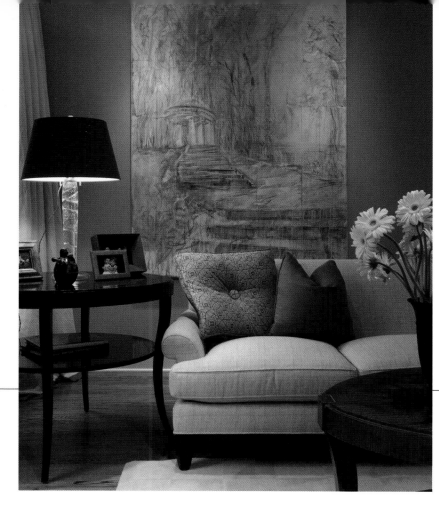

MICHAEL ABRAMS

MICHAEL ABRAMS LIMITED

Born in New York and raised in South Carolina, Michael tempers urban style with a distinctive sense of tradition. His personal aesthetic grew exponentially at The School of the Art Institute of Chicago. Having earned a Bachelor's Degree in Fine Arts in 1981, he further refined his vision at the University of Illinois in Chicago. Melding artistic sensibilities with the practical considerations of architecture, he completed his Master's of Architecture in 1985.

Michael's talents were quickly recognized in professional forums and subsequently sought by such institutions as Continental Bank, Citibank and Goldman Sachs. Each experience added to both personal insight and ability. In 1999, Michael established himself independently, realizing a longstanding dream that allows him the freedom to create client specific solutions that truly reflect his profound dedication to beauty, comfort and home.

Michael is keenly sensitive to create an interior distinct to his client's personality, style and life experience. He firmly believes that people, art and furnishings must do more than coexist; they must share, harmonize and support one another. Mingling artistic, architectural and deeply personal sensibilities in refreshing ways, Michael draws inspiration not just from his substantial experience but, importantly, from each client's desires.

His ability to visualize from the perspective of both architect and interior designer sets him apart from the design services found in traditional interior design firms. He brings not only a refined artistic vision but also expert project management skills honed with over 15 years in the corporate sector. His clients can be comfortable knowing that when Michael makes a promise, there will be timely and professional follow through.

ABOVE:
The simple and elegant furnishings of this client's living room are in perfect harmony for Russian artist Valery Koshliakov's "The Rotunda."
Photograph by Scott Shigley

FACING PAGE:
The client requested an inviting and relaxing family room for conversation, reading and listening to music. The oversized custom chairs swivel to enjoy the room's media wall.
Photograph by Scott Shigley

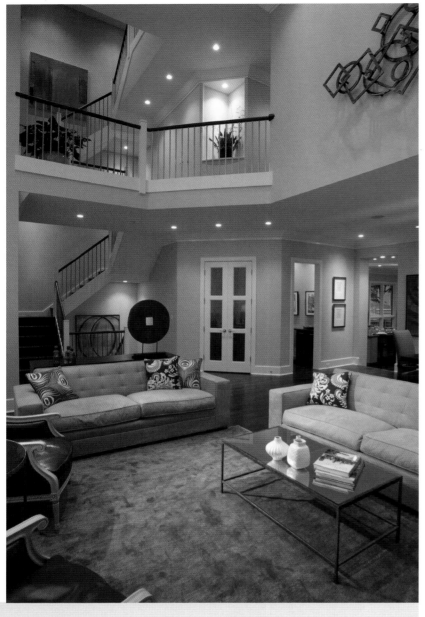

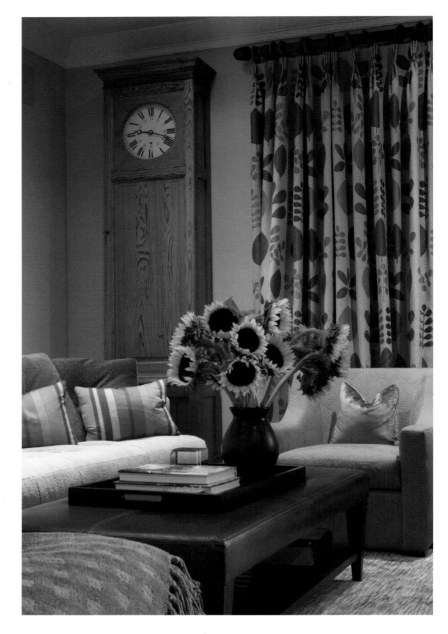

ABOVE LEFT:
Michael created a diverse and dynamic modern art collection for this Bucktown residence. The house's two-story living room and open staircase were designed to showcase large paintings and sculptures.
Photograph by Scott Shigley

ABOVE RIGHT:
This family room features custom furnishings and comfortable fabrics that complement the century-old pine clock from a French rail station.
Photograph by Scott Shigley

FACING PAGE TOP:
The master bedroom was part of Michael's overall design for a 6,000-square-foot single family house participating in Chicago's Annual Luxury Home Tour in 2005.
Photograph by Scott Shigley

FACING PAGE BOTTOM:
This Lincoln Park residence required a complete transformation and new custom furnishings for an international couple relocating from New York City. The project deadline was less than six months.
Photograph by Scott Shigley

Selective in the projects he accepts, Michael desires to be actively involved because his design philosophy of one-on-one collaboration plays such an important role in the success of any interior project. To make the process enjoyable, Michael fosters an open and trusting atmosphere where wishes, objectives and budget can be comfortably shared between client and designer. One client conveyed, "He began the transformation of our home by getting to know us, as people. With a solid understanding of our goals, he then guided the process, all the while soliciting our participation. When he felt strongly about something, he wasn't afraid to challenge us, for which we're deeply grateful."

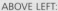

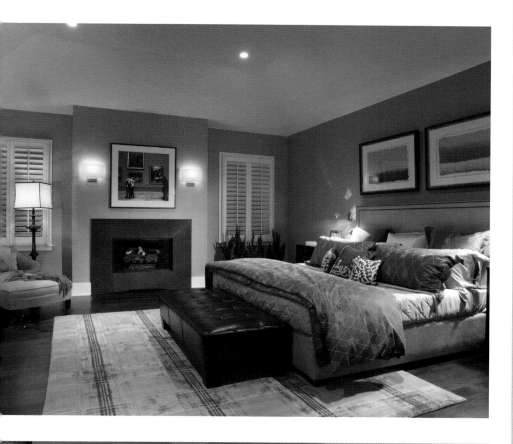

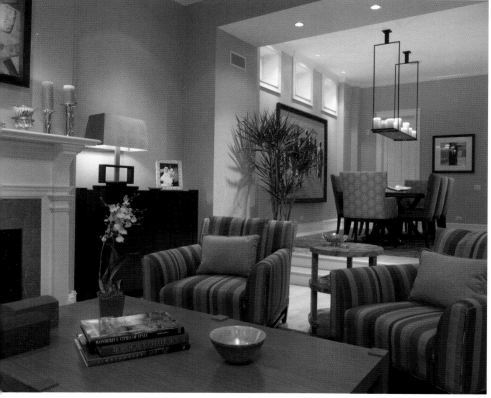

Q&A
more about michael ...

HOW DOES MICHAEL BRING A DULL HOUSE TO LIFE?
He incorporates original art, often a powerful and personal refection of his client.

WHY DO CLIENTS ENJOY WORKING WITH MICHAEL?
The creation of one's home is a tremendous personal journey; with Michael's combination of good taste and relaxed personality, the working experience is truly rewarding.

WHAT DOES MICHAEL DO TO ESCAPE THE PRESSURES OF WORK AND UNWIND?
Michael finds total peace and relaxation at his Michigan farm both entertaining family and friends and gardening. Michael and his partner restored the century old farmhouse and property which have been featured in *This Old House* magazine and the show "Generation Renovation," produced by HGTV.

HOW DID MICHAEL EXCEED ONE PARTICULAR CLIENT'S EXPECTATIONS?
A Chicago client commissioned Michael to transform a beach house on Captiva Island. The house required an extensive renovation and was totally complete and fully stocked before the client's arrival. The installation was so complete that the client need only light the dinner table candles prior to enjoying a prepared meal so that they could immediately start to enjoy their beach island retreat.

MICHAEL ABRAMS LIMITED
Michael Abrams
2446 North Janssen Avenue
Chicago, Illinois 60614
773.848.3039
f: 773.935.5376
www.michaelabrams.com

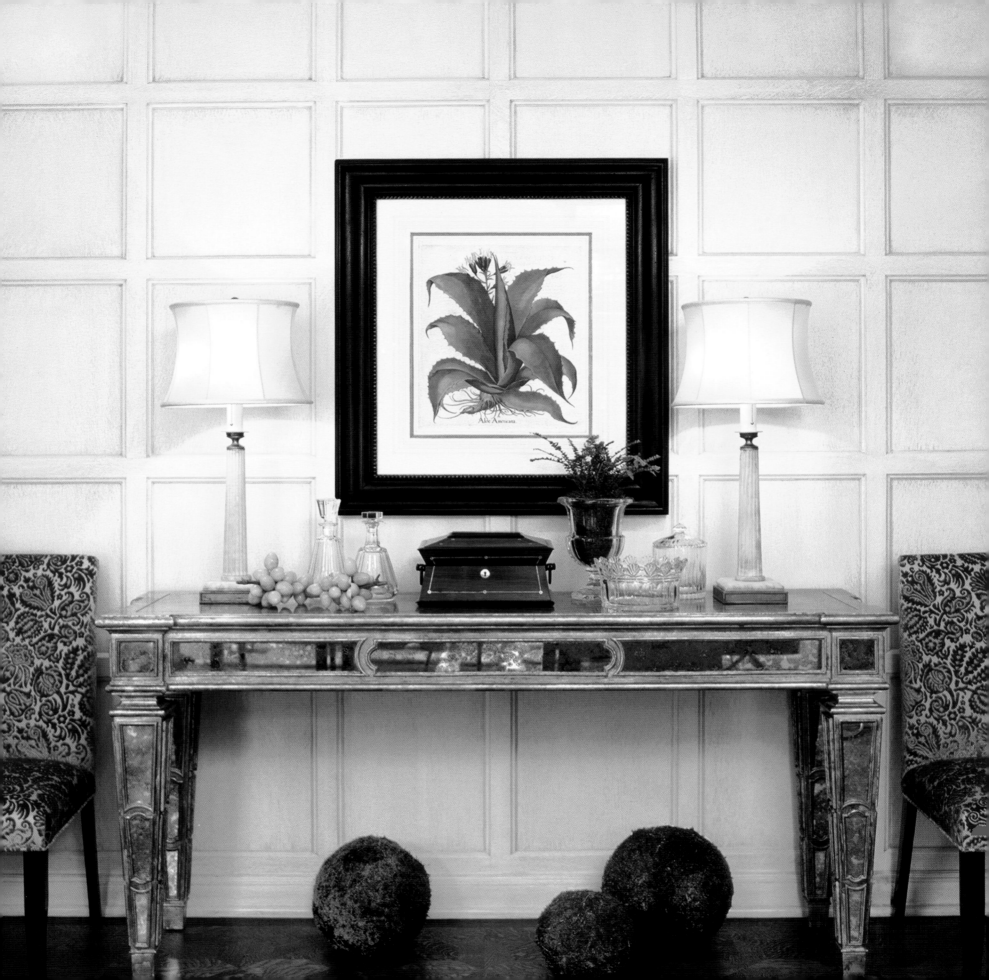

MISSIE BENDER

MISSIE BENDER DESIGN

From the interiors of homes to yachts, jets and even celebrities' luxury motor homes, Missie Bender surrounds her clients with beautiful design. She passionately strives to ensure that every single time a client walks into their home, they love it more and more.

Missie's versatility in design styles allows her the ability to provide her clients with sophisticated, elegant, yet comfortable interiors ranging from traditional to contemporary and everything in between. During the extensive renovation of a historical Tudor home, Missie simultaneously designed a client's extremely contemporary residence. The contrast between the two projects was invigorating.

The celebrated designer attributes her success to a combination of factors. Her keen eye for balance, her ability to listen and lead her clients as well as her unpretentious "get it done" work style all add to the mix. She believes that integrity and trust are the basis for every successful relationship. Because of her enthusiastic personality, Missie has a unique way of making the design process an enjoyable one.

From new construction to rehabs and remodels, Missie's favorite part of the design process is being involved from the inception of a project. Her relationships with architects, contractors and clients are as important to her as watching the vision come to life.

After almost a decade of having been a key member of one of the Midwest's largest design firms, Missie has struck out on her own and opened Missie Bender Design. A combination of an exceptional design sense, an added background in kitchen and bath design and a fantastic design team which she has created, there is no wonder her clients are confident that they are in good hands.

ABOVE:
Clean-lined contemporary family room with free floating fireplace finished in brushed stainless steel and taupe colored porcelain tiles. Woven leather on pull-up chair. Leather area rug.
Photograph by Missie Bender

FACING PAGE:
Elegant antiqued, mirrored dining console—rare 18th century English Bessler botanical print flanked by antique alabaster lamps and custom-designed dining chairs upholstered in silk velvet.
Photograph by Photofields - Sally Good & Tony Bernardi

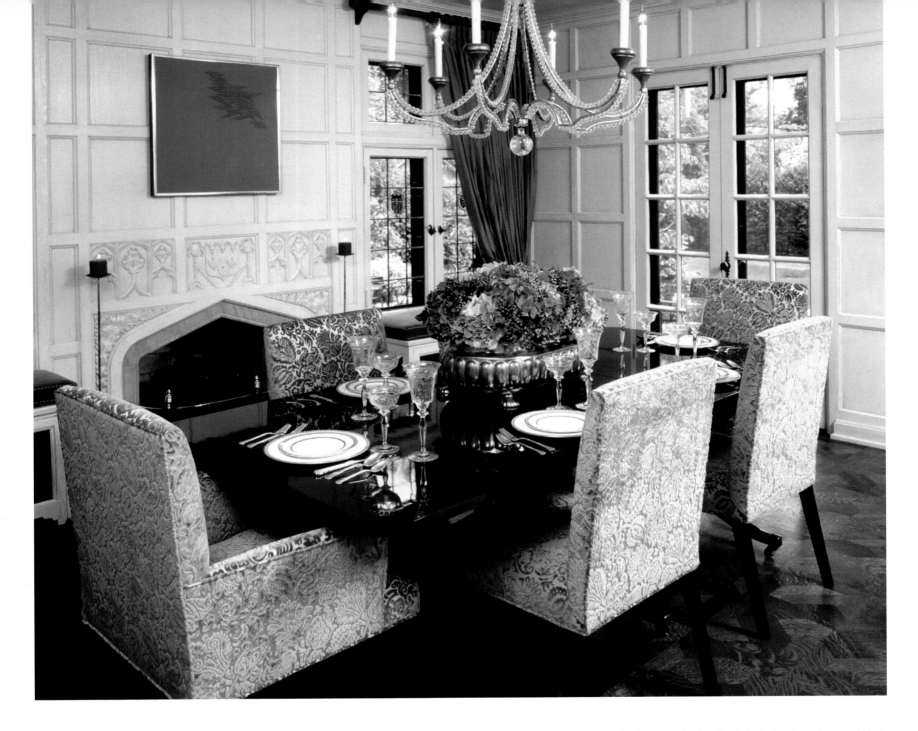

Missie is always on the hunt for beautiful and unique antiques and art. She advises her clients to invest in the best, creating family heirlooms that can be passed from one generation to the next. As her clients transition from the suburbs to the city or visa versa and acquire additional residences, Missie is there every step of the way.

When a glamorous contemporary home that Missie had designed was featured in a publication, the owner of a local premier antique shop who was familiar with the designer's traditional yet exquisite interiors saw the article, she was completely blown away by Missie's wide ranging capabilities.

Clients universally express their appreciation for Missie having changed their lives and homes both aesthetically and emotionally.

Perhaps the greatest tribute to Missie's professional expertise came from a client who left singing messages that reflected her delight in the most recent additions to her home. After the installation of a breathtaking chandelier, which was imported from England and admittedly a royal pain, the client sang quite beautifully, "You light up my life."

Q&A

more about missie ...

WHAT IS MISSIE'S SUGGESTION FOR BRINGING A DULL HOUSE TO LIFE?

Move in.

HAS MISSIE READ ANY GOOD BOOKS LATELY?

Any designer or person familiar with the industry would get a kick out of Adriana Trigiani's *Rococo*, which is a fast and fun read.

WHAT HAS MOST INFLUENCED HER CAREER?

Twenty years of reading *Architectural Digest* and the work of many renowned interior designers. Missie is grateful to her supportive husband whose honesty, insight and attention to detail have proven invaluable.

HOW DO FRIENDS DESCRIBE HER PERSONALITY?

Missie's friends describe her as energetic, witty and always in a good mood. Aside from beautiful results, clients enjoy going through the creative process with her because she makes an otherwise daunting experience a fun one.

MISSIE BENDER DESIGN
Missie Bender
346 Park Avenue
Glencoe, Illinois 60022
847.835.0080
f: 847.835.2003
www.missiebenderdesign.com

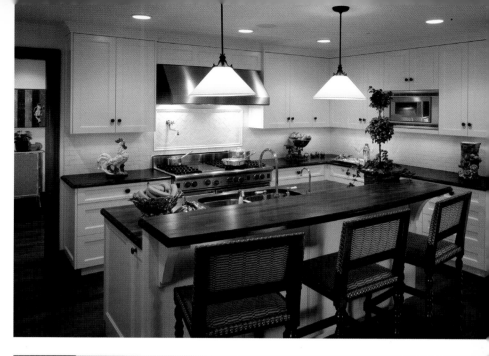

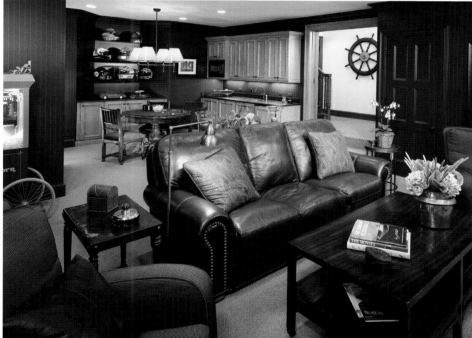

ABOVE TOP:
Classically detailed kitchen with custom cabinets and millwork. Walnut counter tops on island. Soapstone counters on perimeter. Side by side refrigerator/freezer, wet bar with under counter wine cooler. Hand made crackle glazed tile backsplash.
Photograph by Barry Rustin

ABOVE BOTTOM:
Fully outfitted retreat. Doubles as media room with motorized reclining leather sofa and upholstered chairs. Complete with poker table and chairs, old fashion popcorn machine, wet bar, 100-inch movie theater screen and 400 gallon fish tank (screen and tank not shown).
Photograph by Barry Rustin

FACING PAGE:
Beautifully appointed dining room of historic Tudor home. Antique reproduction crystal beaded chandelier. Custom patterned inlaid walnut floor. Exquisite original millwork and plaster ceiling reliefs, custom designed dining chairs in silk velvet.
Photograph by Photofields – Sally Good and Tony Bernardi

MARY SUSAN BICICCHI

INTERIORS BY MARY SUSAN

Mary Susan Bicicchi's impeccable sense of style and personal warmth has led her to become one of the Chicago area's most sought after interior designers. Mary Susan's loyal clientele has hired her for as many as three and four homes, from nearby Lake Geneva to Florida, Michigan, Virginia, Georgia, Hawaii and Paris. The reason is simple. Clients enjoy the award winning designer's fun and collaborative approach to creating beautiful spaces that allow them to live in comfort and style. Over the years, Mary Susan has developed a very effective work method of constantly shifting between the overall "big picture" of the design scheme and small, important details. In order to make the creative process enjoyable, she patiently works with clients to personalize each detail of their project while being mindful of where pieces fit in the grand design scheme.

Project management is an important aspect of interior design that Mary Susan places a high priority on for herself and her staff. Interiors by Mary Susan has been in business for over 15 years. Prior to owning her own design studio, she worked in a small design firm and received a Bachelor of Science degree from Northern Illinois University. She is a knowledgeable insider in the design business and has assembled a talented team of junior designers, an office manager and a comprehensive network of talented and reliable contractors. One of Mary Susan's greatest assets is her ability to

create a friendly and productive working relationship between the client, contractor, architect and designer. Many of her projects begin at blueprints and end at table settings.

As an adjunct to her design business, Interiors by Mary Susan features an art gallery, which reflects Mary Susan's personal passion for art and helps clients to unearth their own sense of visual style. The perfect piece of artwork often sets the stage for a fabulous room and becomes an important focal point in an overall design scheme.

ABOVE:
A perfectly proportioned chair and floor lamp bring focus to the room's magnificent two-story fireplace.
Photograph by Nick Novelli

FACING PAGE:
Copper burnished walls, a faux marquetry floor and custom host and hostess chairs combine to make a unique, opulent and inviting dining room.
Photograph by Bob Mauer

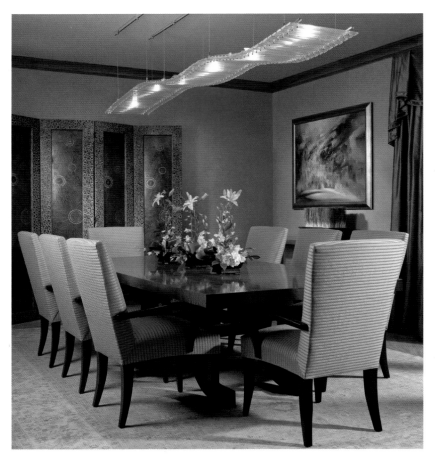

While Mary Susan describes her personal style as a mixture of contemporary and traditional with a bit of unpredictability, she loves working in a wide variety of styles and gets excited about helping each client define and reach their individual design goals. She is a detective skilled at figuring out her clients' needs and personal preferences. When renovating a master bedroom for a client, Mary Susan envisioned pale aquamarine walls with a touch of buttercream yellow. The color palette was a new direction for the client and quite flattering to her porcelain skin and light hair. The client was thrilled with the soothing new color scheme.

LEFT:
The simple lines of this bench and mirror create an elegant entrance to this contemporary home.
Photograph by Nick Novelli

ABOVE:
Notice how the subtle texture shift in this room from the Thai silk chairs, custom Sapelli wood table, wool Persian rug and bamboo screen creates a serene atomosphere for dining.
Photograph by Nick Novelli

FACING PAGE TOP:
The angular architecture of this room is contrasted and softened with the curvilinear shaped furniture. The abacus lamps and mushroom tables add to the playfulness of this family room.
Photograph by Nick Novelli

FACING PAGE BOTTOM:
A completely custom bedroom ensemble of anigre and maple woods is designed for a client's master bedroom.
Photograph by Nick Novelli

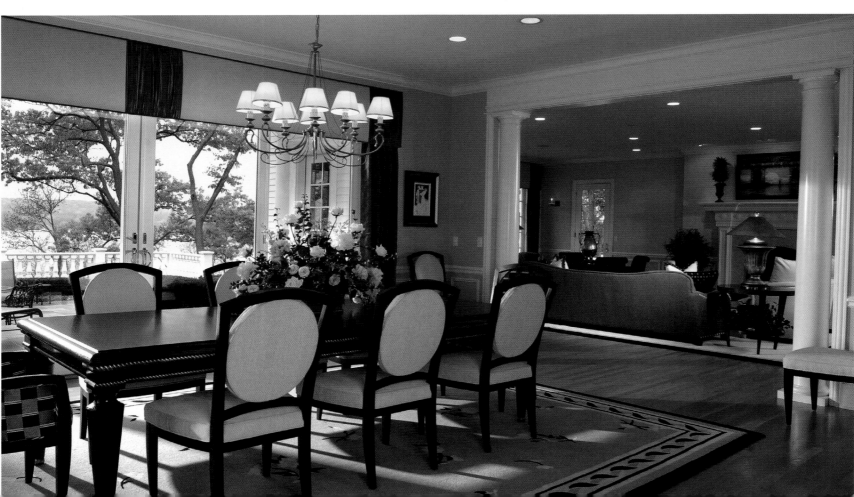

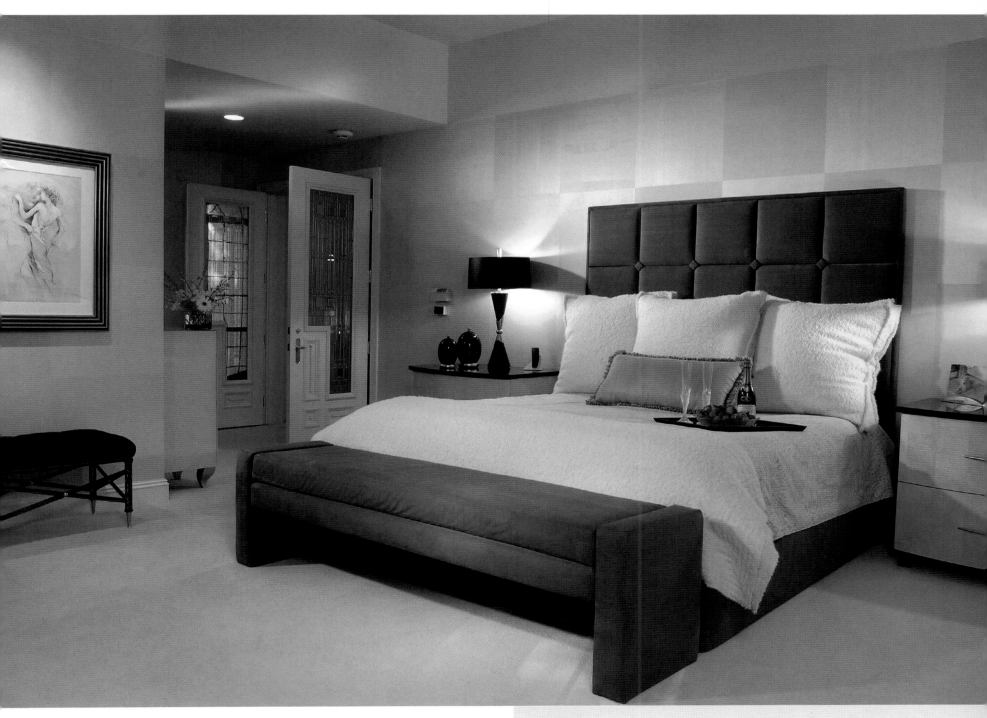

Another project illustrating Mary Susan's skill at bringing client dreams to life was the creation of a very customized lower level entertaining area. The clients wanted to host wine tasting parties, so Mary Susan designed a curved bar with hand carved corbels in a distressed alderwood. Stylish bistro tables sat on custom flooring featuring aggregate stone with a glass mosaic inspired by an ancient piece from Ravenna, Italy. The final touch was a mural Mary Susan commissioned that illustrated fond memories of the clients' vacation to Italy.

ABOVE:
This master bedroom retreat features custom designed furniture with pleasing contrasts of lines and curves.
Photograph by Nick Novelli

FACING PAGE TOP:
Architectural draperies frame a beautiful vista while hues of sand, charcoal, black and caramel create an understated color palette.
Photograph by Nick Novelli

FACING PAGE BOTTOM:
The spectacular outside vista remains the focal point in this airy dining room which is adjacent to the living room in the above photo.
Photograph by Nick Novelli

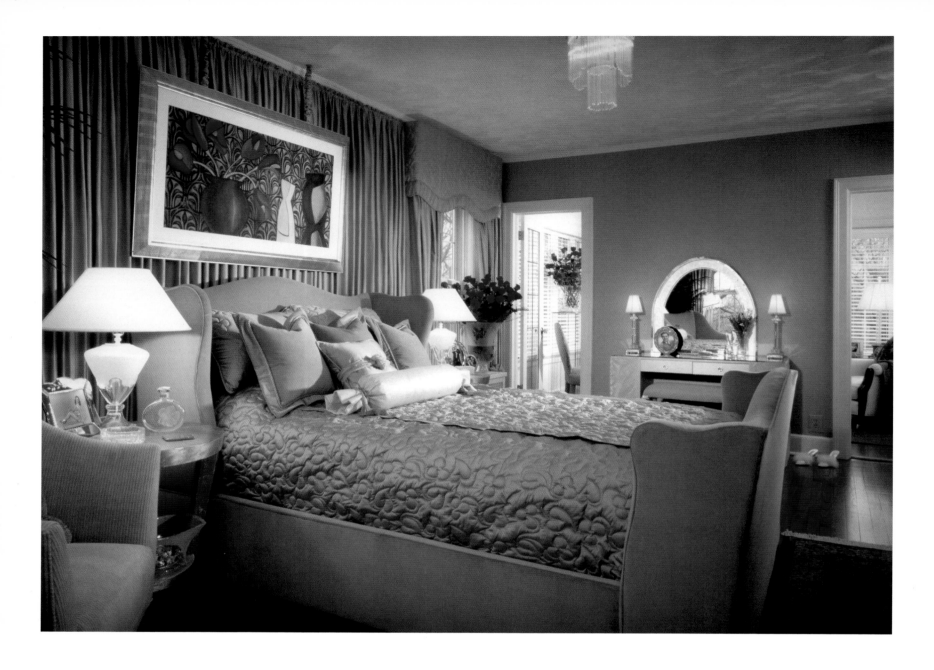

Mary Susan loves the challenge and unpredictability of her work. She is moved when clients communicate the life-changing effect that her designs have had on their lives. A very satisfying aspect of her job is seeing how the creation of beautiful and functional environments increases the well–being of everyone who lives there. One project that holds a special place in her heart is the interior design of a 40,000-square-foot Ronald McDonald House near Loyola Hospital that provides housing for families of critically ill children. The project was massive, but Mary Susan used a combination of practical and whimsical elements to create a comforting haven.

Pictures and articles featuring Mary Susan's work have appeared in publications such as *Chicago Magazine, Chicago Home and Garden, Chicago Tribune, Romantic Homes, The Daily Herald* and *West Suburban Living*. Additionally, she has been recognized with a variety of prestigious

honors including first place awards from the Home Builders Association of Greater Chicago and *Window Fashions magazine*, and she is the winner of the Designer Times Best of the Best Showhouse Award.

Interiors by Mary Susan is a boutique company that offers clients creative and innovative design, efficient project management and a warm and comfortable working process. Mary Susan specializes in being a full project designer that can advise material selections in new construction and renovation and create a fully articulated design from color and furniture to accessories. But whether the project is a large scale renovation or new construction, an art consultation or a room by room project, Mary Susan and her talented staff provide clients with expert help wrapped in a personal touch that is the hallmark of Interiors by Mary Susan.

Q&A

more about mary susan ...

WHO HAS HAD THE BIGGEST INFLUENCE ON MARY SUSAN'S CAREER?

Mary Susan's parents and Italian heritage have enormously impacted her design sensibility. She loves the contrasting styles of Milan modernism and Tuscany earthiness. Raised in a home where friends and family were welcomed with open arms, Mary Susan takes great delight in creating design schemes conducive to such camaraderie.

YOU CAN TELL THAT SHE LIVES IN CHICAGO, BECAUSE...

She is huge fan of Chicago architecture, culture and restaurants. Mary Susan spends as much time as she can in the city and her family includes plenty of diehard Bears and Bulls fans.

WHAT IS MARY SUSAN'S FAVORITE COLOR?

Red. The walls of her master bedroom are covered in a rich tomato hue. She says, "Red makes me feel good and is complementary to my physical features."

WHAT IS THE MOST UNUSUAL DESIGN TECHNIQUE THAT SHE HAS USED?

She has many of them, but one of her favorites is a dining room wall treatment in which she commissioned an artist specializing in faux designs to create a unique pattern by pressing lace into plaster and then burnishing it to a copper glow for a fabulous result.

HOW DO CLIENTS OFTEN COMPLIMENT MARY SUSAN'S WORK?

Changing the way their home looks and functions can be a daunting process for clients, and they often convey their appreciation for her ability to put them at ease and inject a sense of fun in the process. Clients also tell her that the end result "lives well" and is a true reflection of their personal style.

INTERIORS BY MARY SUSAN
Mary Susan Bicicchi, ASID
22 Calendar Avenue
La Grange, Illinois 60525
708.354.5383
www.ibmsdesign.com

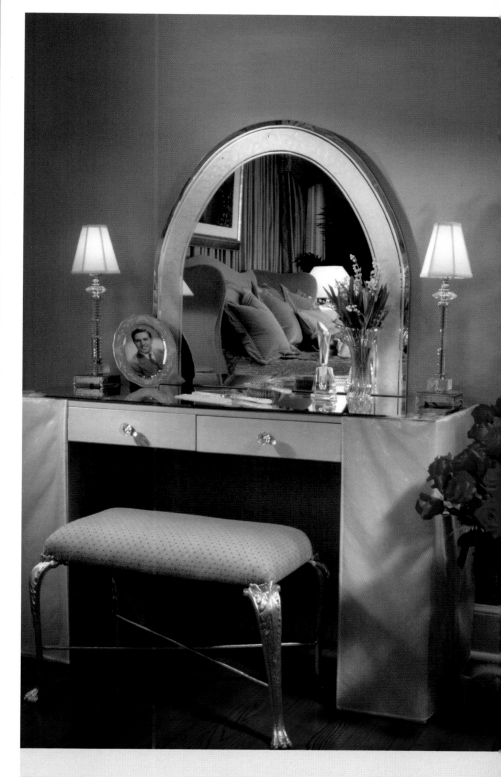

ABOVE:
This sleek custom dressing table features a vintage inspired mirror with 1920's lamps and a turn-of-the-century bench.
Photograph by Jessie Walker

FACING PAGE:
Opposites attract–this is the design of the vintage and contemporary master bedroom suite which features yards of aquamarine silk and velvet to create a romantic atmosphere.
Photograph by Jessie Walker

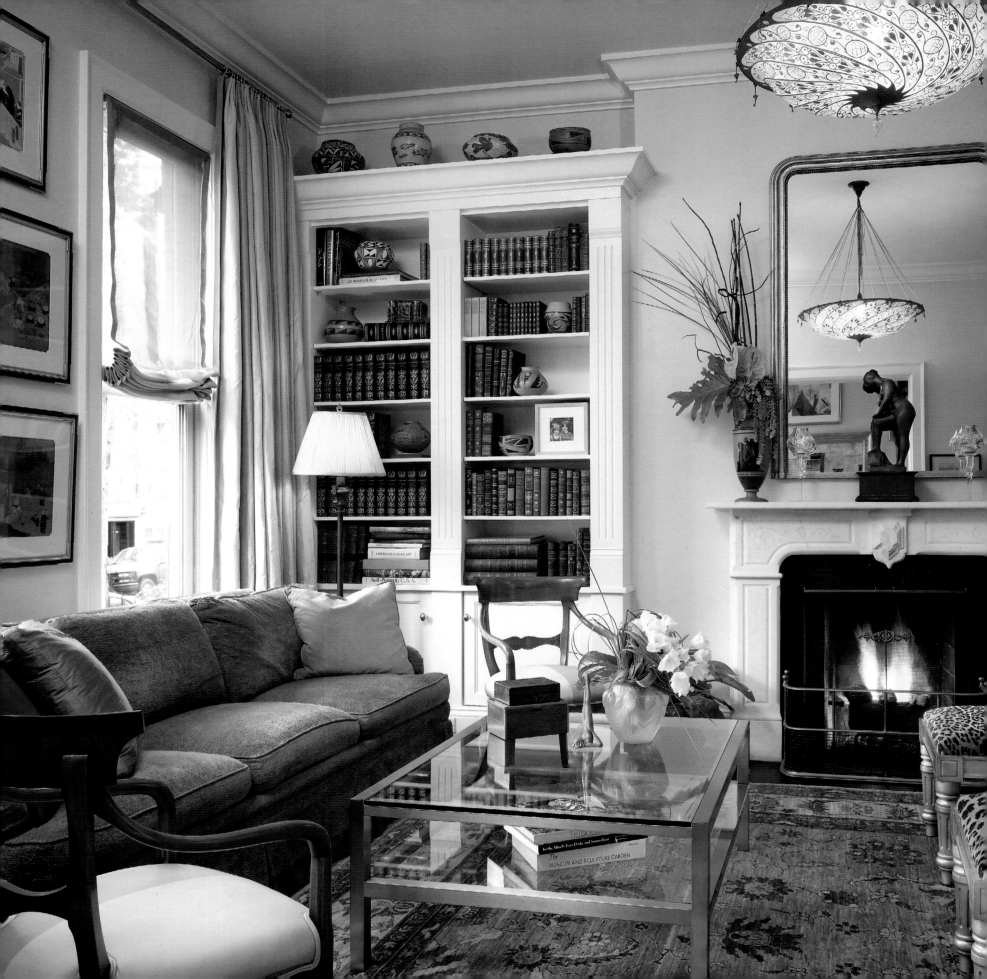

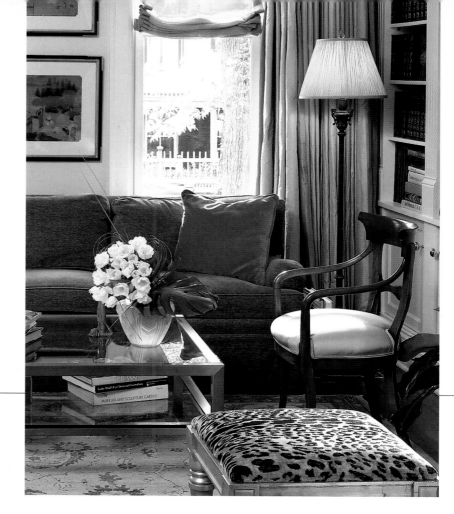

LAWRENCE BOEDER

LAWRENCE BOEDER INTERIOR DESIGN

Larry Boeder's creativity is truly contagious; he is the father of five artistic children and takes great pleasure in helping clients develop their own unique sense of style. While each of Larry's designs is completely original, all have a common thread of good classical style.

He was led to a career in interior design through a natural progression of events—from an initial childhood interest in spatial organization to selling furniture in a Chicago boutique and then being recruited to dress the store windows each week. Larry feels that his early opportunities have had a great impact on his interest in a wide variety of styles and ability to properly execute them.

Clients have often commented that Larry must have a sixth sense for furniture placement, because he has an amazing ability to quickly visualize ideal space layouts and bring them to fruition.

Lawrence Boeder Interior Design provides all-encompassing services and the design principal jokes, "I do it all. I hang pictures, vacuum, make beds, and of course design." In all reality, he does offer a convenient variety of services: material specification, draperies, upholstery, and art restoration just to name a few. Larry is perhaps most known for his breathtaking

special effects walls and notes that he has an expert faux finisher. For one elaborate project, he commissioned custom almond-colored raw silk wallpaper to be produced in India.

His creative inspiration comes from a multitude of sources, namely a lifelong interest in art, painting, and architecture. Through his travels, Larry has experienced many different cultures and become quite fascinated with the work of traditional European masters, modern artists of Central and South America, and especially Native American craftspeople.

ABOVE:
Antique Biedermeier chairs and silk leopard upholstered stools contrast pleasingly with minimal shades and a modern-edged table.
Photograph by Tony Soluri

FACING PAGE:
In this living room, the designer blends antique books, Asian prints, Native American pottery, and an Italian silk light fixture to create a harmonious whole.
Photograph by Tony Soluri

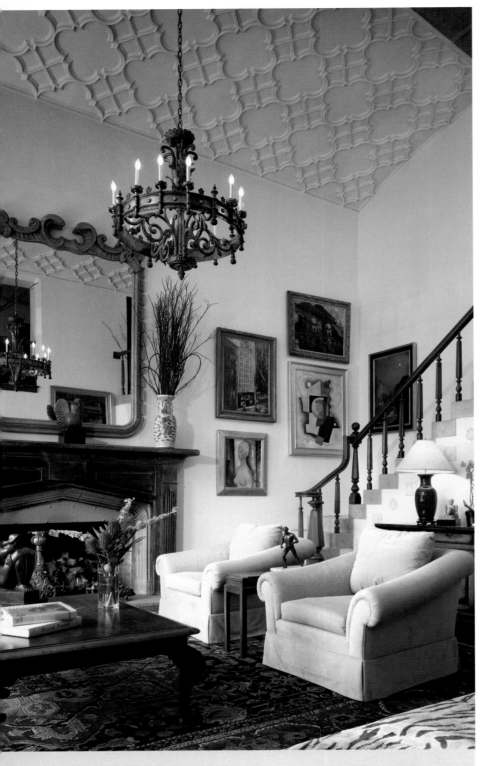

An exciting addition to his portfolio of interiors, Larry designed a log cabin vacation home in the scenic location of rural Indiana. Conducive to family gatherings, he was able to incorporate his much adored collection of American Indian artifacts. Just as he enjoyed showcasing his own treasures, he appreciates the opportunity to highlight art and objects of special significance to his clients.

The design process is truly collaborative with Larry because while he offers his expert opinions, he is completely open to the ideas and desires of his clients. Over the years, Larry has witnessed an exciting transformation in his clients' lives. While their original goal may have been to simply blend in, many have gained new confidence in their tastes and been able to focus on what makes them happy, without regard to the norm.

Although he technically offices from his home, Larry practically lives at Chicago's Merchandise Mart. He enjoys introducing clients to the wealth of options right at their fingertips and patiently guiding them to the designs best suited for their individual lifestyles.

Larry's chief design philosophy is that people set the mood for their home. He elaborates that clients are oftentimes overly concerned about the degree of formalness in their home while the true emphasis should simply be creating interiors that make them happy so that they will want to share the pleasant environment with friends. A formal 1873 row house is Larry's primary residence yet he and his wife are much more laid back.

ABOVE:
An unusual Persian rug from the 1930s grounds the room in warm color; the chandelier, from the 1920s, was taken from an old movie theater.
Photograph by Tony Soluri

FACING PAGE:
The designer arranged the living room to showcase the client's extensive collection of 20th century paintings and sculpture. High windows are left uncovered with dramatic effect.
Photograph by Tony Soluri

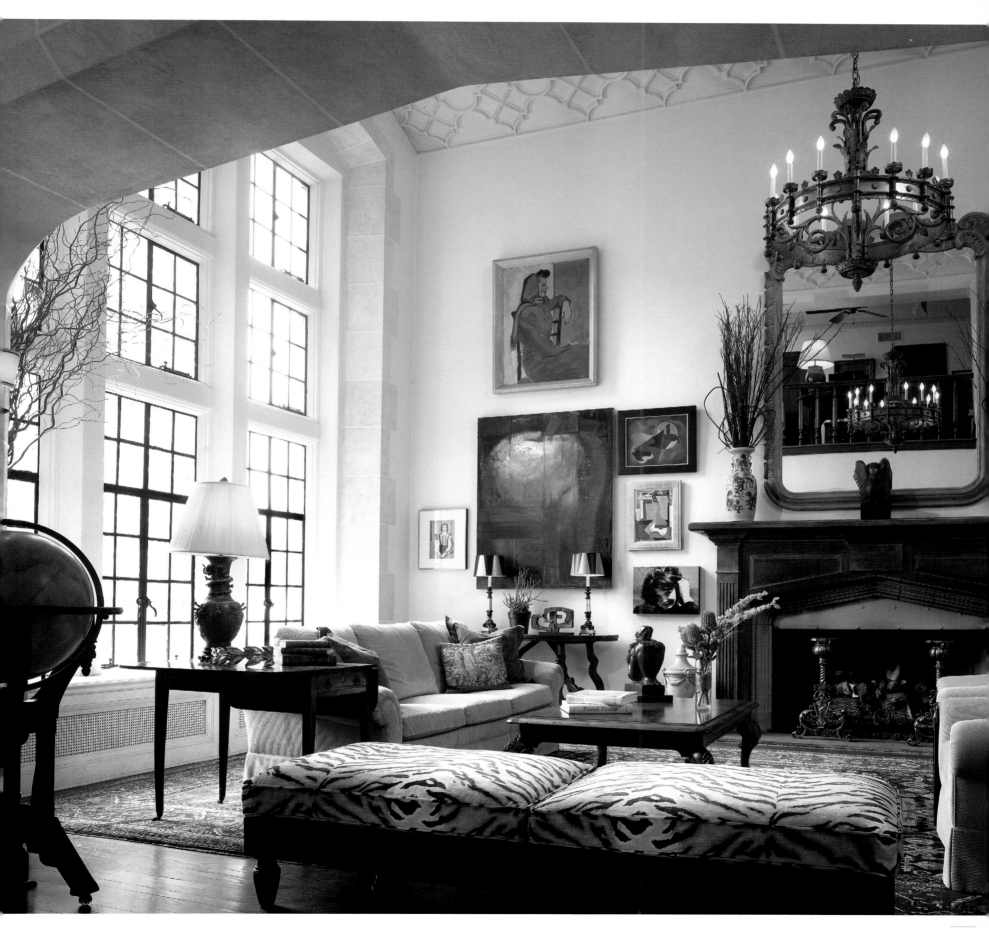

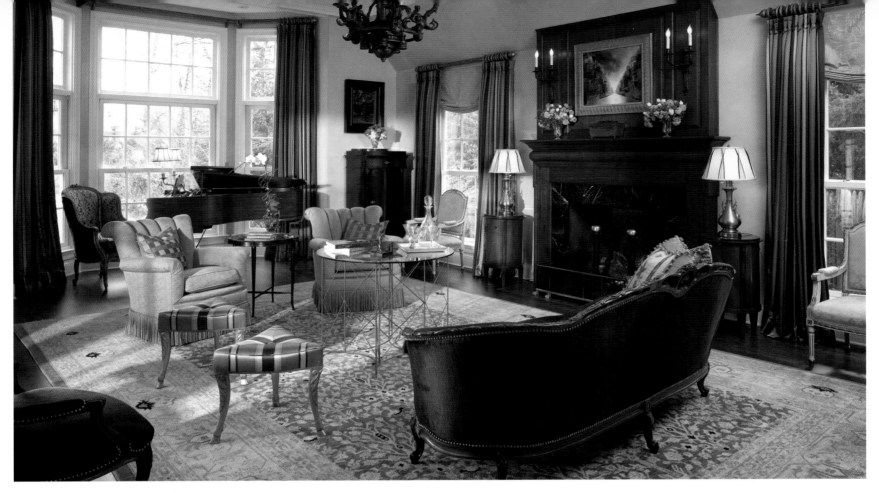

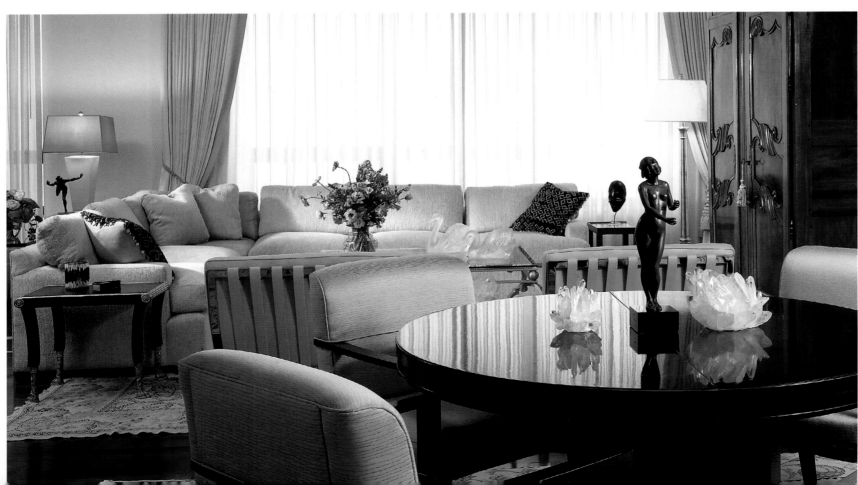

Since the establishment of his firm in 1975, Larry's work has been featured in an impressive variety of regional publications, a few of which include: *North Shore Magazine, Traditional Home, Midwest Living* and the *Chicago Tribune*. With nearly four decades of design experience, Larry is a fixture in the Chicago arts community who is also actively involved in charitable work through Chicago House, an organization that provides housing opportunities for people with HIV and AIDS.

Having grown up in a small Minnesota town with one paint store and no interior designer, Larry takes a casual approach to design because he recognizes the amazing affect that it can have on people's lives and wants the process to be enjoyable. A man of genuinely unique experiences, Larry Boeder appreciates the good aspects of all types of design and shares his passion for beautiful interiors with his loyal clientele.

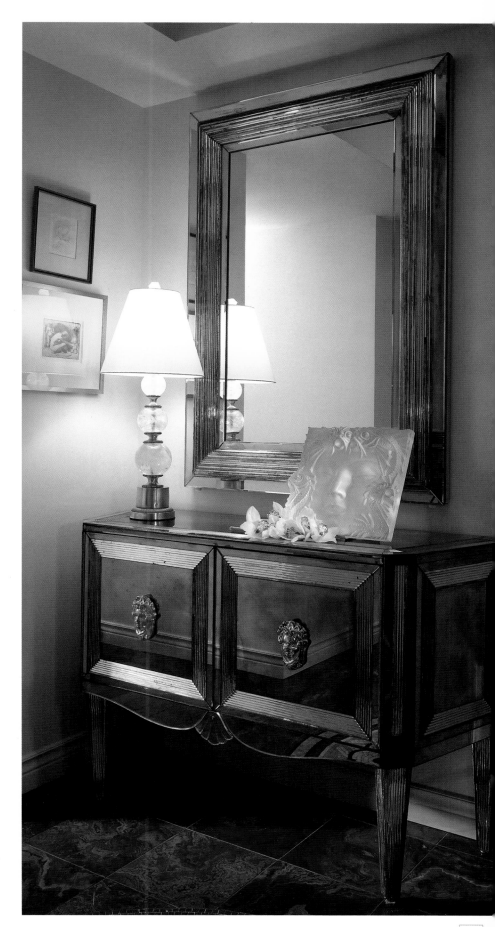

RIGHT:
The clean lines of an Art Deco mirror and console highlight a Lalique sculpture and delicate prints in the client's entry hall.
Photograph by Tony Soluri

FACING PAGE TOP:
Using a lime-green and black color scheme, the designer pulls together Biedermeier chairs, a Hungarian chandelier, and a family heirloom sofa reupholstered in black velvet.
Photograph by Tony Soluri

FACING PAGE BOTTOM:
In this Chicago pied-á-terre, Lawrence uses delicate sculptures and pale color; a 19th-century French armoire houses the client's entertainment system.
Photograph by Tony Soluri

WHAT IS ONE OF LARRY'S GREATEST INDULGENCES?
To restore peace and balance to his life, he has private yoga sessions several times a week.

HOW IS IT OBVIOUS THAT HE LIVES IN CHICAGO?
He is a great parallel parker.

WHAT IS LARRY'S FAVORITE ASPECT OF DOING BUSINESS IN CHICAGO?
As an interior designer, Larry is invigorated by the diversity of people with whom he comes in contact. From talented tradespeople to extremely successful CEOs, he loves the people of Chicago and says they are some of the best in the world.

WHERE DOES HE LIKE TO VACATION?
Larry and his wife Mary, who is of Irish ancestry, enjoy the music and culture of Ireland and also appreciate historically significant destinations such as Spain, France and Austria.

DOES HE HAVE ANY COLLECTIONS?
An avid collector of 18th and 19th century paintings and antique rugs, Larry has thousands of unique home accessories and cherishes his Native American art and artifacts.

IN HIS PROFESSIONAL CAREER, WHAT IS THE MOST VALUABLE LESSON THAT HE HAS TAKEN TO HEART?
When Larry was younger, he had dinner with a very powerful businessman who showed amazing compassion for everyone with whom he came in contact. Larry observed the man genuinely inquire about the doorman's son who had broken his ankle a few weeks prior. That experience reminds Larry of the importance of showing kindness and courtesy towards everyone.

ABOVE:
A pleasant contrast is created between ornate embroidered fabrics and the clean geometric design of the carpet.
Photograph by Robert Mauer

FACING PAGE TOP:
Seafoam green and grey-blue shades create a calming environment for this client's bedroom; line drawings from the 1930s by Carel Holty hang above the bed.
Photograph by Robert Mauer

LAWRENCE BOEDER INTERIOR DESIGN
Lawrence Boeder
2241 North Burling Street
Chicago, Illinois 60614
312.613.6640
f: 773.868.4132
www.lawrenceboeder.com

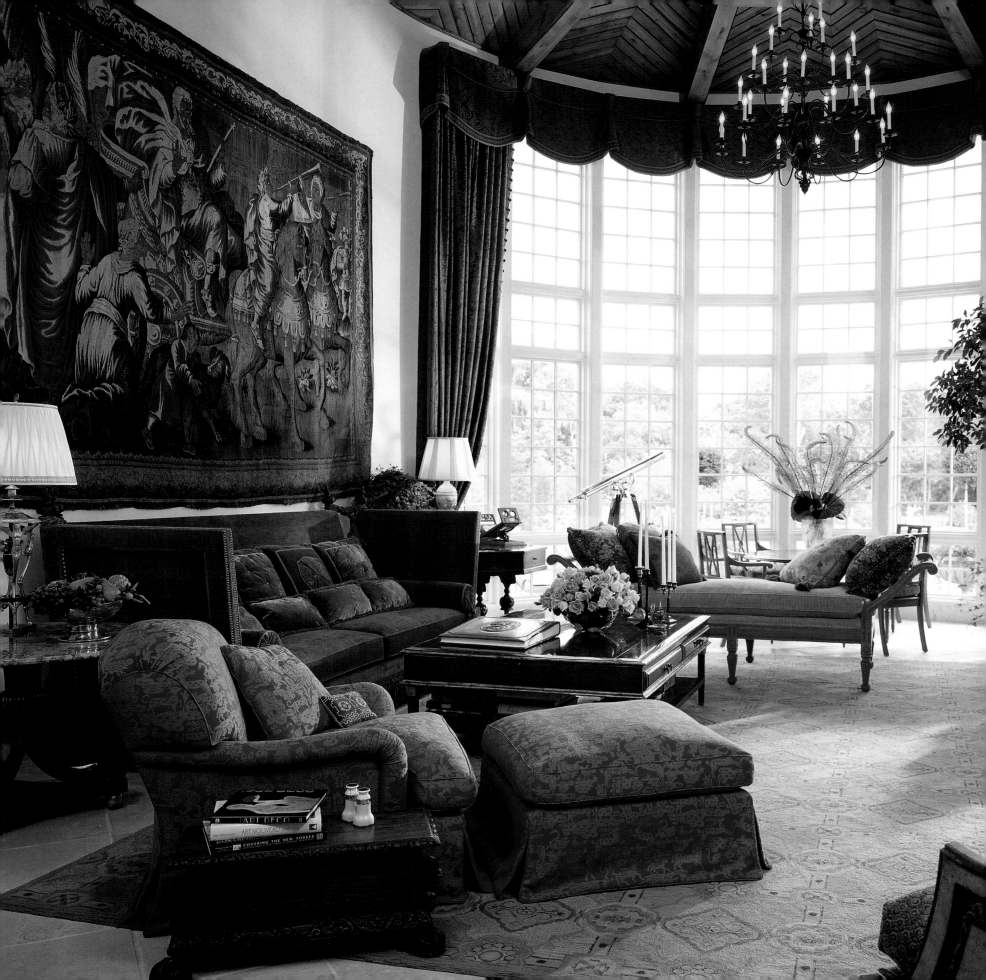

JOHN CANNON

CANNON FRANK A DESIGN CORPORATION PC

Taking clients' dreams well beyond their wildest imaginations for more than 25 years, Cannon Frank A Design Corporation PC designs interiors for a discerning and prominent clientele. Principal John Cannon combines his deep knowledge of the history of furnishings, art and antiques with an astute awareness of interior architecture, plumbing and electrical work to make the design experience as stress-free and exciting as possible.

John's background in period furnishings provides an ideal foundation for the high-end residences he designs, which remain timeless in their appeal and elegance. Pushing the envelope in creative challenges has been his hallmark since his earliest design projects, such as the fascinating way a primitive piece can bring a modern room to life. A graduate of the Ray Vogue School of Design (now the Illinois Institute of Art), the accomplished designer has been widely featured in a wealth of publications, including the *Robb Report, Chicago Home and Garden, Chicago Tribune, Chicago Sun Times, Window Fashions, Hotel and Restaurant* and *CS (*formerly *Chicago Social).*

A favorite project transformed a 15,000-square-foot home into a Greco-Roman style Italian villa—quite a departure from the firm's more typical contemporary designs. Focusing on 17th, 18th and 19th-century antique furnishings, this all-encompassing project pushed John further than any other,

making the result all the more thrilling. Although originally strictly defined by Italian décor, the design grew through John's incredible sense of style to include pieces from the Biedermeier, French Empire, Art Deco, Art Nouveau and all the Louis periods. John searched throughout Europe, New York, Los Angeles and Palm Beach for these amazing finds. Completing this fantasy are a 3,000-square-foot train room, a 15-seat movie theater, bar/lounge, game room, exercise room, steam room, wet room and an aquarium, all with an air of 1930s Hollywood mogul. Cannon Frank's creativity led to the design of the award-winning pool, mosaic murals and pergola and has extended into the garden with the addition of a temple ruin on a private island in the middle of a river, which runs through the property.

ABOVE:
This main staircase leads to the second floor, below a two-tier, 20-foot diameter dome with a hand-painted, gold-leafed mural depicting six mythological deities.
Photograph by Tony Soluri

FACING PAGE:
A 200-year-old Flemish tapestry depicting Caesar's entrance into Rome hangs magnificently in the client's family room. The 10-foot custom sofa was designed by John Cannon.
Photograph by Tony Soluri

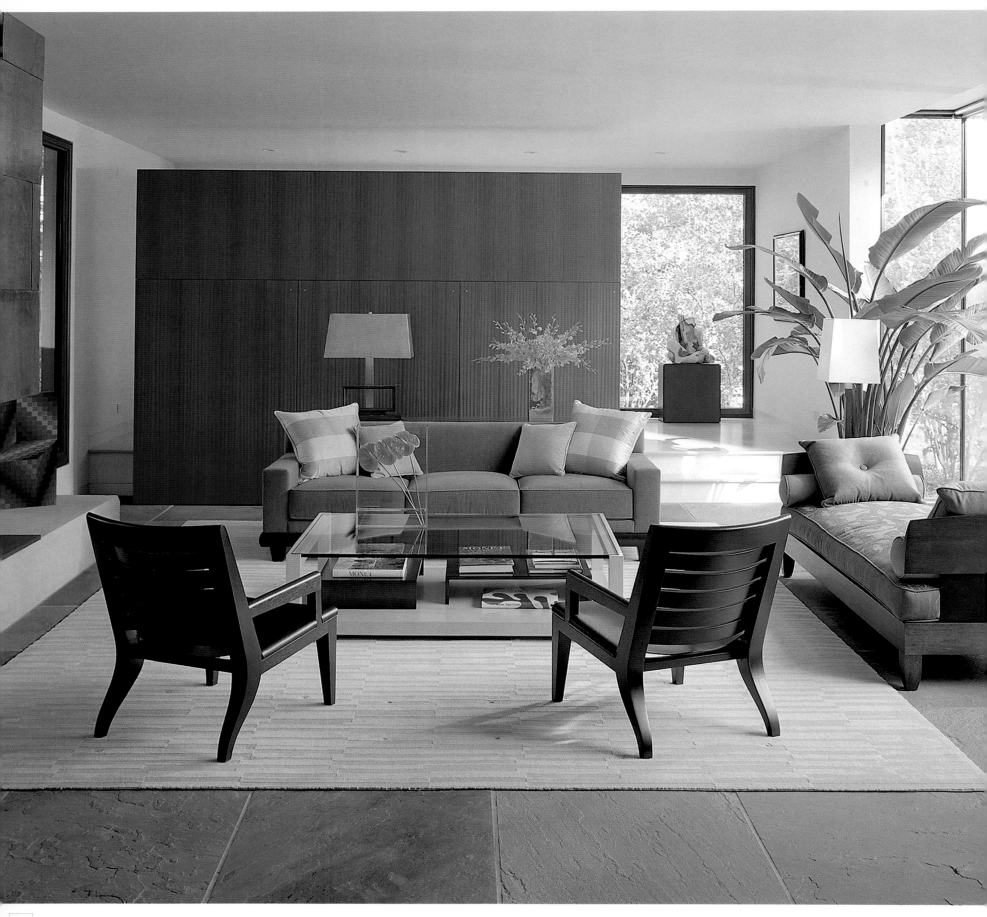

John Cannon's carefully selected team solidifies the firm's expertise and creativity, as ideas develop in a collaborative style with the client's complete satisfaction as the shared, singular objective. Cary Frank, his business and life partner who manages every aspect of the business, applies his own graceful demeanor and unique opinions to deliver invaluable results to a client's needs. John refers to Cary as "his muse," because of his personal style and graciousness, not to mention his client skills.

Giving back to the community for more than a decade, Cary has chaired the house and garden tour for Lakefront Supportive Housing and the Heartland Alliance for Human Needs and Human Rights, two foundations which strive to alleviate poverty and homelessness. Likewise, John has regularly volunteered with DIFFA Chicago, the Design Industries Foundation Fighting AIDS, since its 1984 inception, serving on the board for six years, chairing the designer garage sale for two, and once chairing the DIFFA Ball. Both partners are actively involved with Lambda Legal for which the couple hosted an event for 450 people at their home in 2004.

Since relocating to Chicago's world-famous Merchandise Mart in January 2006, Cannon Frank A Design Corporation's clients have enjoyed the ultimate in high-design convenience by having the vast resources of the world's largest design center at their doorstep. This prestigious location exemplifies the professionalism the company delivers and the quality clients trust. By choosing a design firm such as Cannon Frank, clients enjoy the highest value of a team of designers who collaborate to create the absolute best results with the world's most luxurious resources.

TOP RIGHT:
Koa wood cabinetry and gold-leaf tortoise shell paint supports an antique Edgar Brandt mirror from the client's private collection.
Photograph by Tony Soluri

BOTTOM RIGHT:
Ivory mohair chairs and ottoman sit on acid-washed and sandblasted white marble flooring accented with a Christian Liagre table, while overlooking a forested ravine.
Photograph by Tony Soluri

FACING PAGE:
A collaborative effort between architect and designer featuring classic contemporary furnishings in tones taken from nature.
Photograph by Tony Soluri

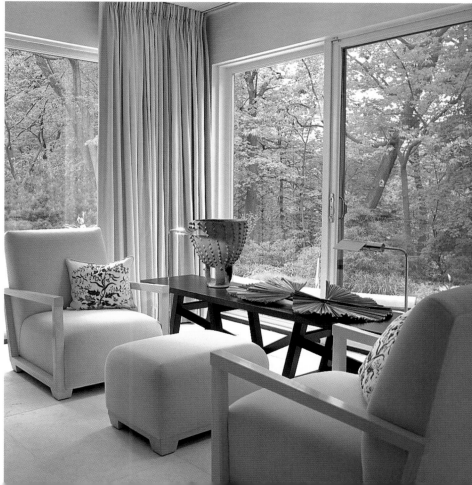

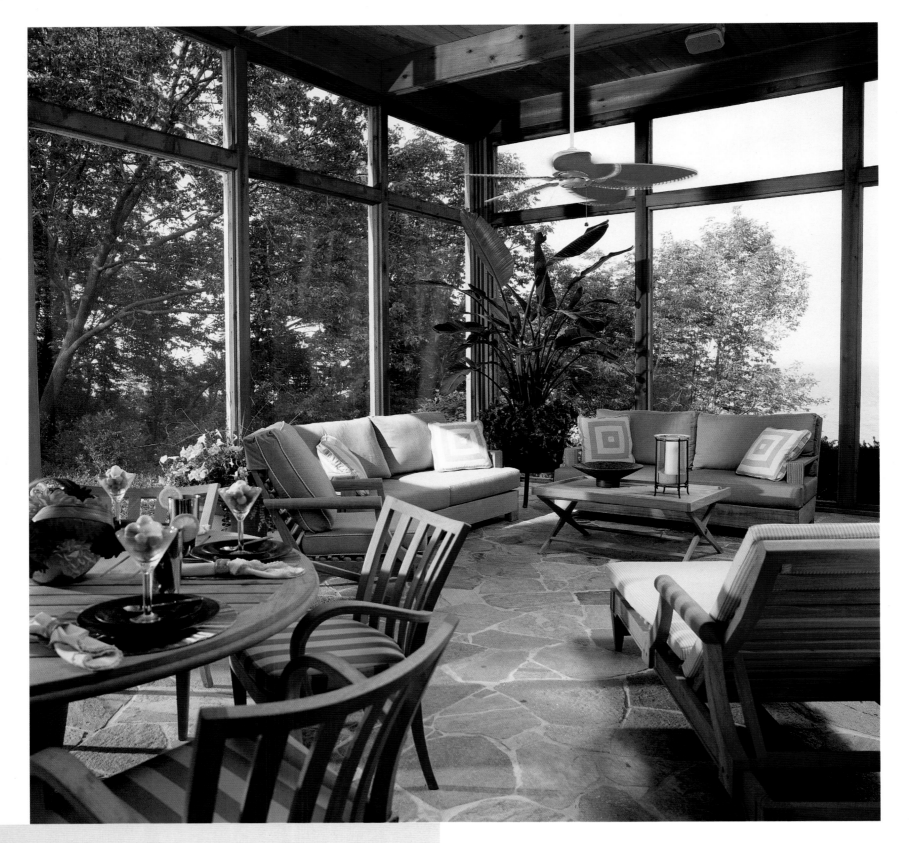

ABOVE:
Sophisticated exterior summer porch in natural teak, stone and cedar creates a casual yet elegant atmosphere filled with warmth and the sounds of summer.
Photograph by Tony Soluri

Q&A

more about john ...

WHAT IS THE MOST UNIQUE PROJECT IN WHICH CANNON FRANK HAS BEEN INVOLVED?

In collaboration with The Art Institute of Chicago, Cannon Frank designed a $250,000 lighted display cabinet to protect a collection of antique paperweights and pens in a room that no one will ever see, but serves as a sanctuary for the clients to enjoy.

WHAT IS THE BEST PART OF BEING AN INTERIOR DESIGNER?

John enjoys creating and living vicariously through the diverse style and taste of his clients.

HOW WOULD JOHN BRING A DULL HOUSE TO LIFE?

He would unclutter the space, then look with a fresh eye, accessorize appropriately and add color to give a clean result.

ON WHAT PERSONAL INDULGENCE DOES JOHN SPEND THE MOST MONEY?

John feels that a personal chef is one of the greatest luxuries you can give yourself, so John and Cary's meals are delivered a few days at a time and need only to be warmed. The menu includes everything from eggplant parmesan to sea bass with sesame crust or even a vegetarian dish; each meal is a delightful surprise, as entrées are rarely repeated. John's love of gourmet food translates into his kitchen design, because as an amateur chef, John knows exactly how a kitchen should work.

WHAT ARE JOHN'S HOBBIES?

An excellent gardener, his landscaping boasts riotous color and a mixture of breathtaking plants. John and Cary's country home features a 100-foot by 75-foot butterfly garden, as one of many gardens where they enjoy watching thousands of beautiful creatures flutter about in the summertime. They also have a 3,000 gallon pond with about 65 assorted rare Koi.

CANNON FRANK A DESIGN CORPORATION PC
John Cannon
1530B Merchandise Mart
Chicago, Illinois 60654
312.595.1550
www.cannonfrank.com

TOP:
This kitchen dining area with sycamore paneling, vintage table chandelier and Georg Jensen tureen is inviting even without a gourmet meal!
Photograph by Tony Soluri

BOTTOM:
A symphony of ivory silk on the walls, bed and furnishings (most of which are antique Ruhlmann) help create a sumptuous night of slumber.
Photograph by Tony Soluri

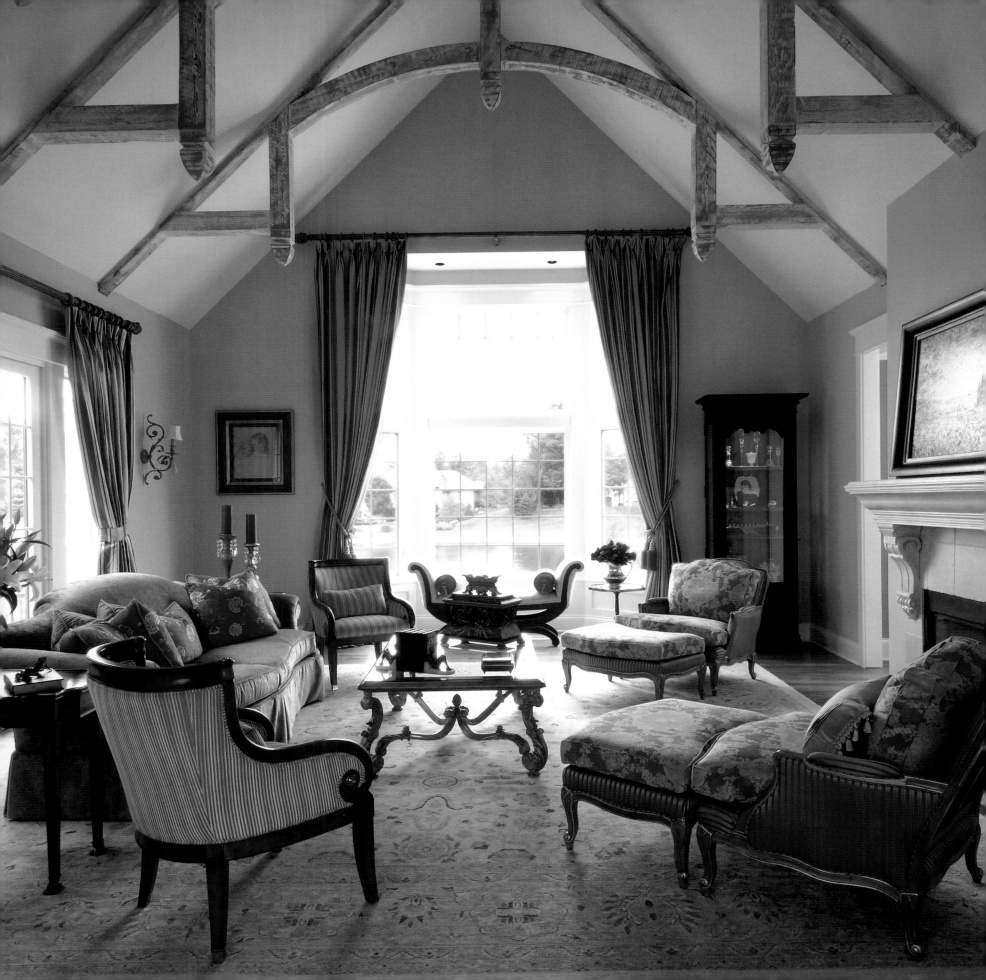

LAUREN COBURN
LAUREN COBURN, LLC

By treating clients the way that she would like to be treated, Lauren Coburn approaches design with fresh ideas to create timeless interiors.

Although she recently established her namesake design firm in 2004, Lauren is no stranger to the industry. She has intimate knowledge of design, having earned a degree in interior architecture from the Art Institute of Chicago and spent several years with Chicago's renowned Tigerman McCurry Architects where she gained a deep appreciation for design as a cooperative effort between architect, designer and client. Lauren whole-heartedly enjoys the challenges of design and believes that with good communication between everyone involved with the project, truly spectacular results can be achieved.

A professional member of both the Chicago Architecture Foundation's auxiliary board and The Interior Design Society, Lauren executes her clients' design wishes in a timeless and sophisticated manner, drawing from many periods and styles to create a look all of their own. She loves to mix antiques into contemporary settings and combine stylistic elements from contrasting genres to add further interest. This technique was exemplified in a client's Chicago dining room in which Lauren designed custom French Art Deco pieces, inspired by the 1920s French Art Deco designer Jules

Leleu. These furniture pieces along with accessories such as vintage table torchierres of black lacquer with aged Murano glass shades that Lauren found through auction, helped to add an elegant and sophisticated layer to the modern home.

Clients enjoy working with Lauren because she patiently guides them through the creative process—never rushing them to make selections. She wants clients to be completely comfortable with every decision so that the interior will be enjoyed well into the future.

ABOVE:
An elegant combination of Holly Hunt furniture is complemented by a Stark Carpet rug and window treatments fabricated by Countryside Draperies with Great Plains fabric.
Photograph by Mark Rodansky

FACING PAGE:
A clean lined traditional living room in Niles, Michigan features vaulted ceilings and window treatments by Countryside Draperies using Scalamandré fabric. Oversized chairs and ottomans upholstered in fabric by Coraggio Textiles and an exquisite rug by Oscar Isberian Rugs add to the elegant feel.
Photograph by Paul Doughty, Pkdog Inc.

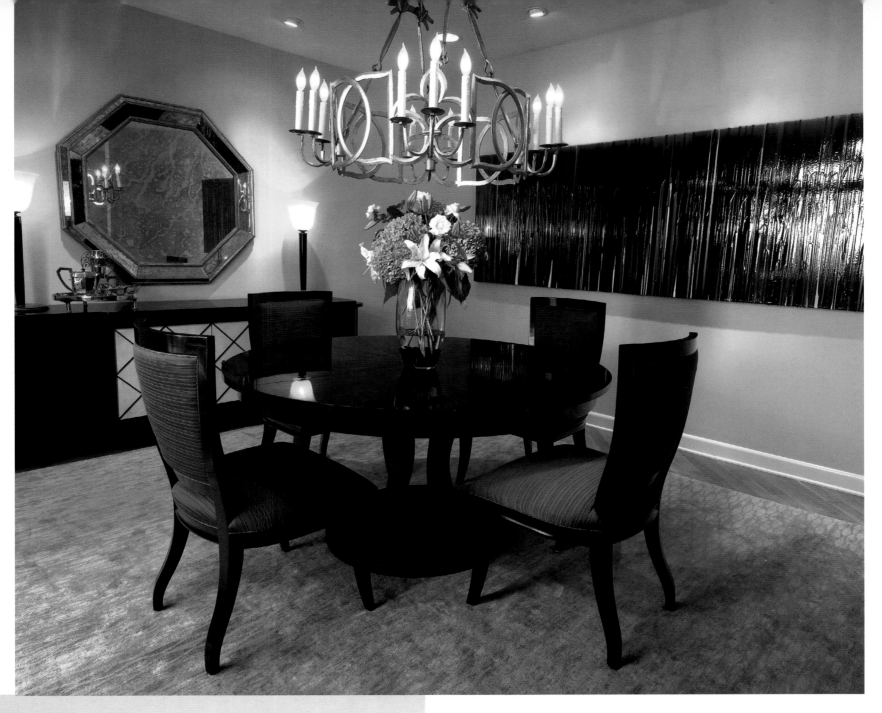

ABOVE:
French Art Deco inspired, this Highland Park dining room boasts a dining table as well as buffet and dining chairs, all custom designed by Lauren Coburn. Table and buffet fabricated by Koch Smith; dining chairs fabricated by Rick Barron. Barbara Barry designed rug from Oscar Isberian Rugs and mirror by Niermann Weeks enhance the timeless feel. Abstract resin by Michael Douglas, represented by Gruen Galleries, Chicago, Illinois.
Photograph by Paul Doughty, Pkdog Inc.

FACING PAGE TOP & BOTTOM:
In this Highland Park living room, modern and traditional lines converge. An eclectic feel was achieved by blending antiques with Holly Hunt arm chairs, custom window coverings fabricated by Countryside Draperies with Nancy Corzine fabric, and Watson Smith crème rug. Small sofa is covered in Coraggio Textiles fabric; large chocolate brown sofa is covered in Great Plains fabric. The oval table is crafted of antique onyx and bronze.
Photograph by Paul Doughty, Pkdog Inc.

Lauren has a talent for designing custom furniture for her clients and works with the highest quality custom craftspeople to execute these pieces. Her clients are involved with each stage of the process and Lauren enjoys the fact that they will have unique custom pieces in their homes.

Upon meeting Lauren, it quickly becomes evident how enthusiastic and passionate she is about interior design. Raised by a very artistic mother and a father who is both a doctor and racecar driver, Lauren feels that design is the perfect blend of her technical and creative talents. She makes herself very accessible to clients by officing from her stylish 67th floor Hancock Building apartment and goes to great lengths to keep projects on schedule, orders organized, clients happy and still has time to be extraordinarily creative.

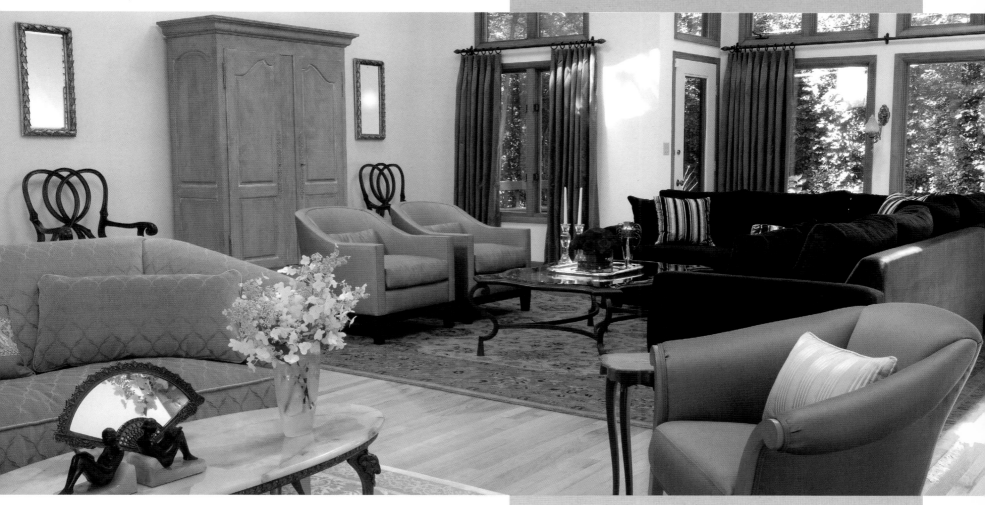

Q&A

more about lauren ...

WHAT IS THE HIGHEST COMPLIMENT THAT SHE HAS RECEIVED?
One industry professional equated: Lauren is to design what Chanel is to fashion.

HOW DO LAUREN'S FRIENDS DESCRIBE HER?
Embodying the best of all worlds, she is vivacious, sweet, savvy and can be "kittenesque" at times.

WHAT ARE HER GREATEST INDULGENCES?
True to her diverse design interests, Lauren collects vintage jewelry, French Deco antiques and classic modern furniture.

LAUREN COBURN, LLC
Lauren Coburn, IDS
175 East Delaware Place, Suite 6710
Chicago, Illinois 60611
312.337.7127
c: 312.303.0111

JANET DEBITS

J.R. INTERIORS

As former president of The American Society of Interior Designers, Illinois Chapter, Janet Debits has mastered the art of communicating ideas and managing people. Although Janet's design styles include traditional, transitional, prairie and modern, she does not force her personal preferences. She loves to help her clients achieve their own style.

Janet is a free-spirited designer who has been recognized for her work through a variety of sources, including: *Better Homes and Gardens, Fine Furnishings* and *House Beautiful*, just to name a few. Encouraged by her father to follow her dreams, Janet earned a B.A. in art from The Oklahoma College of Liberal Arts; she then went back home to study interior design at The Chicago School of Interior Design.

With a family heritage of volunteerism, it is no surprise that Janet is very generous with her time and design talent. She has served numerous organizations, including: The Spirit Foundation in Chicago, Infant Welfare Society of Oak Park and The West Suburban Hospital Auxiliary.

Janet provides a unique interior design service of staging. Many clients commission her to rearrange their homes for a particular party; she brings in fresh flowers, professionally lights the area and makes other subtle changes to invite the appropriate atmosphere. Her talent is so encompassing that many clients will not hang a picture without her expert opinion. Janet feels great when she hears clients tell their friends that they wouldn't hire anyone else and that she has had a key to their house for 20 years.

J.R. INTERIORS
Janet Debits, ASID
537 North Harvey Lane
Oak Park, Illinois 60302
708.386.2963

ABOVE:
Elegance is added to an otherwise drab Mediterranean foyer and stairwell.
Photograph by Robert Mauer

FACING PAGE:
Midwestern "Prairie Influence" in an English Tudor study.
Photograph by Nels Akerlund

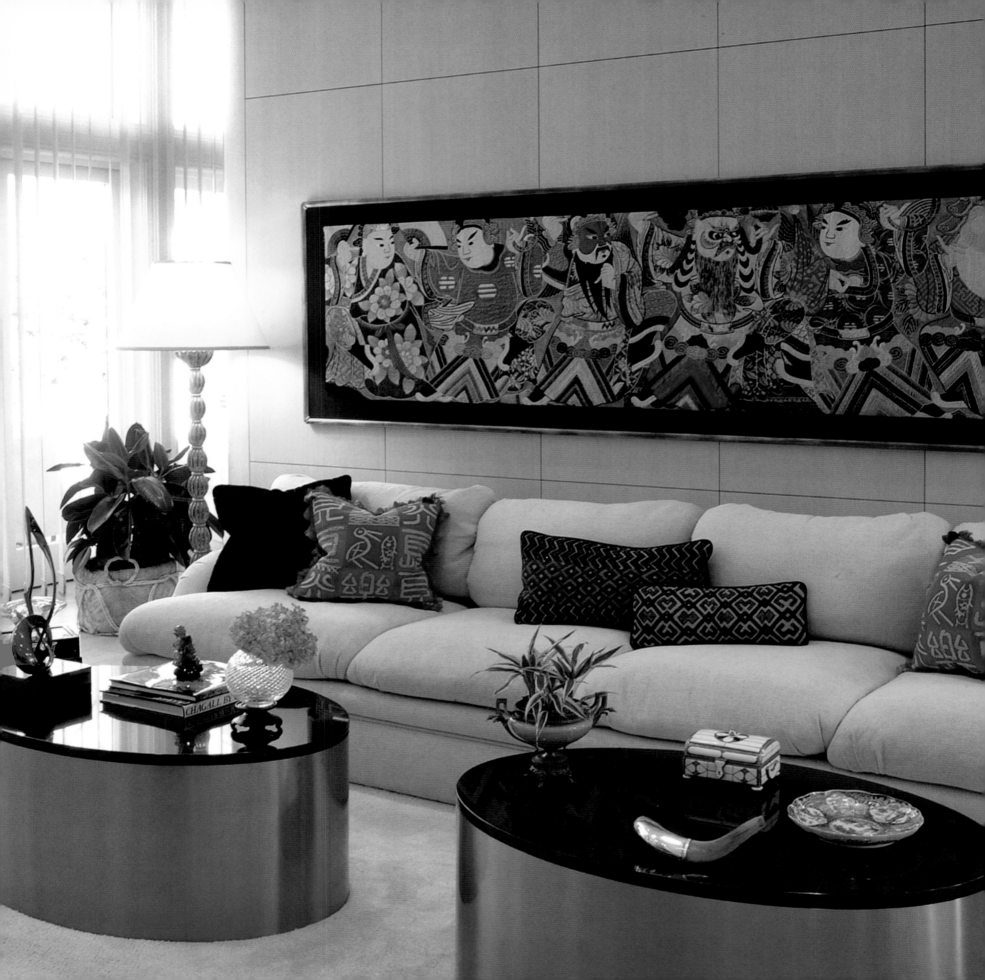

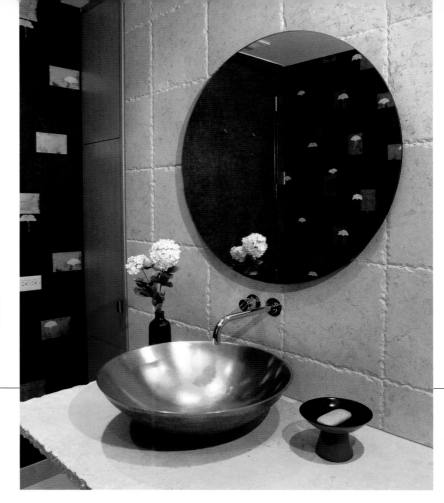

LARRY N. DEUTSCH
WILLIAM F. PARKER

DEUTSCH | PARKER DESIGN, LTD.

With over 40 years of experience, Larry and Bill offer comprehensive design services for both residential and commercial spaces. Bill is passionate about 18th century English furniture in contemporary settings, while Larry prefers a more sparse eclectic style with appropriately scaled furnishings. Each designer has a unique perspective but both strive to develop their clients' sense of style.

Larry and Bill have complementary educational backgrounds. Both are graduates of The University of Arizona, where Larry earned a BFA in Art while Bill specifically pursued interior design. Clients have the full attention of one designer, but behind the scenes, Larry and Bill are in constant collaboration to create inventive solutions for their clients. Bill quickly absorbs information from design books and Larry stays current with world events and trends through periodicals; their combined knowledge-base is priceless.

Late design mentor Richard Himmel, FASID, taught Larry the importance of being knowledgeable about antiques and the history of style traditions. Larry translates this design foundation to his clients by teaching them while they shop. Sometimes clients are initially a bit intimidated, but they soon come to value the educating experience which allows them to take more pride and ownership in their home décor.

Featured in notable publications such as *House and Garden*, *Architectural Digest* and *Better Homes and Gardens*, Deutsch|Parker Design, Ltd.'s designers have the professional experience to take on any project. Clients often comment on the in-depth consultations which Bill and Larry provide because the talented interior designers provide an entirely new perspective.

DEUTSCH | PARKER DESIGN, LTD.
Larry N. Deutsch, ASID
William F. Parker, ASID
1240 North Lake Shore Drive
Chicago, Illinois 60610
312.595.9330
f: 312.595.9366
www.dpddesign.com

ABOVE:
A vessel bowl and floating oval mirror offer a stylistic counterpoint to the rectangular shapes in the Asian-influenced wall covering.
Photograph by Francois Robert

FACING PAGE:
An Art Deco Chinese silk embroidery from the Paris flea market hovers over a contemporary banquette enhanced by various African and Chinese influenced pillows.
Photograph by Francois Robert

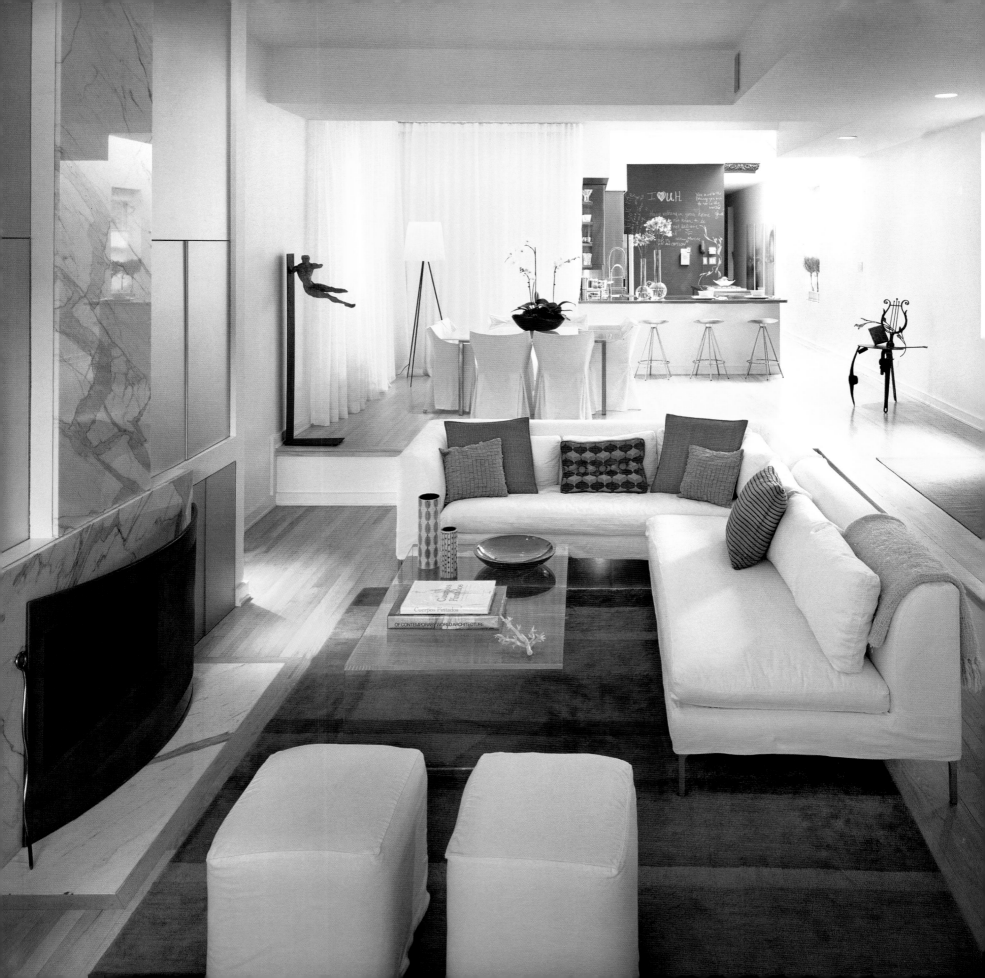

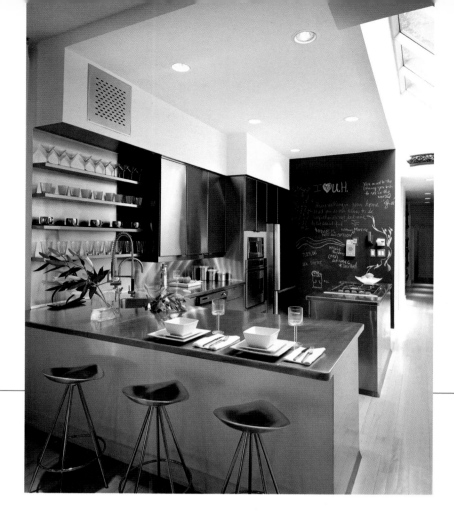

LISA EWING

EWING DESIGN GROUP

An easy-going interior designer, Lisa Ewing enjoys the organic process of helping people express themselves by combining contemporary designs with eclectic pieces. She loved the challenge of renovating a loft in the former Oreo cookie factory. Lisa maintained the building's architectural integrity while transforming three oven rooms into elegant living spaces. Balancing functional and aesthetic needs, Lisa's primary objective is to create environments which are relaxing, quiet havens.

Finding beauty in everyday objects, she once designed a custom chandelier from pieces of twisted copper pipe and refrigerator bulbs. The piece hung above an antique Rococo glass and gilded table. Lisa has found that juxtaposed items can add interest and character to any setting.

Lisa loves to experiment with new materials. She sometimes creates custom sliding wall partitions with Kalwal, a translucent material used for skylights. Moveable walls keep areas open, but can easily be repositioned for a more intimate setting. The architectural element provides both auditory and visual privacy in a stylish manner.

Advocating clean lines, Lisa patiently works with her clients to edit their belongings. She realizes the importance of mementos but believes that people function and live better in spaces that are visually uncluttered. Lisa has made great use of her home office space by designing a wall of storage hidden behind beautiful drapery. Downstairs, a 600-square-foot space serves as a quiet research area complete with a library of books and textile samples, which clients love to peruse.

ABOVE:
A sleek, normally hard edged industrial stainless steel kitchen illustrates that contemporary design can be fun, functionional and not overly cold. The soul of the house, a whimsical chalkboard created with Benjamin Moore chalkboard paint, allows friends to write favorite quotes and family members to stay in touch. Open floating shelving over the sink promotes a "grab a glass and relax" sensibility.
Photograph by Robert Murphy of Robert Murphy Photography

FACING PAGE:
A peaceful, heavenly sensation was created in this inviting living room by keeping clutter to a minimum. The overall color scheme is white, yet there are continuous reminders of the sea and sky to punctuate the calming effect. Soft denim slip covers provide easy maintenance. Cabinetry is faced with sandblasted satin silver mirrors and hides the mechanics of everyday life.
Photograph by Robert Murphy of Robert Murphy Photography

One of her many design secrets is combining expensive pieces with cost-effective ones. For example, a great piece of art could make an ordinary or inexpensive chair look like "a million bucks." Although she can work with virtually any budget, she never sacrifices quality in items that will be touched on a daily basis.

Lisa was selected to appear on HGTV's popular show, "New Spaces" in 2006 and was surprised at how much hard work was involved in the lengthy process. She conveys that it felt like each scene required a hundred different takes to acquire the appropriate camera angles and it was challenging to maintain the same level of enthusiasm on the first and last run-throughs, but overall she enjoyed the adventure.

Her impressive design career reaches back many years to running a Miami showroom with her mother, an art lover and avid collector of African masks. Lisa's father spent 13 years traveling all over the world on his 120-foot yacht and brought back many interesting things. Greatly influenced by world traveling parents who were fascinated with a variety of unique cultures, she cherishes the experiences they shared with her and will someday devote an entire room to display memories and artifacts. Part Cuban, Lisa is fluent in Spanish and has a working knowledge of French and Italian; she appreciates diversity, which is evident in the international flair of her design work.

Columbian artist Juan Jose Molina, is a favorite of Lisa's because he creates acrylic paintings that resemble black and white photographs and contain imagery that parallels time. She feels that by removing color, emotion is taken away and the viewer can really focus on the painting's subject matter and composition. Fascinated with the impact that color has on design, Lisa loves to experiment with unique combinations. The color that best describes her is "Cafe con Leche" because it is soothing, comforting, gratifying, and appeals to a broad demographic.

With experience at two major auction houses, Lisa is well-versed in acquiring and restoring the perfect pieces for her clients. She earned a bachelor's degree from Florida State University and then continued her studies at Harrington College of Design. Since establishing Ewing Design Group, Inc. in 1997, Lisa has attracted the attention of various distinguished publications, and her work has been featured in *Florida Architecture*, *Chicago Tribune*, *Des Moines Homestyle* and *Chicago Home*.

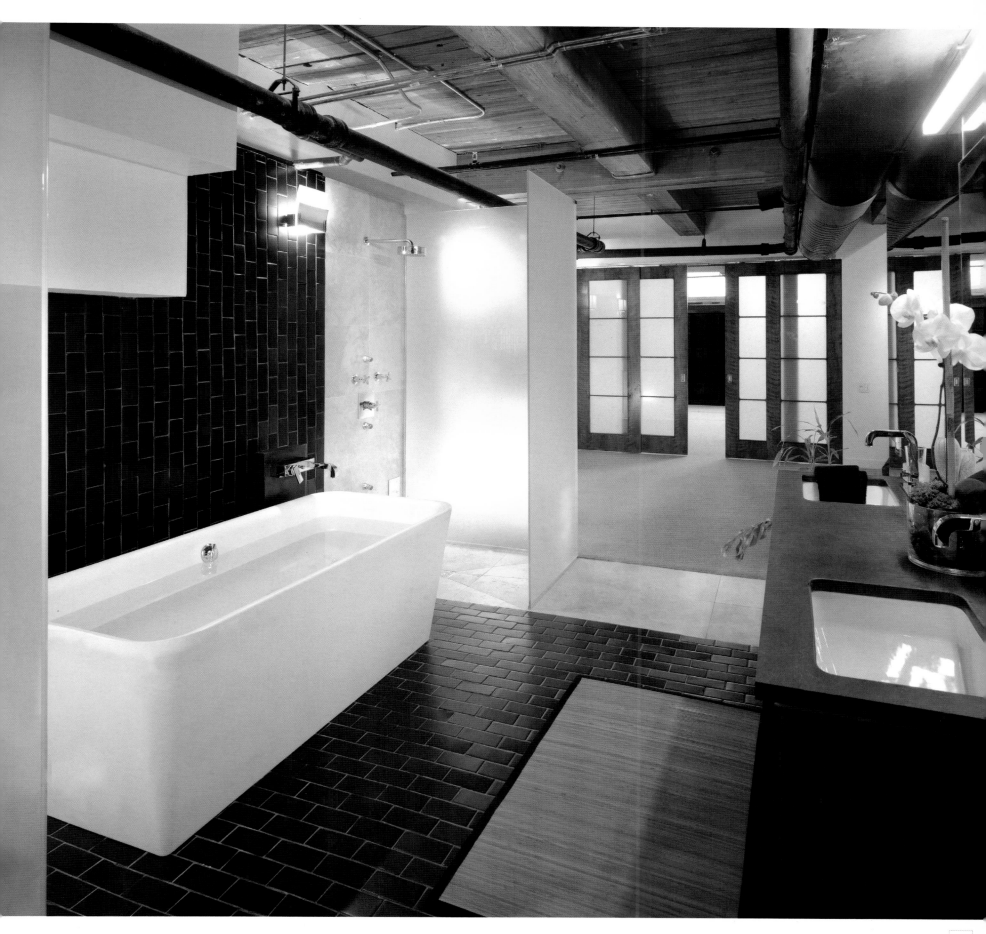

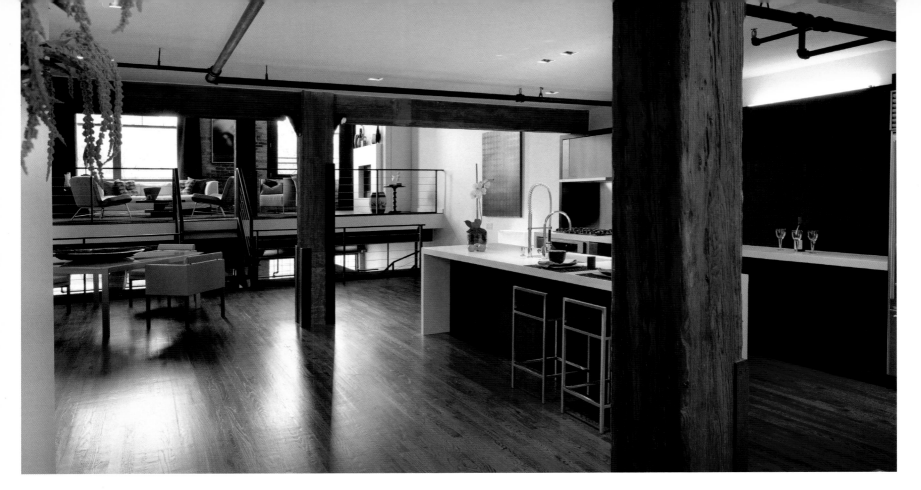

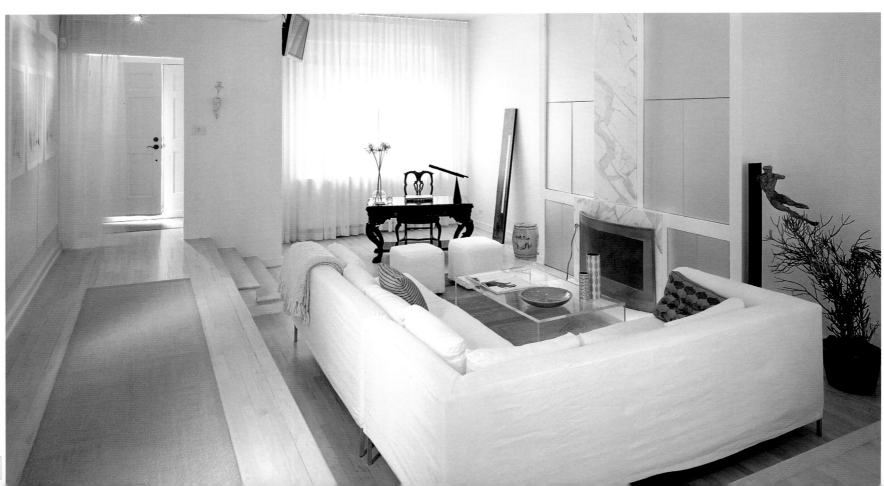

Q&A

more about lisa ...

WHAT DO MOST PEOPLE NOT KNOW ABOUT LISA?
She loves "roughing it" and relying on the natural elements for survival on islands and in swamps and deserts.

HOW WOULD LISA'S FRIENDS DESCRIBE HER?
Even though she loves working with her clients, Lisa's friends would convey shat she is very shy and would rather not be in the spotlight.

WHAT ARE HER PERSONAL INDULGENCES?
She collects art and design books and loves to be pampered with massages.

WHAT IS ONE OF HER FAVORITE BOOKS?
She enjoys reading *The Captain's Verses* by Chilean poet Pablo Neruda, who won the Nobel Prize for Literature in 1971.

HOW DOES LISA ADD INTEREST TO A DULL AREA?
Lisa finds that simply introducing exotic potted plants, such as orchids, or adding a big bowl of mangos, green apples or artichokes really makes a statement.

WHAT IS LISA'S FAVORITE ASPECT OF OFFICING FROM HER HOME?
Since design schemes often pop into Lisa's imagination in her sleep, she explains that there is nothing quite like designing in her pajamas, uninterrupted and comfortable.

EWING DESIGN GROUP
Lisa Ewing
1867 North Bissell Street, Suite A
Chicago, Illinois 60614
312.951.6090
f: 312.873.3883
www.designewing.com

ABOVE:
The third level of a loft allows a glimpse of 25-foot timbered ceilings softened by Zen-like backlighting of wood and glass doors. The juxtaposition of aged elements against sensuous materials transforms industrial spaces into real living environments.
Photograph by Robert Murphy of Robert Murphy Photography

FACING PAGE TOP:
Understated metal squared-off railings and Zen-like squared-off cabinetry in ebonized mahogany sans distracting hardware allow the architecture's drama to reign. Honed limestone 2 ¼" thick monolith countertops balance the space.
Photograph by Robert Murphy of Robert Murphy Photography

FACING PAGE BOTTOM:
An antique American Federal-style desk commands attention in the corner of the bleached living room—the old punctuates the new. Soft wall drapery hides a long bank of hidden cabinets housing a home office.
Photograph by Robert Murphy of Robert Murphy Photography

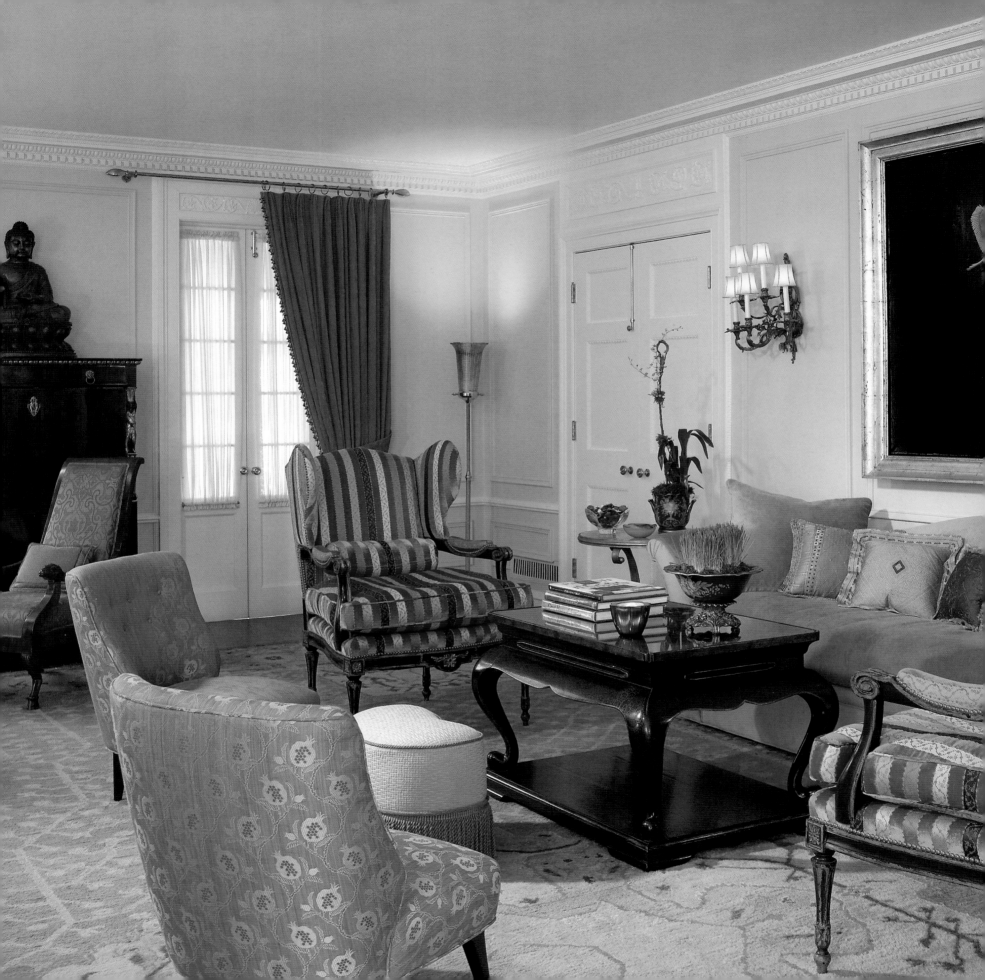

THOMAS FITZGERALD

THOMAS FITZGERALD INTERIORS

Thomas Fitzgerald's eclectic modernist style has developed through a culmination of life experiences and influences. He credits his success to the 15 years spent with design mentor Bruce Gregga, who inspired him to discerningly observe the world around him. Tom absorbs architectural and artistic styles through his travels and locally by exploring shops, museums and diverse Chicago neighborhoods.

An eclectic devotee, Tom's original designs often combine contrasting themes such as Italian, Swedish, Biedermeier, continental and contemporary. Tom is particularly inspired by Jean Michel Frank's minimalist clean lines and the furniture and sculpture of Giacometti. He also appreciates the aesthetics of Asian culture evidenced in his creation of a personal city Zen garden.

Tom begins the design process for clients by distilling their priorities, style preferences and budget. He helps his clients understand their own unique style by discussing various magazine pictures, boutique finds and internet resources. The first item on Tom's list is generally an area rug; he feels that wall color should be secondary to textiles and artwork.

LEFT:
An antique Oushak rug inspired the living room design. Vienna Empire Fallfront Secretaire circa 1810 in mahogany, poplar and fruitwood veneers. Painting is *Emergence* by Don Pollack.
Photograph by Tony Soluri Photography

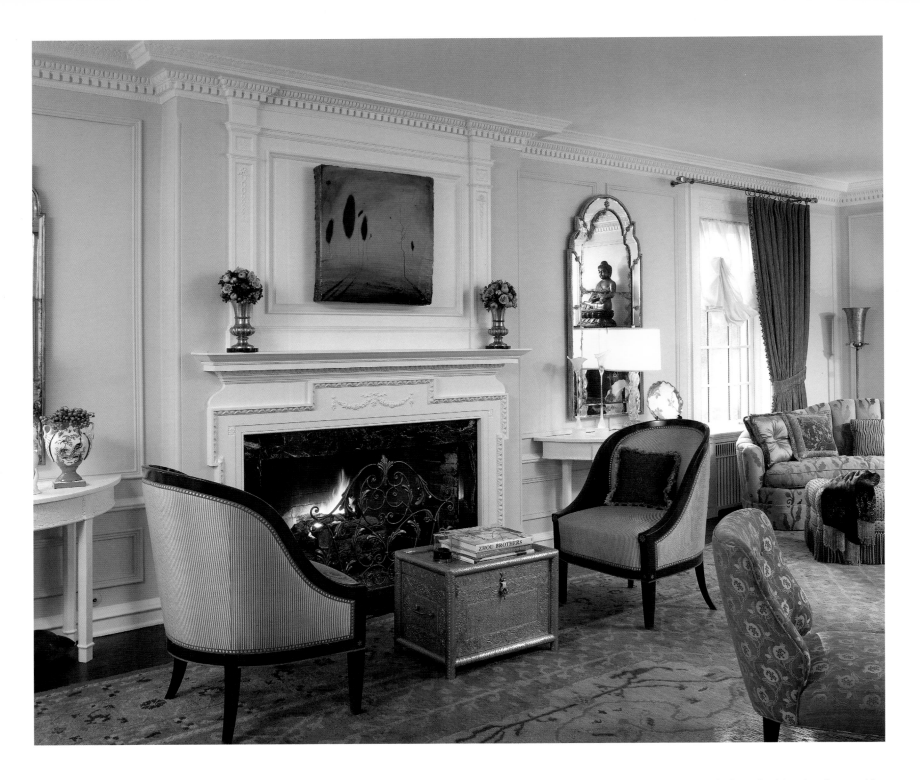

One of Tom's favorite undertakings was a vacation home in Vail, Colorado. Side-by-side houses were combined to form a 6,000-square-foot residence, and Tom orchestrated every detail of the renovation and design. The ski home features contemporary décor with clean lines and a monochromatic color scheme that highlight the client's extensive art collection. The customized retreat was made complete through the design of a large gym for the fitness-conscious owners.

Although Tom likes bold color, his home is designed with crisp linen white walls to feature his art collection. He enjoys the caramel color leather sectional and custom iron etageres of the living room, which opens up to an almost rustic kitchen with restaurant shelving, stainless fixtures and a glass-top regency table. Stylish cable halogen lighting, maple flooring and two-inch wood slat blinds tie the rooms together. Tom's sunroom, with its Chinese travel basket coffee table and French doors to the garden, provides a tranquil setting to read the Sunday paper.

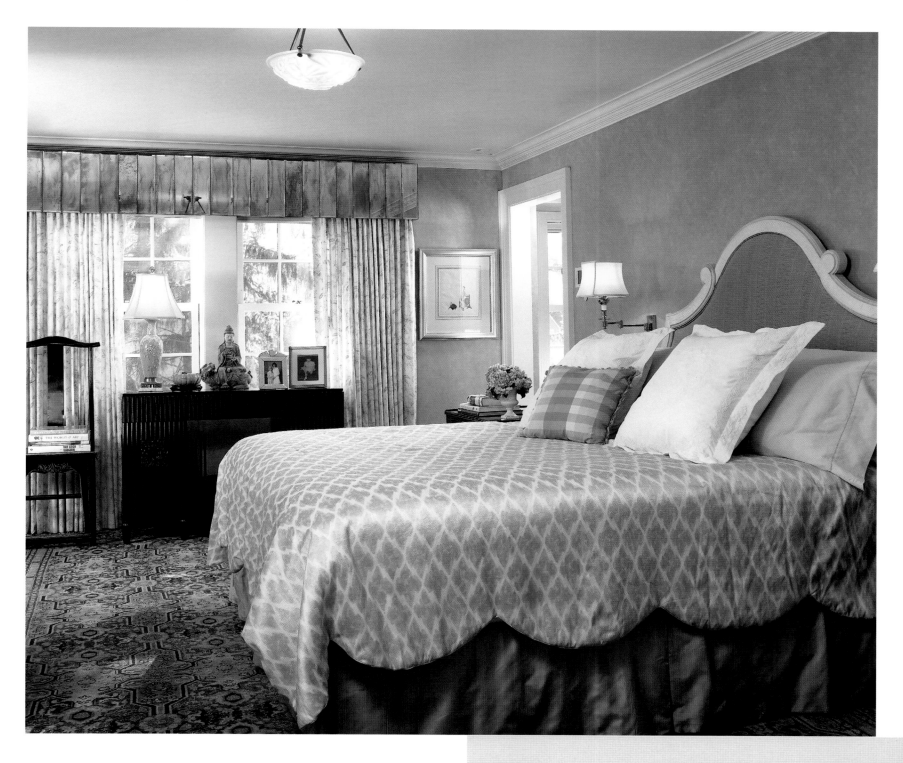

ABOVE:
Thomas Fitzgerald Interiors designed the painted wood framed headboard upholstered in Bergamo silk and the mirrored valances over Oriental blue toil curtains. Antique Tabriz area rug. Jerome Sutter swing arm lamps.
Photograph by Tony Soluri Photography

FACING PAGE:
Antique Beidermeir chairs upholstered in Clarence House fabric face a silvered Moroccan trunk. Dennis & Leen mirrors flank the fireplace. Ceramic art is *Left Standing II* by Charles Timm–Ballard.
Photograph by Tony Soluri Photograpy

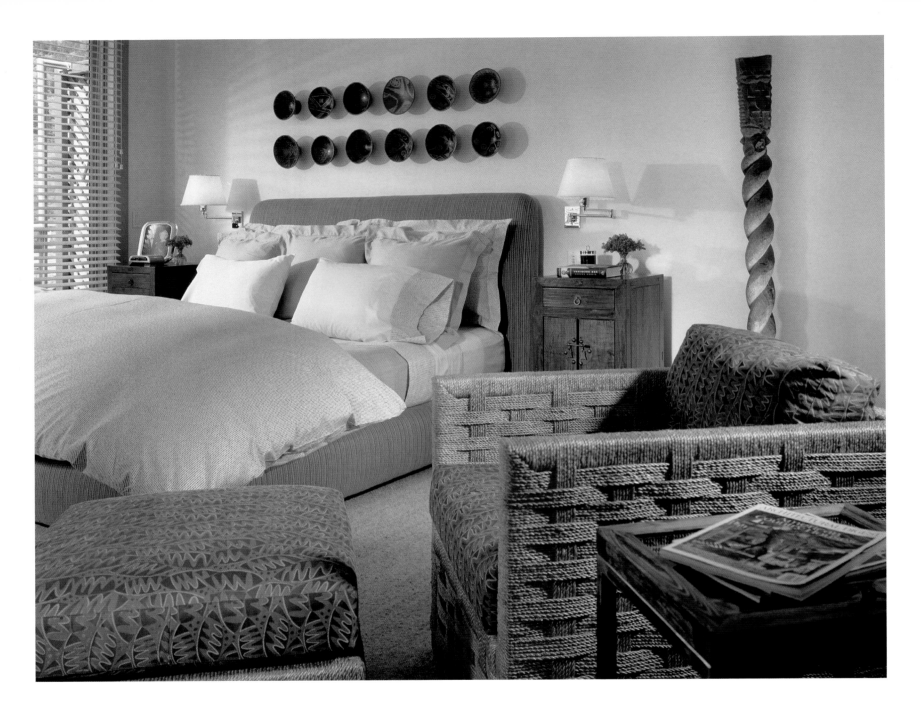

One favorite piece in his art collection is the painting *Battleground* by Robert Donley hanging in his sunroom. The six-foot by four-foot vertical painting brings strong color to the setting and features Donley's trademark modernist funk-figure imagery. Another treasured piece, a small print of a pigeon, is endearing for its simplicity and being a gift from Bruce Gregga.

Tom, originally from Wisconsin, relocated to Chicago after serving in the army during The Vietnam War. He immediately fell in love with all the aspects of culture and entertainment which the city has to offer. Favorite weekend excursions include the farmers and antique markets during the summer, art museums and galleries during the colder months and trips to visit family in nearby Wisconsin.

Thomas Fitzgerald Interiors is located on the first floor of his three-story Chicago residence. He prefers the freedom of a small company because he can be fully involved in each project. His clients appreciate his awareness of every project detail and expertise at interpreting their various style preferences.

With over 25 years of interior design experience, Tom brings a unique blend of styles to his contemporary design. He is the recipient of ASID's Design Excellence Award and subscribes to the philosophy that "if you remain true to your beliefs, you'll never go wrong."

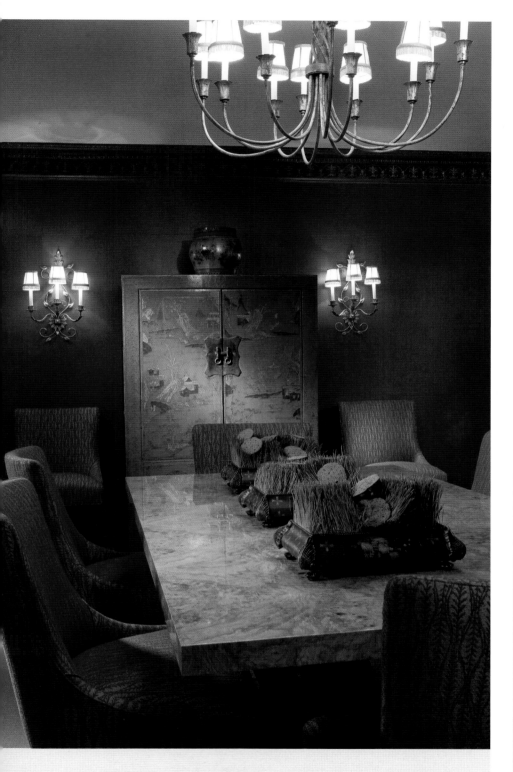

ABOVE:
Maya Romanoff wallcovering is a rich backdrop for the red lacquer chinoiserie Chinese cabinet. Kuhlmann style dining table in olive ash burl.
Photograph by Tony Soluri Photograpy

FACING PAGE:
Thomas Fitzgerald Interiors designed bed upholstered in E.N.T. woven leather. Wicker Works rope chairs in J. Robert Scott fabric. Chinese elmwood 19th century bedside tables. Columbian 12th century earthenware bowls over bed.
Photograph by David O. Marlow

Q&A

more about thomas ...

WHAT IS THE BEST PART OF BEING AN INTERIOR DESIGNER?
Appreciative clients. Tom loves to design for returning clients that appreciate the understanding he has for their lifestyle and design preferences.

WHAT DOES TOM LIKE MOST ABOUT DOING BUSINESS IN CHICAGO?
Midwestern sensibilities. People in Chicago tend to be pleasant to work for due to their friendliness, straightforwardness and honesty.

HOW DOES TOM BRING A DULL HOUSE TO LIFE?
He adds an artistic element. Tom is an art enthusiast who appreciates the value that a good piece can add to any room.

DOES HE HAVE ANY PETS?
Two dogs and a cat. He enjoys being outside with his dogs while his cat keeps her eye on everyone from her special vantage point in the living room.

ON WEEKENDS, HOW DOES TOM RELAX?
Tom loves to spend time outdoors by taking walks through interesting Chicago neighborhoods, gardening and entertaining friends and family.

THOMAS FITZGERALD INTERIORS, INC.
Thomas Fitzgerald, ASID
2247 West Belden Avenue
Chicago, Illinois 60647
773.384.1111
f: 773.384.1112
www.thomasfitzgeraldinteriors.com

CORDIA FORTE

INSPIRED HOME DESIGNS

Promoting spiritual, mental and physical well-being in every aspect of interior design, Cordia Forte's greatest satisfaction derives from clients who truly enjoy spending time at home. Always striving to create places of peace and tranquility, each space is designed with the utmost attention to detail, ensuring that residents may take full advantage of "the art of living."

An honors graduate of Harrington, Cordia has always been interested in creating healthy environments for others. Spending time with in-laws who have been involved in the construction industry for over 30 years, Cordia is familiar with the many details of home building through finish out. Cordia and her husband completely renovated their 1884 Victorian era house, preserving the historical character and mingling a formal yet inviting scheme of décor.

Deep tones of red-violet appeal to Cordia and describe her personality: strong, vibrant and energetic. Aware of the impact that color has on people's lives, she uses the element to reflect clients' lifestyles, creating appropriate atmospheres. She developed a palette of rust, copper, turquoise and earth brown after researching ancient Egyptian culture for an ethnically inspired day spa, which needed to cater equally to men and women.

Featured on both ABC's "Home Design Friday" and the popular television program "Divine Restoration," Cordia is extremely down to earth, donating her time to a variety of charitable organizations including Stroke of Hope Foundation and Apostolic Faith Church where she shares her vocal talent.

Through her company, Inspired Home Designs, Cordia uniquely offers "The Gift of Design," a program which allows clients to purchase her time as a gift for friends who have everything, family members just starting out or anyone in need of phenomenal design.

INSPIRED HOME DESIGNS
Cordia Forte, Allied Member ASID,
Associate Member IIDA
3126 South Calumet Avenue
Chicago, Illinois 60616
312.791.0518
f: 312.791.0518
www.inspiredhomedesigns.com

ABOVE:
Family and friends take pleasure in relaxing in the warm and inviting sitting room where Victorian charm meets modern-day elegance.
Photograph by Jamale Johnson, Mouse Trap Studios

FACING PAGE:
Cordia enjoys "tinkling the ivories" in her Bronzeville home's ethnic inspired piano room done in an earthy palette, featuring mud cloth and hand-woven baskets.
Photograph by Jamale Johnson, Mouse Trap Studios

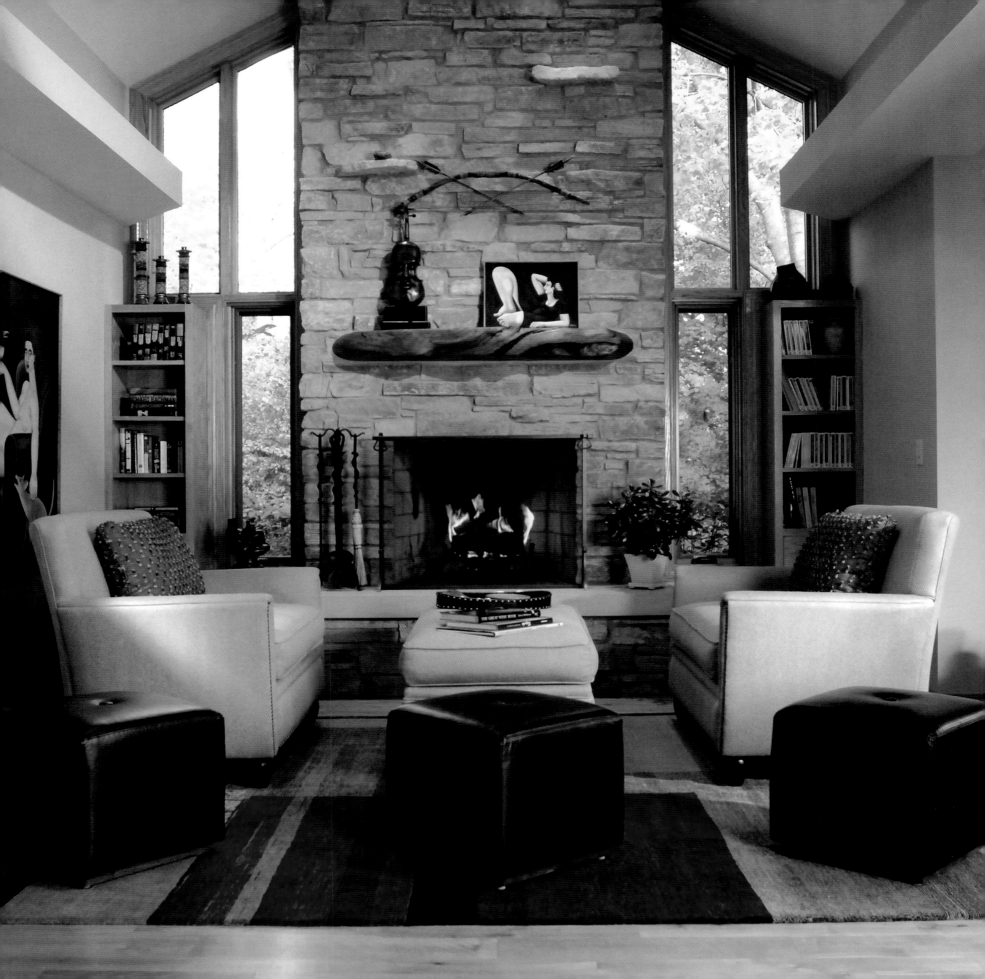

SUSAN FREDMAN
LONNIE UNGER
BARBARA THEILE
BARBARA INCE

SUSAN FREDMAN & ASSOCIATES

Infinite possibilities abound at the well-established design studios of Susan Fredman & Associates, Ltd. For over 30 years, a collaborative design approach has been key to creating captivating environments that celebrate the lifestyles, imaginations and desires of their clients. Regardless of a project's scale or location, the team is comprised of more than a dozen crème de la crème interior designers who contribute their unique experiences and perspectives.

The company founder, Susan Fredman, is a soft-spoken woman who makes a big impression with her visionary and global perspective, according to co-president Susan Rossie. To stay abreast of design trends, Susan Fredman travels frequently and shares her expertise as an adjunct professor at Harrington College of Design and numerous speaking engagements throughout the United States. With a firm belief that the sum of the whole is greater than its parts, Susan fosters a nurturing environment that is conducive to personal and professional growth and recognizes the talented individuals on her team for their outstanding accomplishments.

Designing residential and commercial interiors across the country, co-president Lonnie Unger has shared her versatile and trend-setting approach with the firm for over 20 years. Lonnie enjoys mentoring younger team members, helping them develop their creative talent and communication skills. She appreciates the opportunity to make a difference in people's lives and describes her style as an infusion of different elements, selected to reflect the taste of each client. Since Midwesterners are resilient, diverse and motivated, she enjoys creating relaxing environments that help people restore balance to their lives.

Barbara Theile loves designing in Chicago because the city has fantastic energy, and with an active arts community something exciting is always taking place. She holds a B.A. in Interior Design and has been with Susan Fredman & Associates since 1991. Her own home—an 825-square-foot

ABOVE & FACING PAGE:
Exemplifying sophistication and Southwestern style, this spacious living room utilizes various natural elements to create warmth and intimacy in the open space. Stacked stone pillars, an impressive stone hearth and red birch flooring are highlighted against the room's neutral palette. A custom wood mantle and creamy wall color create the ideal backdrop to showcase the homeowner's impressive art collection.
Photographs by Nick Novelli

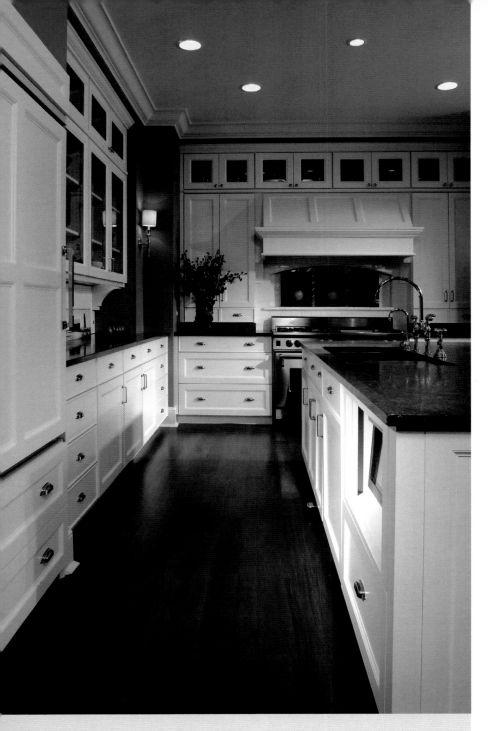

historical loft in the heart of Chicago's South Loop—was featured on HGTV's popular show, "Small Space, Big Style" for the innovative way that she capitalized on storage and living space. Barbara strives to create havens that combine simplicity with a splash of the unexpected for her clients.

Likewise, designer and team leader Barb Ince strives to develop her clients' sense of style by holding true to her philosophy of embracing open spaces. She subscribes to the Mies Van Der Rohe school of thought: less is more. With a B.A. in Architecture and impressive experience as an interior designer, Barb brings a unique skill set to the Susan Fredman & Associates team. Managing the company's Michigan location, which features both garden and interior design, Barb has open communication and rapport with all her team members. She particularly enjoyed the challenge of designing a condominium that encompassed an entire floor of a high-rise building that overlooked Lake Michigan. Barb designed an elaborate entryway complete with abalone veneer-wrapped pilasters that the client loved. Recipient of ASID's Design Excellence Award, Barb believes in the power of design to inspire, comfort and define a space for people to call home.

Author of *At Home With Nature: Great Interiors From The Great Outdoors*, Susan Fredman created a fabric line of the same name and continues to develop her company through interesting new ventures. Her latest venture, an on-line shopping store, Susan Fredman At Home, provides both unique and private label products developed specifically for the retreat home. In 2001, Susan established Supporting the Spirit Foundation, which has since merged with Heartland Alliance to form Designs For Dignity, a nonprofit organization that draws on Chicago's design talent to create safe and nurturing spaces for nonprofit organizations. Advocating that everyone should have the right to be nurtured by design, the interior designers of Susan Fredman & Associates endeavor to transform environments and enhance lives through their collaborative approach to creativity.

ABOVE:
An asset to any home, this versatile, family-friendly kitchen provides ample space for eating or entertaining. The traditional kitchen features exquisite custom cabinetry, a sleek granite island and numerous storage possibilities. Custom additions include under-the-counter refrigerators and wine coolers, thus maximizing the efficiency of the space for an active family's lifestyle.
Photograph by Nick Novelli

FACING PAGE:
A sizeable space is transformed into a warm, welcoming area in this formal living room. Plush, large-scale furniture balances the size of the room and the casual arrangement provides for several intimate conversation nooks. The living room is flooded with an abundance of natural light from the full-height bay windows, which also grant guests gorgeous views of the back lawn.
Photograph by Nick Novelli

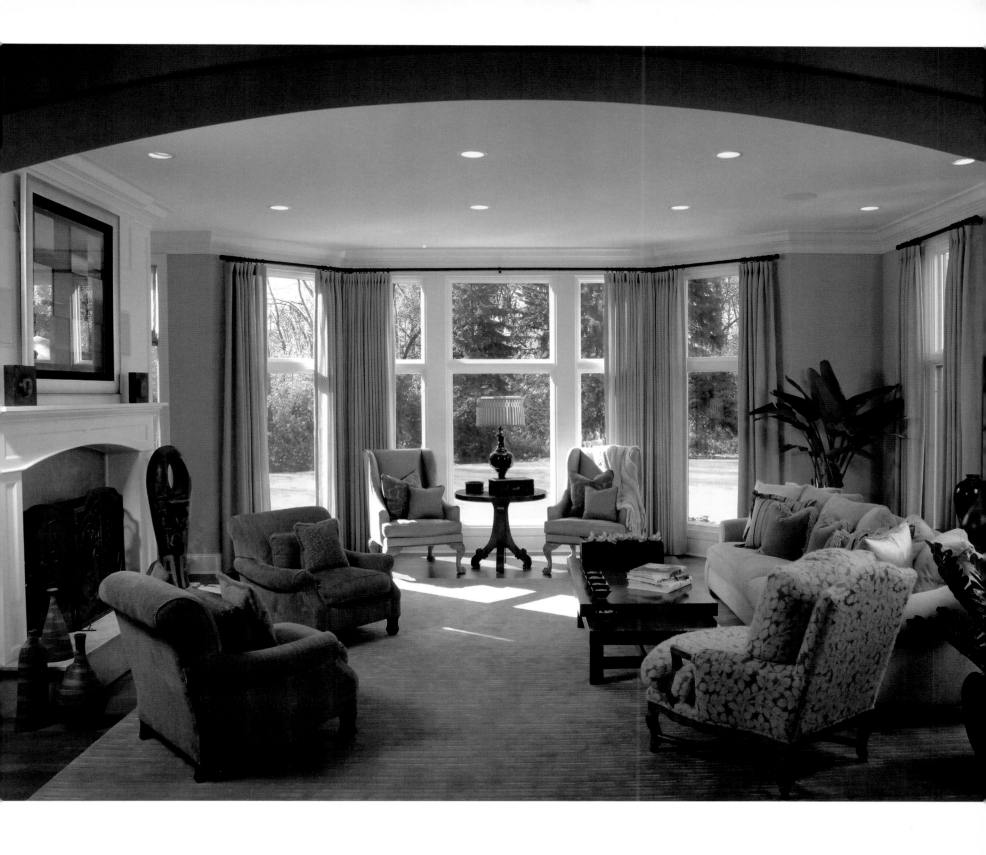

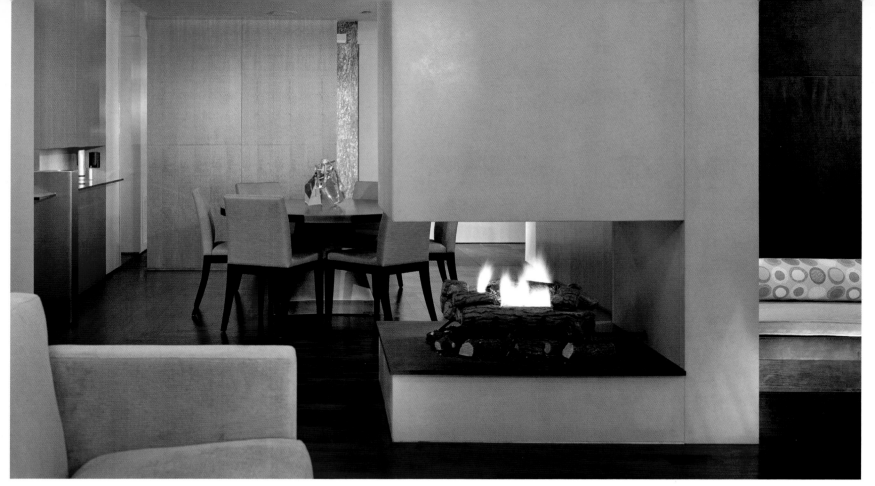

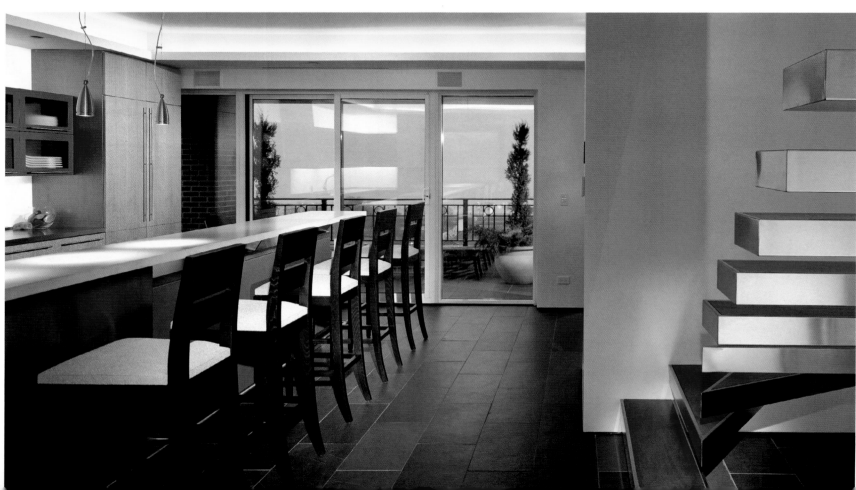

Q&A

more about lonnie, barbara theile and barbara ince …

WHAT ARE THEIR PERSONAL INDULGENCES?

As designers, enrichment is top on the list. Through their unique collaborative approach to design, they enrich each other which naturally enriches their clients. All three designers love to travel and discover new ideas, garner new inspiration and uncover new products. Like so many women, they love to shop which makes their work both fun and satisfying.

WHAT DO THEY LIKE MOST ABOUT DESIGNING IN CHICAGO, MICHIGAN, AND ACROSS THE COUNTRY?

"Chicago is an amazing place—filled with world class design and architecture—that provides sophistication while the heartland offers solid Midwestern values. It would be difficult to find a better combination."

TO WHAT PHILOSOPHY DO THE DESIGNERS OF SUSAN FREDMAN & ASSOCIATES SUBSCRIBE?

The designers of Susan Fredman & Associates believe that design is a service—a way to make a real difference for people. Their trademarked approach is called Designology, a personalized program that was created in order to identify how every client wants to live. The designers, therefore, can create an environment that is not only beautiful but specific to a client's lifestyle.

SUSAN FREDMAN & ASSOCIATES, LTD
Susan Fredman, ASID
Lonnie Unger, ASID
Barbara Theile, Allied Member ASID
Barb Ince
350 West Erie, Suite 2S
Chicago, Illinois 60610
312.587.8150
f: 312.587.9560
www.susanfredman.com
www.susanfredmanathome.com

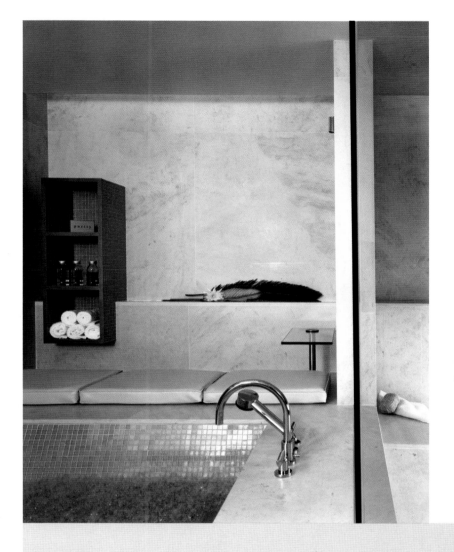

ABOVE:
Invoking the soothing qualities of traditional spa retreats, this master bath utilizes minimalist materials, such as limestone panels and celadon glass mosaics, and it includes a two-person tub to create a refuge from city living. Built-in ledges and niches give an architectural quality to storage and seating. Mimicking a natural, glowing light, the floating ceiling planes add to the overall serene.
Photograph by David Clifton

FACING PAGE TOP:
A unique alternative to the traditional wall, this peninsula fireplace artfully separates the living and dining rooms without obstructing the incredible lake views from the dining room. A sculptural creation comprised of pre-cast concrete panels, it perfectly balances and accents the two rooms. Various architectural elements, including the niche in the dining room and the "floating" bench adjacent to the fireplace, add to the overall Mondrian quality of this modern design.
Photograph by David Clifton

FACING PAGE BOTTOM:
A space any chef would adore, this industrial kitchen has the capacity to make even the novice cook look professional. Stainless steel counters create a sleek workspace, and the cool waters of nearby Lake Michigan inspired the Anigre wood and blue lacquer cabinetry accents. A floating staircase allows for easy access to the space and provides an interesting design element.
Photograph by David Clifton

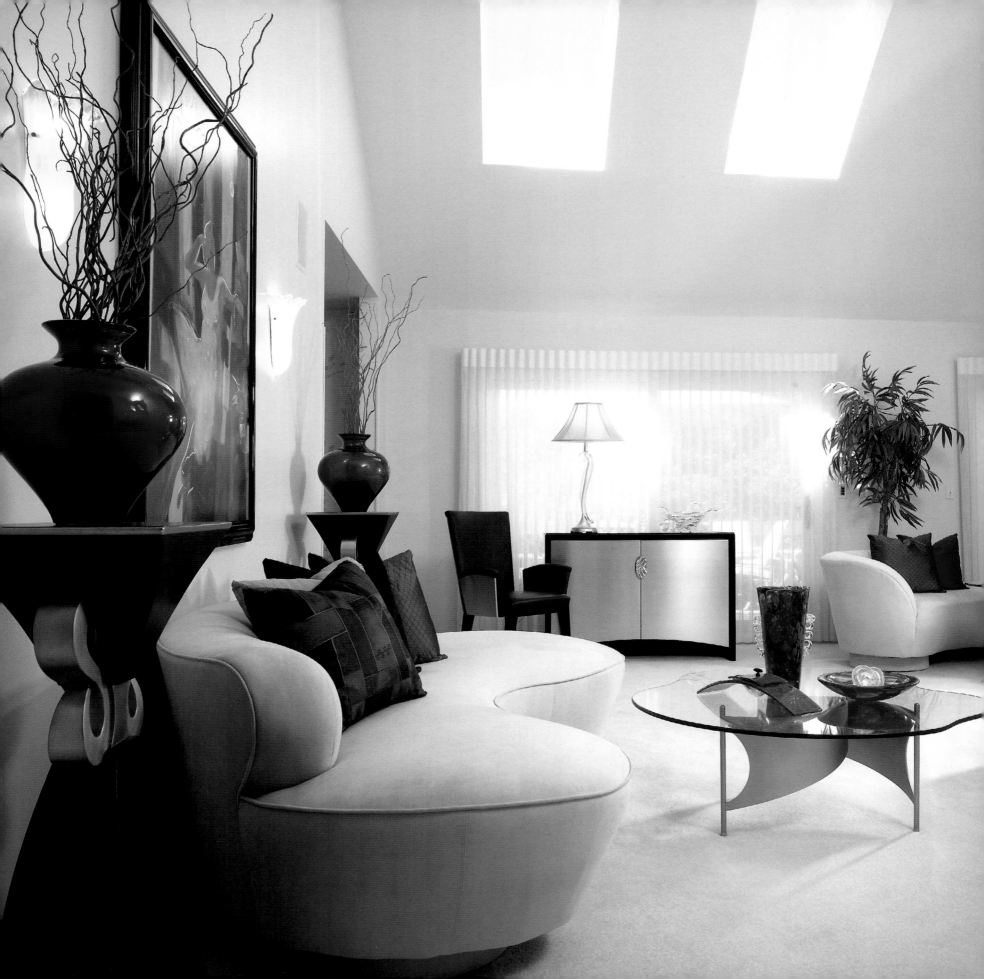

LORRIE A. GALEK

GALEK INTERIORS

Lorrie believes that every child has a talent waiting to be discovered and when she was young, dolls were secondary to perfecting their home décor. Lorrie attended the University of Illinois before finding her real passion at The Art Institute of Fort Lauderdale where she received her degree in interior design. She was recognized for outstanding academic achievement and creative performance along with her Dean's List status. 1982 was the beginning of a dream when she established Galek Interiors and began sharing her creative expertise with discerning clientele across the country.

Nationally published early in her career, Lorrie's work was used to promote Levolor blinds in *Window Magic*. Over the years, she has been widely featured for her originality, but the greatest flattery comes from lifelong clients. After 30 years of designing exquisite interiors, her passion for creating environments that echo her clients' personalities remains as fervent as ever.

Taking design direction from her clients' preferences, Lorrie has noticed that many times what goes unsaid provides as much insight as what is spoken. She takes each relationship seriously, striving to eclectically design flawless interiors.

Her own home is quite reflective of her personality with an open floor plan and ambience conducive to entertaining. She cherishes her colorful dining room for its French café effect that was partially created

LEFT:
Living room.
Photograph by Tony Soluri Photography

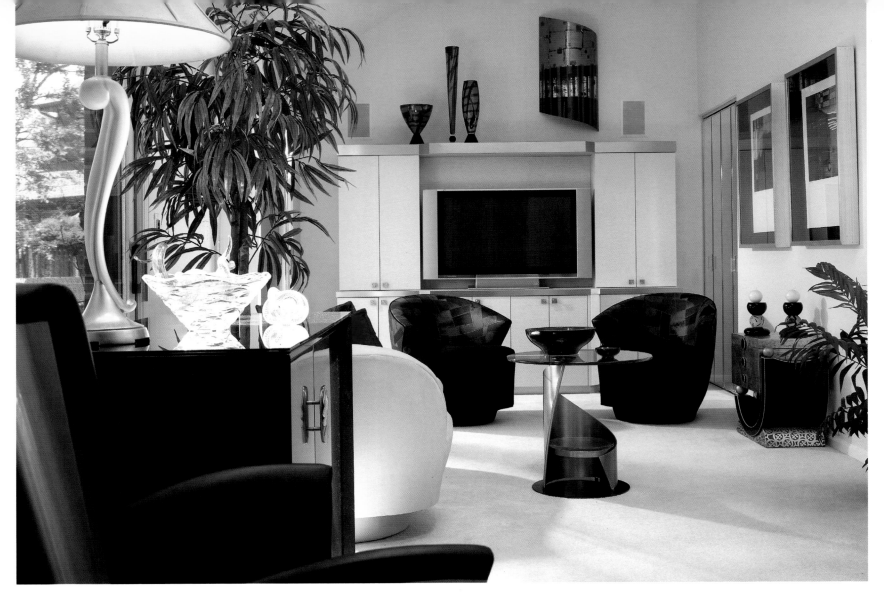

by hanging traditionally exterior shutters on the interior. Additionally, Lorrie commissioned an artist to create a mural as the room's focal point to achieve a Parisian restaurant atmosphere.

Lorrie's design capabilities are as widely varied as her clientele, and although she appreciates all genres, a great deal of her work may be classified as transitional or contemporary. Creating dramatic and functional environments, she playfully refers to herself as the "Mistress of Illusion" for her ability to employ glass, mirrors and scaled down furniture to give undersized city spaces a luxuriously oversized look.

A particularly unusual yet sincerely rewarding project involved the central admissions of a mental health facility. Striving to provide a less-clinical feel, Lorrie chose soothing colors to create a peaceful, residential-like atmosphere complete with custom artwork. This study further proved the theory that color can be an extremely powerful psychological factor.

Since each job is like a puzzle, the accomplished designer recognizes the imperative nature of pulling the right pieces together. HolidayEssentials and

Home Décor co-owners Lorrie A. Galek and Michelle R. Szela strive to find those perfect accents. They travel to many markets throughout the country as well as use local talent to give the store a very diverse and unique appeal. In addition to furniture and accessories, the store is embellished with holiday décor including ornaments, distinctive theme accents and gift ideas. Lorrie and Michelle consider their showroom the "bow on the package" when it comes to holiday flair and year round entertaining.

ABOVE:
Media/theater room.
Photograph by Tony Soluri

FACING PAGE TOP:
HolidayEssentials and Home Décor showroom.
Photograph by Tony Soluri

FACING PAGE BOTTOM:
Living room by Galek Interiors.
Photograph by Tony Soluri

Q&A
more about lorrie ...

WHAT IS LORRIE'S GREATEST PERSONAL INDULGENCE?
She loves to travel and celebrated her long overdue 25th wedding anniversary with a cruise to Italy, Greece, Turkey, France and Spain.

WHO HAS MOST INFLUENCED HER CAREER?
Steve, Lorrie's husband, is extremely supportive and gives her the space to achieve her goals and dreams.

GALEK INTERIORS
Lorrie A. Galek, Allied Member ASID
4895 Westhaven Court
Barrington, Illinois 60010
847.991.6522

HOLIDAYESSENTIALS AND HOME DÉCOR
Michelle R. Szela & Lorrie A. Galek
10 West Campbell Street
Arlington Heights, Illinois 60005
847.637.3110

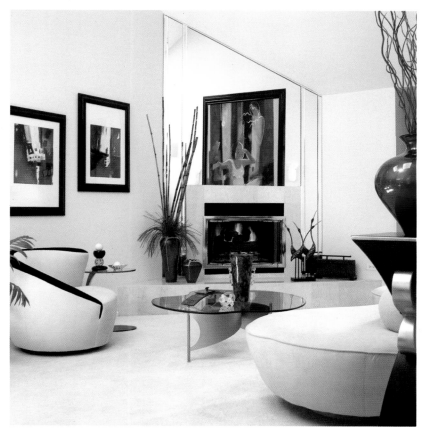

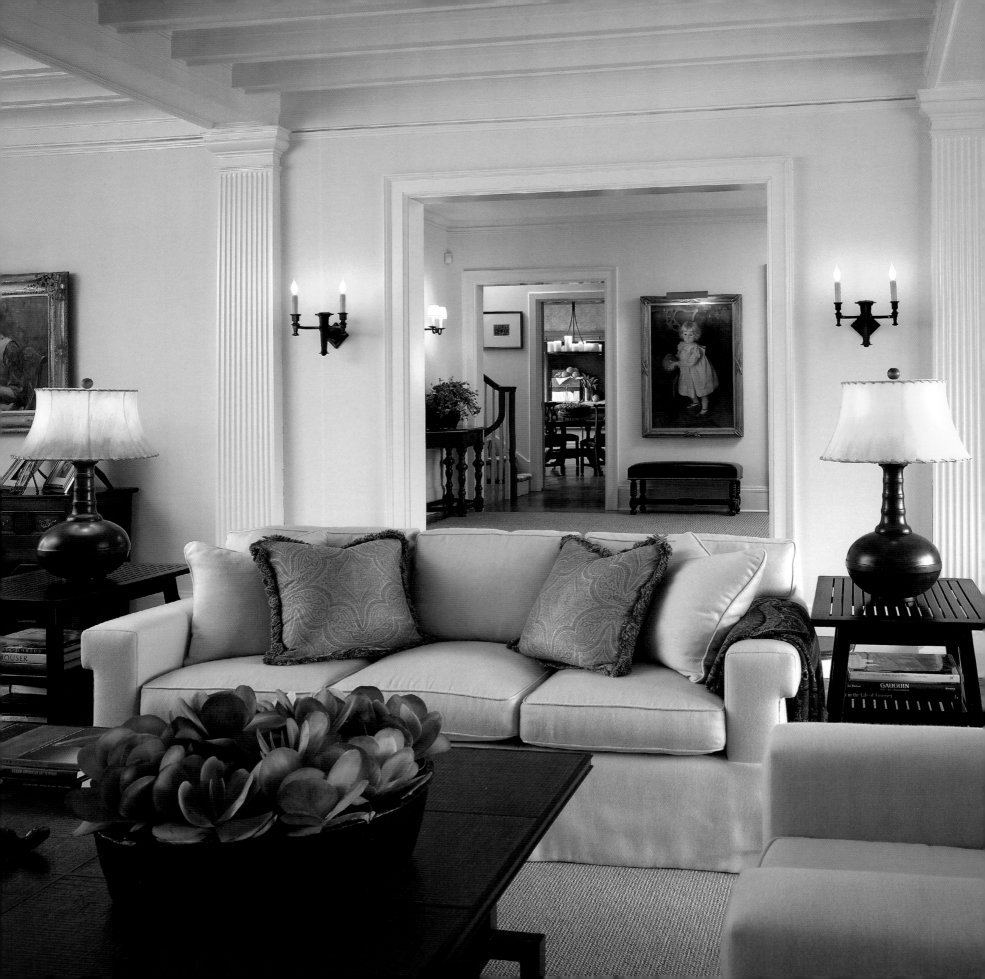

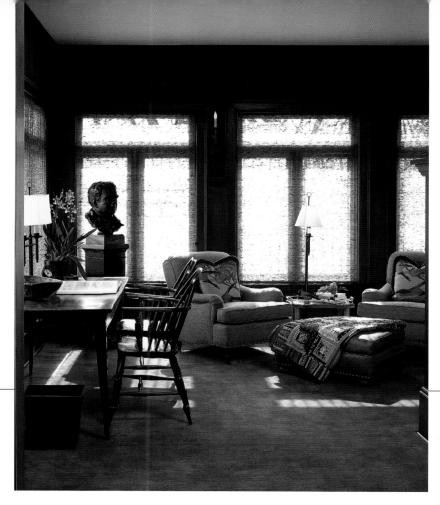

CHRISTINE GARRETT

GARRETT PASCHEN, LTD.

Christine Garrett's design style is varied but can always be recognized by her spare traditionalism and her sense of effortless balance. Blending practical comfort and interesting decorative elements, her rooms share a common grace whether they are cottages or large formal homes.

Chris's decorating is probably as notable for the design clichés she works to avoid, as it is for the unique or surprising items she includes. With understated elegance and limitless creativity, Chris creates distinctive interiors which truly represent the taste of each client.

Describing the objective of her work, she feels that getting to know the client on a level in which ideas can be freely exchanged is essential to creating truly reflective environments. She explains, "My office deals almost exclusively in residential work because it is personal and I like being able to give them my edited version of just what they had in mind or introducing them to something they would like if they knew about it." The initial design goal is to create a pretty or handsome home, but when possible, Chris strives for a loose, ongoing, designer-client arrangement that allows the house or apartment to evolve well beyond the original finish line.

Chris has been in the interior design business for almost 30 years, working on homes and apartments in Chicago and around the country.

She says it is the long time experience that has led her to one non-negotiable requirement in her office: everyone must be nice. She describes her staff as easy to work with, honest and reliable, always striving for the design collaboration to be pleasant for everyone. One of her design secrets for making a home personal is adding books that appeal to her clients, because books speak volumes about a person or family's interests. Recognized for her talent, she has been selected twice to participate in the Lake Forest Showcase House.

Rooms and homes designed by her company, Garrett Paschen, have appeared in show houses and a variety of national and local publications and she is occasionally a design guest on WGN Radio.

ABOVE:
In this room, color and art were blended with lighter scaled furniture from the previous house to make a room comfortable and interesting.
Photograph by Tony Soluri

FACING PAGE:
Clients moved from a formal English center entry Colonial to an open plan Ernest Mayo Prairie Style. Larger scaled furniture and antiques are blended with pieces of the clients' eclectic art collection.
Photograph by Tony Soluri

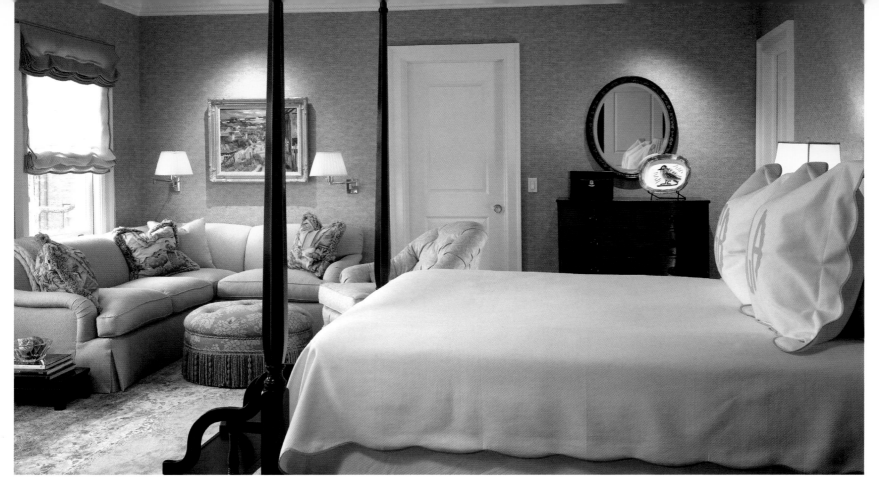

Q&A
more about christine ...

DOES CHRISTINE HAVE A PERSONAL EXTRAVAGANCE?
Christine says it is probably flowers, but a close second would be design and architectural books. "Amazon.com," she says, "is a dangerous place."

WHAT IS THE BEST PART ABOUT WORKING IN CHICAGO?
The location between coasts gives Christine a particular opportunity to buy and deliver things from all over the country. With the internet and professional websites such as 1stdibs.com, choices are more available and practical to bring here.

WHO IS HER FAVORITE DESIGNER?
Christine admires the late Jed Johnson. He was a brilliant decorator who died in his late forties on Flight 800. She explains, "He could do anything with such intelligence and wit. People should read about him just to know how he got started. That was serendipity!"

HOW DOES SHE USUALLY BEGIN DESIGNING?
First, she makes certain that all the moulding and other trims are there and scaled correctly. She fixes the mantle if needed, upgrades doors and re-trims windows to provide a foundation for attaching appropriate window coverings. Chris gives attention to architectural details before starting to ensure the most optimal canvas on which to design.

GARRETT PASCHEN, LTD.
Christine Garrett, Allied Member ASID
409 Greenwood Street
Evanston, Illinois 60201
847.866.6999
f: 847.866.7001
www.garrettpaschen.com

FACING PAGE TOP:
The master bedroom is a luxurious retreat inspired by the soft lake colors and used as another soothing area in the house to relax and read.
Photograph by Tony Soluri

ABOVE & FACING PAGE BOTTOM:
The board room and morning room were designed to showcase the view of Lake Michigan. Both are distinguished by delicate plaster work ceilings which dictated the soft simple coloring.
Photograph by Tony Soluri

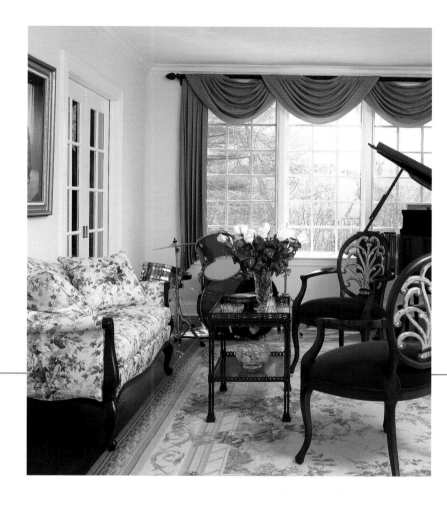

LOIS B. GRIES

LOIS B. GRIES INTERIOR DESIGN

Lois Gries likens her designs to her children: each is beautiful and has a unique point of view; she could not possibly prefer one over another. Friends describe Lois as unpredictable because she thrives on trying new things, a philosophy that translates nicely to her interior designing.

Earning a B.A. in art from Pennsylvania State University and an interior design degree from Harrington College, Lois most values her experience in Paris. During the time that Lois studied at the Parsons School of Design through The Museum of Decorative Arts, she gained a lifetime of knowledge. She learned the history of interior design from caveman to contemporary, while walking each cobblestone of Paris. Since then, she has been an active professional member of ASID, serving on the board and as a past president of the Illinois chapter.

Lois's experience with color as a painter provided a natural transition to the world of interior design. A professor once told her that if someone could tell who designed a room, it was a failure, because an interior designer's job is to help clients develop their own style. Lois has stuck to this philosophy by embracing all styles, from traditional to contemporary.

From the ground up, Lois designed a three-story Michigan beach house which featured fossil-filled limestone and a relaxing monochromatic color scheme. Lois created a feeling of understated elegance by blending chenille, silk,

leather and other textures in tones from camel to white as a background for her client's extensive art collection.

Her favorite home accents are vintage European and American light fixtures which often serve as a room's inspiration piece. With Lois's tremendous foundation of design experience, she can make any style work well for her clients.

LOIS GRIES INTERIOR DESIGN
Lois B. Gries, ASID
400 North Lasalle Drive, Suite 4402
Chicago, Illinois 60610
312.222.9202
f: 312.222.9207
www.loisgries.com

ABOVE:
This traditional music room is designed with mahogany wood, soft colors taken from the Aubusson rug, and accents of red on the chairs and in the antique oil painting.
Photograph by Tony Soluri

FACING PAGE:
This contemporary condo is a study in curves and angles. Neutral colors were used with varying textures from Kravet velvet to J. Robert Scott metallic weave.
Photograph by Tony Soluri

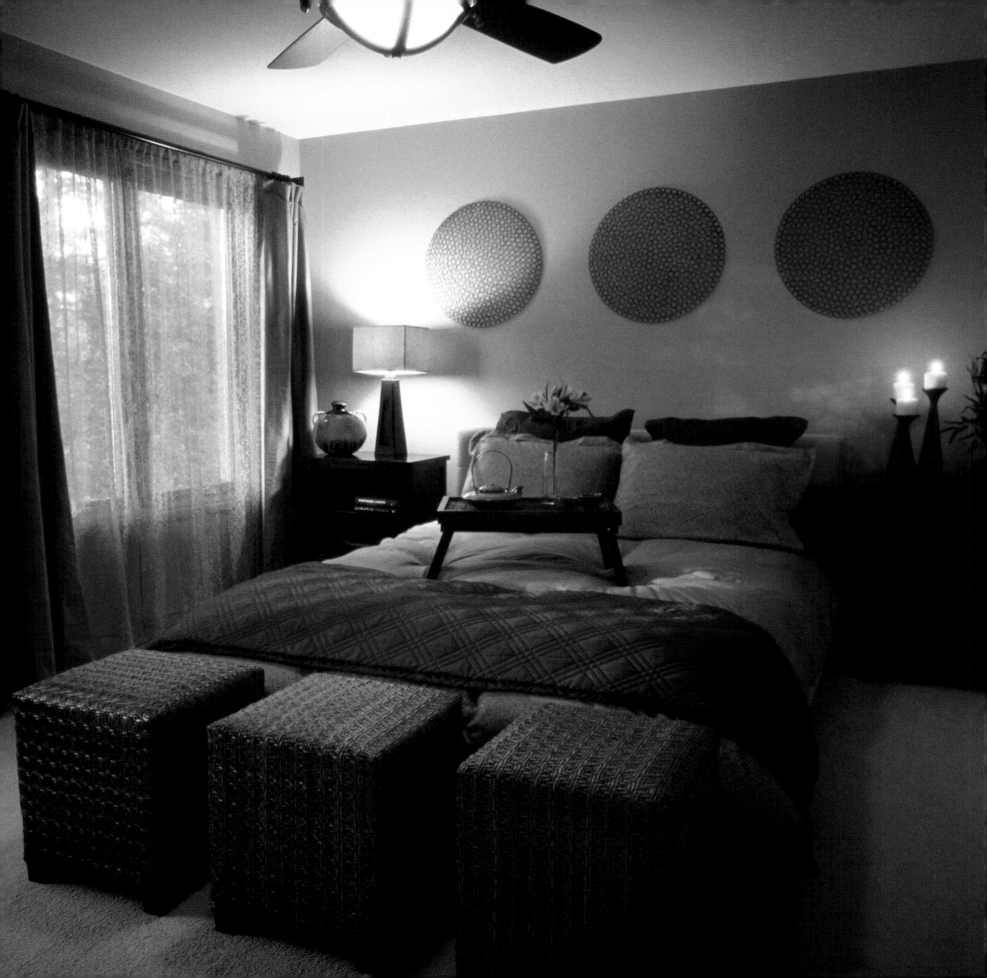

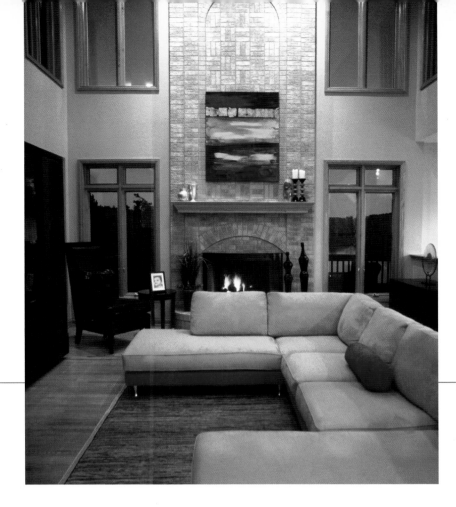

TRACY GROSSPIETSCH

STUDIO G INTERIORS, INC.

"Collaboration" is the byword at Studio G Interiors, Inc., a design firm that has been creating exquisite interiors in the Chicago area since 1998 when the firm was established by Tracy and Jim Grosspietsch.

Studio G's operating premise is to locate locally but work as a team. With nearly a dozen designers scattered among five offices, the firm has roots in each community. Resident designers know the zoning laws, the best local craftsmen and contractors and what is happening at the chamber of commerce. All design projects start locally, but the lead designer has access to the whole team's expertise. At Studio G, good design is always tailored to the lifestyle of the client.

Each designer has special talents: Tracy is a "big-picture" person, but also excels at interior architectural details and finishes. Others are experts on particular styles, product lines or hard-to-find resources. Because of the firm's unusual structure, nobody ever treads water: there is always someone with an idea or a source for just the right piece. Jim plays a role too: as vice president of operations and marketing, he handles the paperwork so the designers can focus on being creative.

Though they are delighted to design that one perfect room, Studio G has also carved out a niche in new construction and whole-house renovation. Tracy has confidence in each designer's ability to take the homeowner's concept and create a seamless transition throughout the house. Studio G-designed spaces are meant to be lived in, not just admired. Designers consider everyone's wishes and needs, including children and pets, so that homeowners immediately feel comfortable. "There's no look-but-don't-touch about our designs," says Tracy. "Our spaces are dramatic, but they're also functional, durable, practical and completely livable."

ABOVE:
Tonal hues and custom contemporary furniture and case goods allow the real star of the room to shine—the view of the lake.
Photograph by Tiamo Studio

FACING PAGE:
Soothing colors and clean lines create a restful guest bedroom retreat for international visitors.
Photograph by Tiamo Studio

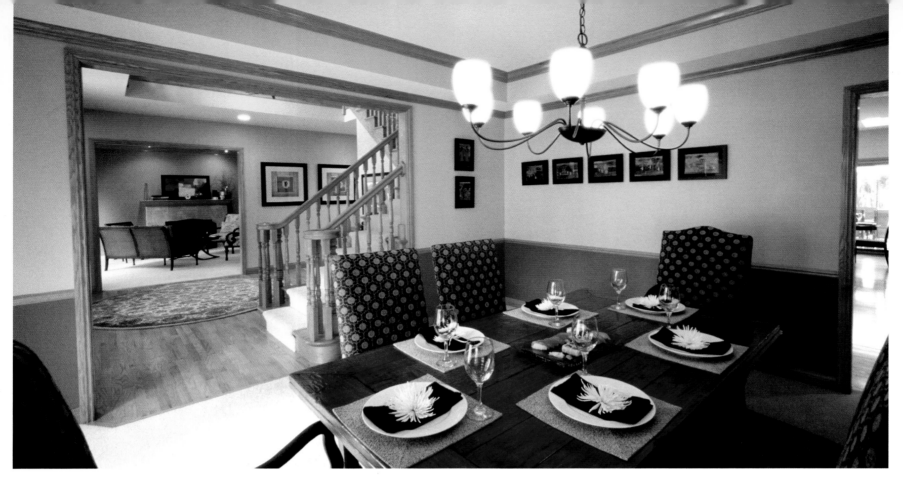

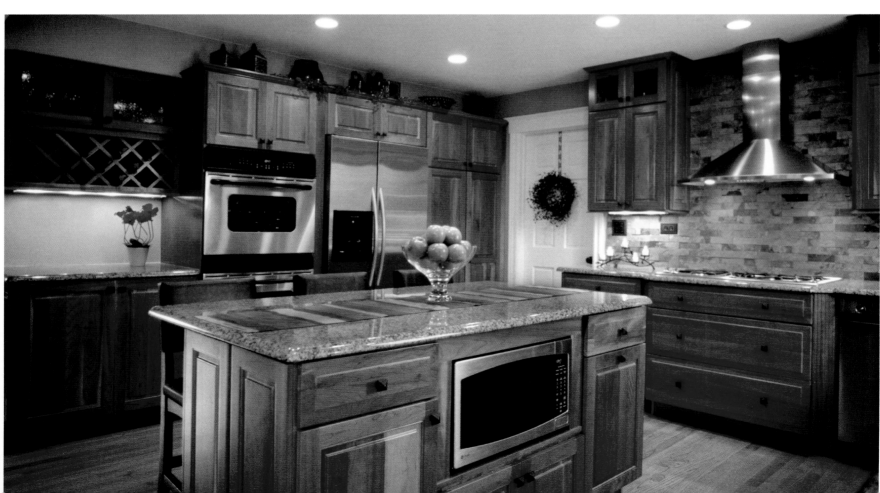

Q&A

more about tracy ...

WHAT DO MOST PEOPLE NOT KNOW ABOUT TRACY?
Her receptive, friendly personality comes from an upbringing in a central Kansas town of only 2,500 people. She credits that small-town background—where everyone has an opinion and voices it—for her open-mindedness toward other people's design ideas.

WHAT COLOR BEST DESCRIBES HER?
Sunflower. Its warm yellow evokes childhood memories of sunny-day drives along Midwestern country roads dotted with the cheerful blossoms. There is no sunflower in her own home, though. True to her credo, she does not force her design opinions on others, not even her family. So until there is a unanimous opinion, those golden accents will have to wait.

DOES TRACY HAVE A FAVORITE DECORATIVE ACCENT?
Sculptural three-dimensional pieces. She likes to put them in unexpected places to catch the eye.

WHAT IS THE MOST VALUABLE SKILL THAT THE STUDIO G DESIGNERS HAVE DEVELOPED?
The spirit of collaboration that brings the best of everyone's skills to each unique project.

STUDIO G INTERIORS, INC.
Tracy Grosspietsch, Allied Member ASID
1156 Berkshire Lane
Barrington, Illinois 60010
847.550.8580
www.studioginteriors.com

Studio G provides a wide array of interior design services: space planning, architectural detailing, lighting, art acquisition and the selection of finishes, furniture and decorative accents. Since all interiors are custom designed, the creative process can be complex, but each step offers an exciting challenge. Tracy loves the point at which homeowners realize how spectacular their home is going to look.

Tracy credits her grandfather, a farmer who once aspired to be an architect, with nurturing the creative passion that led her to pursue a B.F.A. in interior design from Iowa State University. After graduation, she studied with a group of European craftsmen in a multi-disciplinary firm for several years. Their sensitive approach to design and meticulous attention to detail left a lasting impression on Tracy. From them, she also learned the drafting and building skills she applies to her work today.

Studio G's talented designers and innovative collaborative structure have earned the admiration and respect of peers and clients alike. One satisfied homeowner said it best: "This is the way the design process should always be."

FACING PAGE TOP:
The elegant simplicity of the antique vintner's table is counterpoint to the sophisticated combination of colors, patterns and South African art.
Photograph by Tiamo Studio

FACING PAGE BOTTOM:
Warm cherry cabinets combined with a natural slate backsplash bring the outdoors inside in this very stylish yet functional kitchen.
Photograph by Tiamo Studio

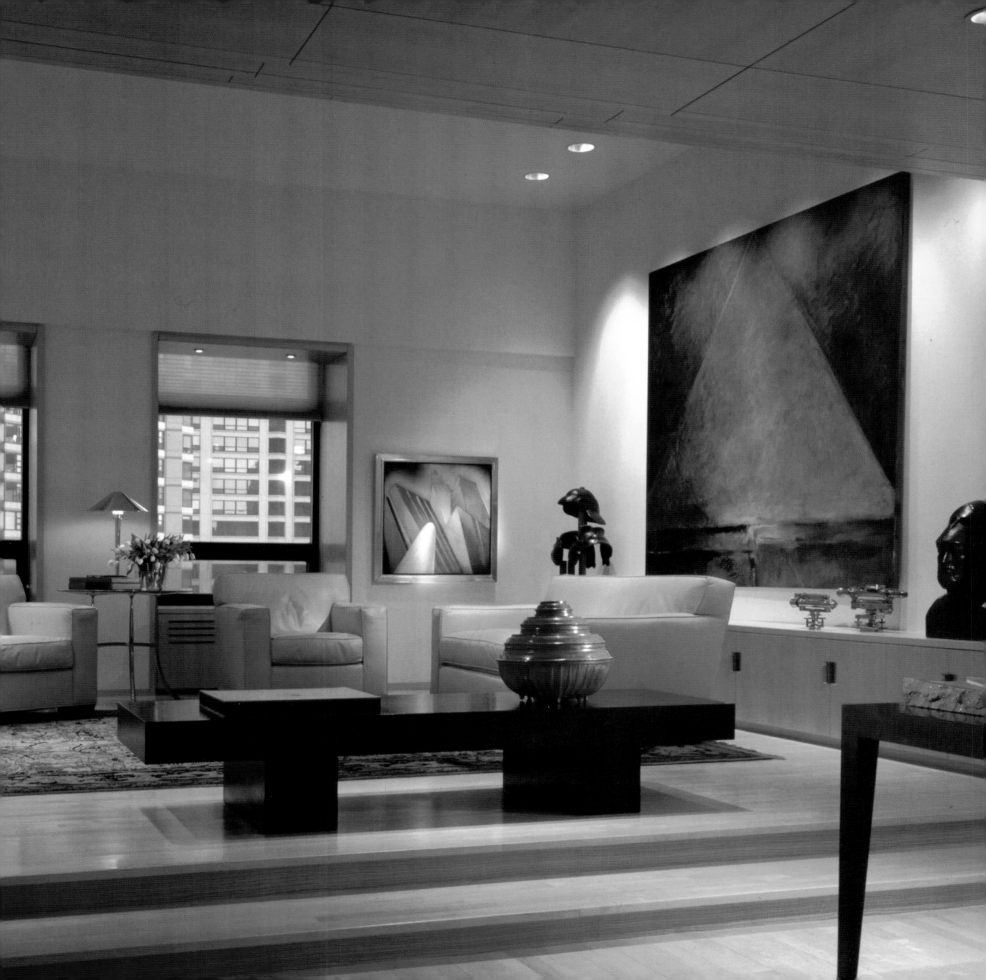

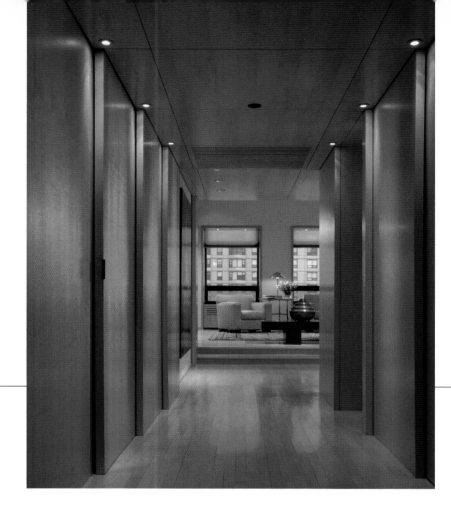

NINA HANCOCK

HANCOCK + HANCOCK INC.

Interior designers and architects collaborate at Hancock + Hancock Inc. to provide their diverse clientele with a comprehensive service offering. Established in 1979 by interior designer Nina Hancock and her husband John, an architect, the firm thrives on new challenges presented by clients across the country and internationally.

From personal residences to country clubs, corporate offices, healthcare facilities and restaurants, the Hancock + Hancock team is concerned with functionality but more importantly, how spaces affect people. The professionals feel that thoughtful design is important everywhere—healthcare patients regain their strength faster; business associates are more productive; residents find greater comfort and pleasure. Knowledge of one setting enlightens the next, and Nina conveys, "Each design reflects a desire for simplicity and strength, order and harmony, integrity of construction and detail."

Collaboration is the cornerstone of Hancock + Hancock's success. Projects are led by either Nina or John, and ideas are constantly bouncing between the team members. Whether clients have commissioned architectural or interior design services, they have the benefit of their project being reviewed by the other discipline to ensure successful results. For patrons who take advantage of the full spread of creative services, seamless transition, superb communication and timely completion are welcome attributes.

Additionally, clients love the convenience of the firm's second office in Naples, Florida as many have vacation homes in the tropical state. Although the creativity happens in Chicago, the designs are executed locally by a small team. Designing from California to New York and even overseas, Nina has found that distance can easily be overcome with technology.

ABOVE:
A staggered wood paneled entry creates a forced perspective towards the living room.
Photograph by Steve Hall © Hedrich Blessing

FACING PAGE:
An eclectic mix of furniture, art and objects enhance this architecturally defined living room platform for a Chicago residence.
Photograph by Steve Hall © Hedrich Blessing

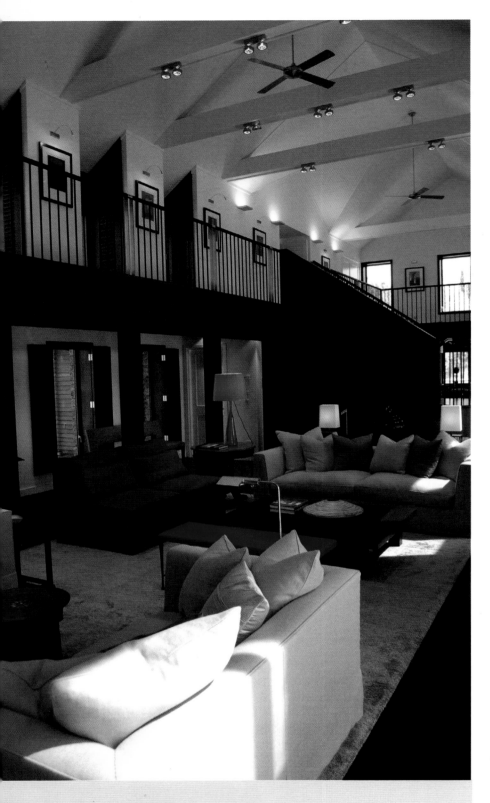

In 2006, her firm completed the architectural and interior design of a home in New Zealand. Sympathetic to neighboring architecture, locally found materials, such as schist and stained cedar, were integrated into the two-story home which was designed to resemble a barn of historical intrigue. A counterpoint scheme of vintage and contemporary design, the interior takes full advantage of 360-degree mountain views and Nina surrounded her clients with neutral, tactile fabrics with splashes of bright accents for comfortable, modern living.

New construction is exciting, but the firm also designs around existing architecture. A Boston renovation project turned exciting restoration when upon peeling back the walls, Nina's team discovered a glass ceiling in the conservatory, amazing mouldings, architraves, sconces and even a trompe l'oeil. Through her research and creativity, Nina brought the house back to life by repurposing authentic materials and gently incorporating contemporary elements.

Interested in design for as long as she can remember, Nina recalls absorbing page after page of the latest shelter magazines even as a teenager. Intrinsically connected to textiles, colors, furniture and the arrangement of such elements, Nina delights at the opportunity to enhance people's lives through design.

ABOVE:
A contemporary two-story, open plan living room with a sculptural stairway and mezzanine was designed for a private residence in Queenstown, New Zealand.
Photograph by Hancock + Hancock Inc.

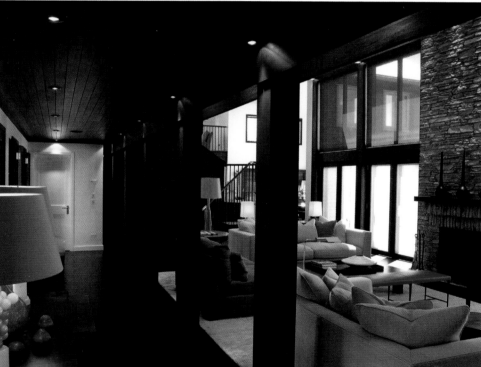

Q&A

more about nina ...

HOW DO NINA'S FRIENDS DESCRIBE HER?

Generous with her time and talents, Nina is elegant, warm and no matter how busy she is, she always makes her friends feel special. One of her friends commented, "Nina has a very international style, yet remains grounded in Midwest comfort."

WHAT IS A PARTICULARLY THOUGHTFUL COMPLIMENT THAT NINA HAS RECEIVED?

One of Nina's clients shared photographs of their recently built home with a friend, who replied, "Your house is so beautiful and its setting so serene, that during stressful times at work, I look at those photos for relief and inspiration."

WHAT DO NINA'S PERSONAL RESIDENCES LOOK LIKE?

Her city pied-à-terre is contemporary in style, enjoyed a few nights each week for entertaining and convenience. Nina and John like to relax in their country home, which is an eclectic mixture of furniture and travel artifacts.

WHAT STYLISTIC PHILOSOPHY HAS NINA MAINTAINED?

Timelessness. She feels that interiors should be livable for many years and age gracefully.

ABOVE TOP:
Dark stained furniture and louvered shutters in the dining room are contrasted with classic chairs and decorative candelabras.
Photograph by Hancock + Hancock Inc.

ABOVE BOTTOM:
A wood mezzanine level frames the view of the full height schist stone fireplace which adds texture and mood to this casually elegant living room.
Photograph by Hancock + Hancock Inc.

HANCOCK + HANCOCK INC.
Nina Hancock, Associate AIA
320 West Ohio Street, 4 West
Chicago, Illinois 60610
312.587.1300
f: 312.587.1399
www.hancockinc.com

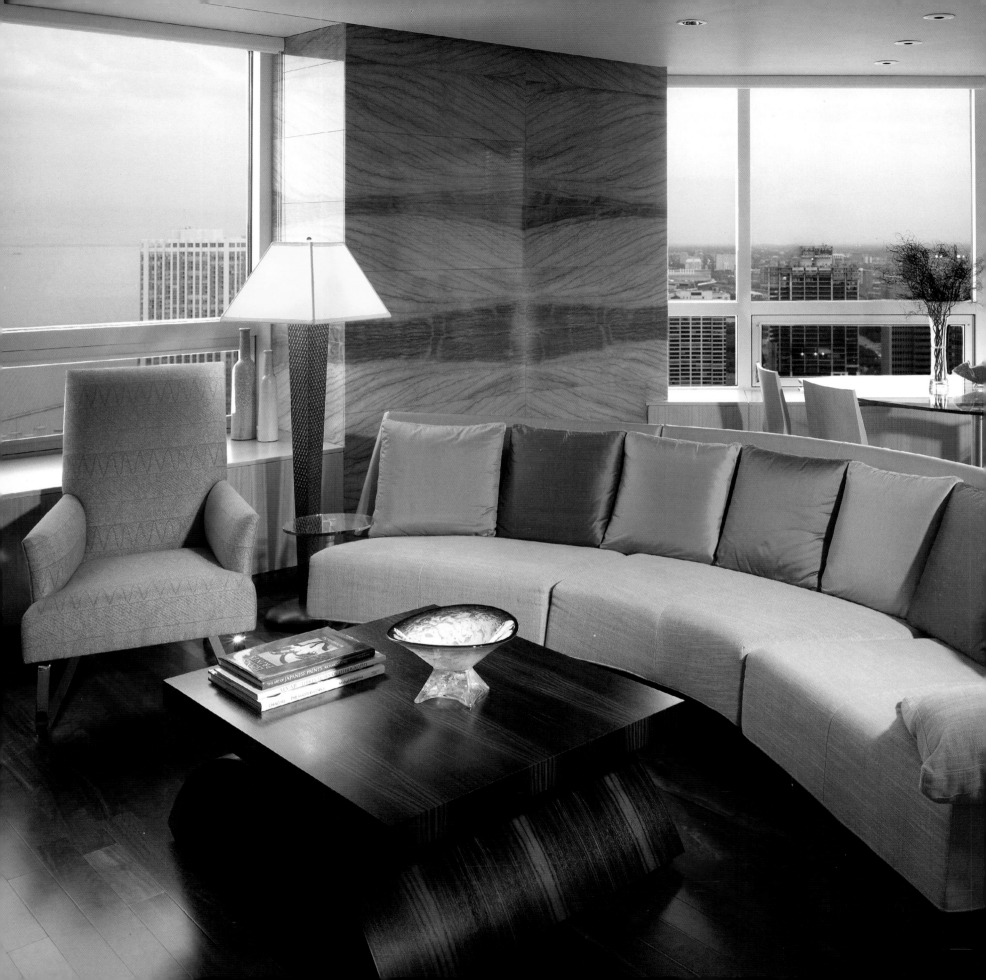

KARIN HANKE

KARIN HANKE, INC.

After an impressive corporate career that took her all over the world, Karin Hanke returned to her passion for design and was working on several large scale projects for clients even before graduating from Harrington College of Design in Chicago. One of her first projects, the ground up design and interior finish out of a multi-level private residence, was so successful that Karin was commissioned for the clients' next residence.

Karin's versatility can be seen in recent projects ranging from traditional to Old World, retro to contemporary. Clients tell her the universal appeal of her work is warmth, and love her creative and unique approach with each project. To bring intimacy to a 53rd floor lakeside residence, she designed in a complementary color scheme with blue macauba stone and exquisite burnt orange Venetian plaster walls, incorporating her own custom designed furniture, rugs, beautiful glass objects, bronze sculptures and artwork.

Providing comprehensive services from concept drawings to final installation, Karin makes the decision process very enjoyable for all parties. Clients appreciate her design intuition as she previews countless options with their taste and budget in mind and presents them with a handful of equally effective choices. Karin works closely with each client to help them interpret their vision and unique requirements, creating a fabulous plan that ties all of the elements together. From interior architecture to lighting, furniture,

LEFT:
Karin worked with David J. Krope Architect, Ltd. to infuse a 53rd floor lakeside residence with a warm, contemporary atmosphere. Alvar bronze sculpture from Boulevard Fine Art. Custom macassar ebony coffee table from Black Wolf Design. Odeon club chair and fabric from Donghia.
Photograph by Tony Soluri

textiles, artwork and accessories, she considers all elements important to the overall success of the design.

In addition to high-end residential interiors, Karin has established a reputation for designing furniture. She became involved in this design niche while creating an interior in Hinsdale, and after some time spent searching for the perfect foyer bench, she designed a custom piece inspired by a photograph of an antique. While working on this piece with the custom furniture manufacturer, the owner thought so highly of her work that a professional relationship began. Karin is now working on several collections of her own furniture designs for Black Wolf Design which will be available in retail stores across the country and through Henredon's Chicago, New York and Florida trade showroom locations.

Karin has gained tremendous inspiration from her international travels, first spending two years attending a German university, during which time she discovered her love of architecture and interiors. Later, while working and traveling in Europe, Asia and South America, she gained a deep appreciation for the local artisans and the beautiful designs particular to each region. Karin draws inspiration from everything around her—interesting people, unique textiles, colors and shapes in nature, great architecture and design. She loves the creative process of sketching and developing original designs and seeing her clients' delighted reactions as everything comes together in a beautiful composition.

TOP LEFT:
Recessed spice niches inset into the custom-designed plaster hood are accented by handmade ceramic tiles in the niches, stove hood and backsplash. Counter stools by Black Wolf Design.
Photograph by Tony Soluri

BOTTOM LEFT:
Glazed squash painted cabinetry in an Old World interior is accented by Italian made lighting from Falb Illuminazione throughout the kitchen.
Photograph by Tony Soluri

FACING PAGE TOP:
Venetian plaster provides the backdrop for artwork by Kerry Hallam and Marc Chagall. Macassar ebony foyer console by Karin Hanke, Inc. for Black Wolf Design.
Photograph by Tony Soluri

FACING PAGE BOTTOM:
Soothing green and gray tones are juxtaposed against a view of the city at night. Salon chair by Donghia with Henry Calvin Fabric. Artwork by Aleah Koury.
Photograph by Tony Soluri

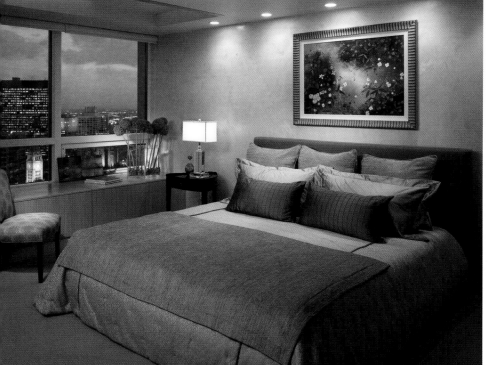

Q&A
more about karin ...

WHAT IS THE BEST PART ABOUT BEING AN INTERIOR DESIGNER?
Karin has a lot of fun working with beautiful things such as tile, fabrics, furniture and artwork. She finds interaction with clients to be very rewarding and loves seeing their reaction as everything comes together.

DOES SHE COLLECT SPECIFIC MEDIUMS OF ART?
Fascinated with glass artistry, Karin loves to collect Venetian and Scandinavian glass, as well as glass pieces by talented North American artists. She has a great eye for fine art, but loves to collect local folk art and ceramics indigenous to wherever she travels.

HOW WOULD KARIN BRING A DULL HOUSE TO LIFE?
She would add warmth through the introduction of color, whether on the walls, in artwork or even through a vase of fresh cut flowers. Adding layers of texture with a rug or a weaving further contributes to the room's energy.

WHO HAS HAD THE BIGGEST INFLUENCE ON HER CAREER?
Karin has been greatly influenced by Italian design and the British Arts & Crafts period. She loves the history of European artistry and craftsmanship, and has been particularly inspired by Italian tile, glass, fabrics and furniture. Among her favorite architects and interior designers, she lists David Adler, Carlo Scarpa, Charles Allem and Thomas Pheasant.

KARIN HANKE, INC.
Karin Hanke, Allied Member ASID
434 Naperville Road
Clarendon Hills, Illinois 60514
630.850.0638
f: 630.850.7351
www.karinhanke.com

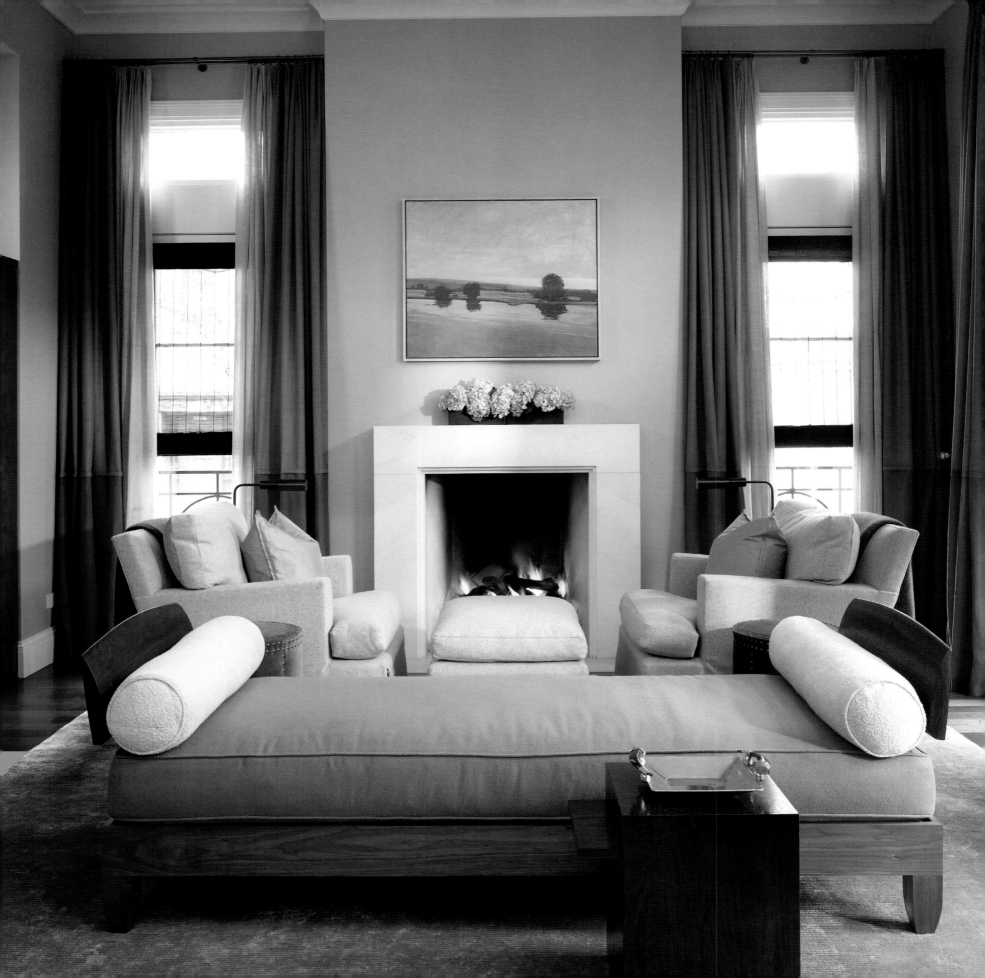

TRACY HICKMAN
HICKMAN DESIGN ASSOCIATES, LTD.

A satisfied client of Tracy Hickman's once remarked that of all the beautiful hotels she and her husband had vacationed at, none compare to the elegance of their home. Respected for her layering techniques and exquisite application of texture, Tracy's style—while truly reflective of each homeowner's preferences—has a universal appeal as graphic yet cleanly classic.

She studied abroad in Paris, London and Milan while completing her bachelor's degree in interior design with a minor in graphic design from Michigan State University. After becoming NCIDQ certified and then working with a respected residential designer for several years, Tracy established her firm, Hickman Design Associates, Ltd. in 1992. It did not take long for her creativity to catch the eye of editors from *Chicago Home* and *Shelter Magazine*.

Tracy designs beautiful, transitional interiors which truly meet the unique needs of each client. To ensure that every room will be used and lived in, she incorporates elements that invite residents to linger throughout the home. Tracy redesigns unused formal dining rooms and living rooms to be both comfortable and luxurious, and she is not above putting televisions in these rooms if requested. Ultimately, she strives to help clients make good use of every space in their home, while creating a beautiful aesthetic.

To bring any setting to life, Tracy focuses on creating a specific mood, rather than a "look," by incorporating various elements of design—color, lighting, texture, scale and floor plan—while fully respecting the space's architecture. Depending on the client's desires, she begins with designing a layout, either symmetrical for a soothing environment or asymmetrical to create unexpected movement and energy. In regards to illuminating the space, Tracy prefers a subtle mixture of sconces, fixtures and recessed and ambient lighting to accentuate key elements.

ABOVE:
The curved legs of this Gerard desk complement the tailored lines of this home office showing how warm and comfortable a contemporary interior can be.
Photograph by Tony Soluri

FACING PAGE:
A Pucci daybed fronts this inviting reading area. Farrow & Ball's "Hardwick White" is the cool backdrop for a painting by Andrew Skouret and is flanked by contrasting banded draperies.
Photograph by Tony Soluri

Employing all of these design techniques, a particularly impressive project to her credit was a sprawling country home in Michigan for which she directed all material specifications from rooftop to landscape and details as specific as embroidered towels and linens. Tracy enjoys comprehensive undertakings of this nature yet is equally enthusiastic about individual room designs. Clients appreciate that as an interior designer, Tracy brings unique interests and abilities to all phases of the project from architecture to construction and finish out.

Tracy's design portfolio includes a wide variety of projects and many original techniques. Her concoction for a brilliant dining room included sanding walls for two days, meticulously glazing them and then adding a topcoat of cinnamon-hued auto paint. The result of another project was a breathtaking checkerboard silk-paneled powder room. It is fine detailing and unique ideas such as these that truly set Tracy's designs apart, regardless of their size or location. Although Chicago is home to most projects, she has designed several vacation home interiors across the country and in the beautiful Cayman Islands.

Further diversity in Tracy's interests is evident in her passion for travel. She enjoys being immersed in locations untainted by modern society such as Africa, where she has traveled on numerous occasions through the breathtaking wilderness with a guide while camping in tents furnished with amazing oriental rugs and comfortable cots. Tracy finds inspiration in distinctively different cultures around the world and translates the creativity she has experienced—from imaginative color palettes to interesting textural combinations—into appropriate stateside settings.

ABOVE:
An outdoor dining area contained within a walled garden in Adrian, Michigan illustrates how important a common vocabulary becomes between the architect, landscaper and interior designer.
Photograph by Nathan Kirkman

FACING PAGE TOP:
Cabinets combine bookmatched makore veneer and rice paper sandwiched between thin layers of glass. Crystal pendants are by Allison Berger and Donghia bar stools are upholstered in an unexpected spring green hair on hide.
Photograph by Tony Soluri

FACING PAGE BOTTOM:
Comfort and elegance combine with subtle texture and pattern in this Lincoln Park living room. Upholstery by Melrose House flanks a Maxine Snyder display table.
Photograph by Tony Soluri

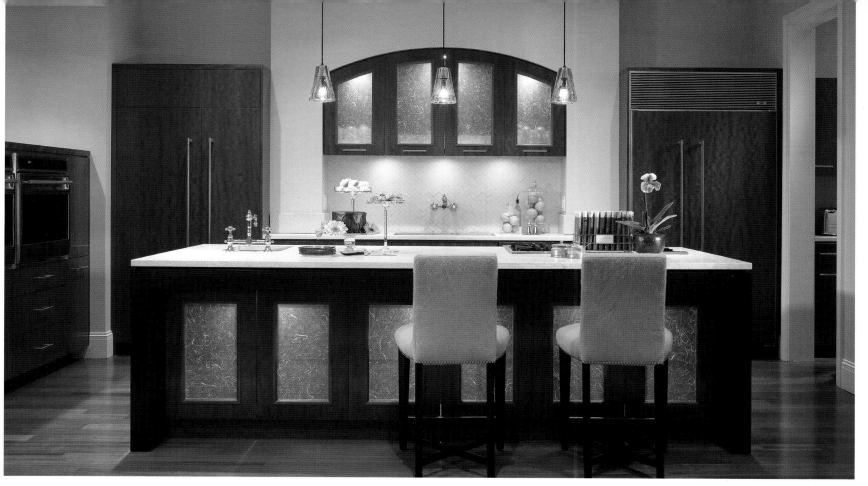

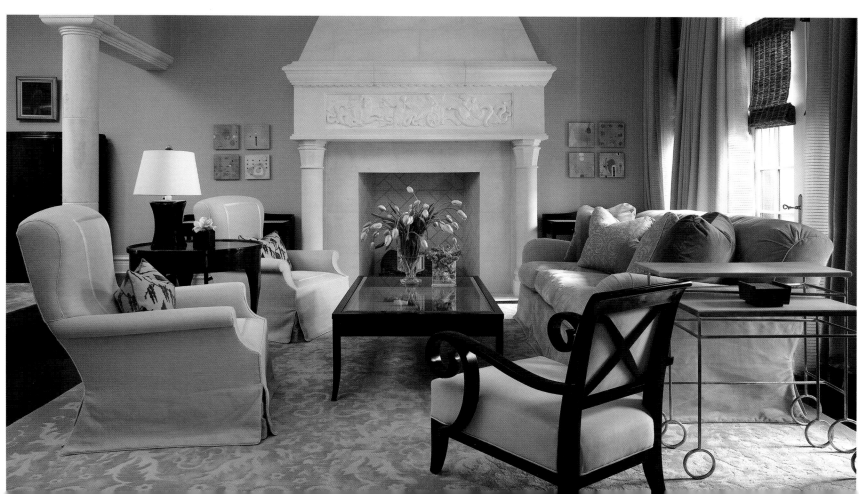

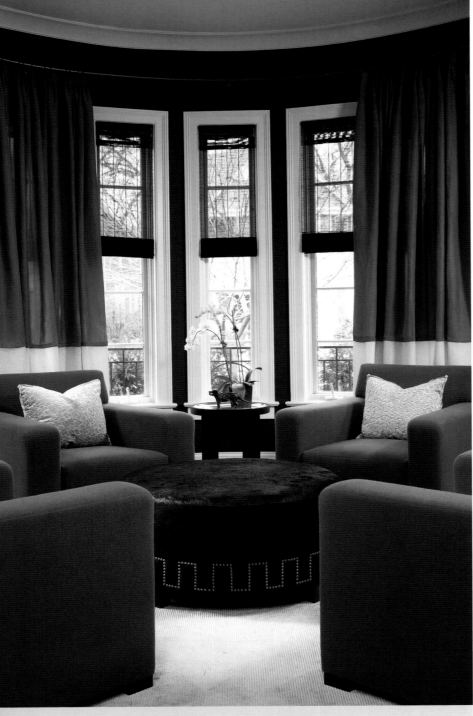

Tracy's personal residence represents her philosophy of practicality without compromising luxurious details. Since her dog, Guinness, is an important member of the household, Tracy selected flooring and fabrics that are both durable and attractive. The designer's Chicago home is transitional with a modern slant and features an abundance of French doors, reminiscent of Paris. While she loves color, a scheme of neutral tones emphasizing texture and contrast was selected as a means to cleanse her palette between the vibrancy of her clients' homes.

To uphold her commitment to personal attention, she accepts a limited number of projects each year. Clients appreciate the opportunity to work directly with Tracy, who not only designs every detail of the space but oversees the entire process, whatever that encompasses for the project. Tracy says that nothing would be possible without her project manager Lucretia Hohenfield—whose organizational skills are second to none—because of her uncanny ability to anticipate and complete tasks before they are even requested.

Over the course of her career, Tracy has had the opportunity to personally influence a multitude of clients' lives. While the creative aspect is invigorating, she conveys that the most meaningful part of interior design is being able to create spaces that welcome people home.

ABOVE:
A circular library rich with bittersweet chocolate walls highlights graphic caramel and ivory draperies. A signature hair on hide ottoman with nailheads was designed as a focal point surrounded by Donghia wool chairs.
Photograph by Tony Soluri

FACING PAGE TOP:
An antique Aubusson rug was the springboard for this living room. The buttercream paneled walls highlight the massive chinoisserie secretary. Silk striped goblet pleated draperies frame views to a parterre garden beyond.
Photograph by Nathan Kirkman

FACING PAGE BOTTOM:
The square walnut dining table and chandelier were intentionally offset to make an elegant dining room more inviting. The walls were sanded and sprayed with a cinnamon auto paint. The painting is by Alberto Pino.
Photograph by Nathan Kirkman

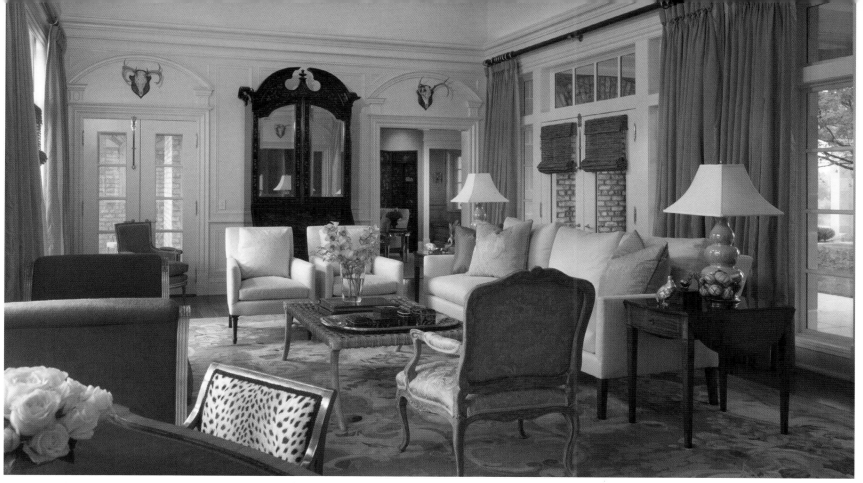

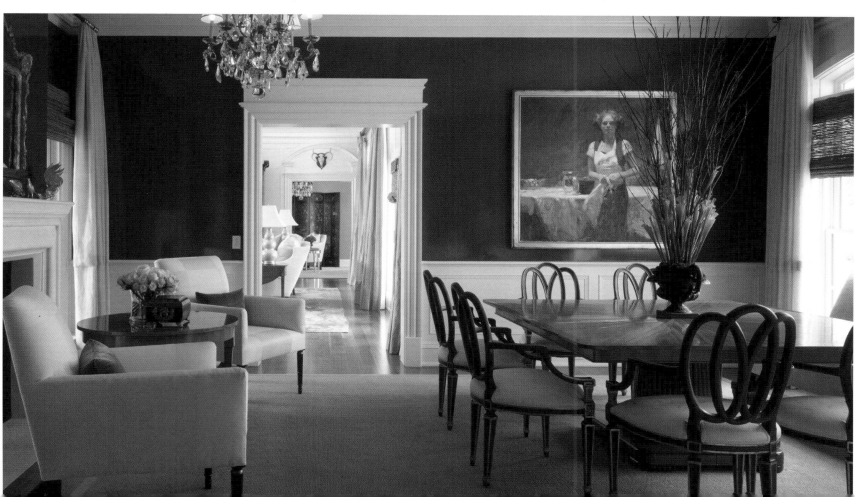

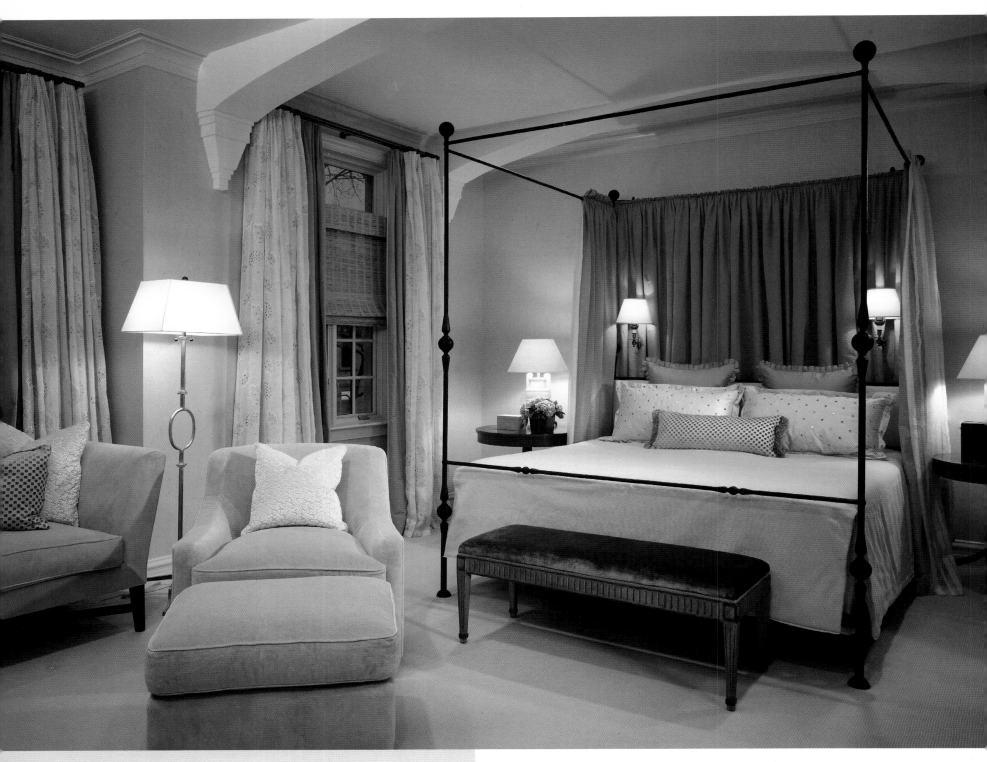

ABOVE:
An iron bed with luxurious custom bedding sits on silk carpeting against a soothing backdrop of celadon rice paper. Layered draperies cover the windows with shades from Holly Hunt.
Photograph by Tony Soluri

FACING PAGE:
A graphic cobbled checkerboard floor leads the way to the master suite. This photo highlights how important and beautiful even a corridor can be. Tracy designed the light fixtures, and the chairs and console are from Nancy Corzine.
Photograph by Nathan Kirkman

Clients find Tracy very pleasant and easy to work with because of her low-key personality; the mutual respect between client and designer provides a firm foundation on which to successfully design interiors and have fun in the process. For Tracy, design is not just a business; it is a thrilling opportunity to change people's lives through expressive interiors.

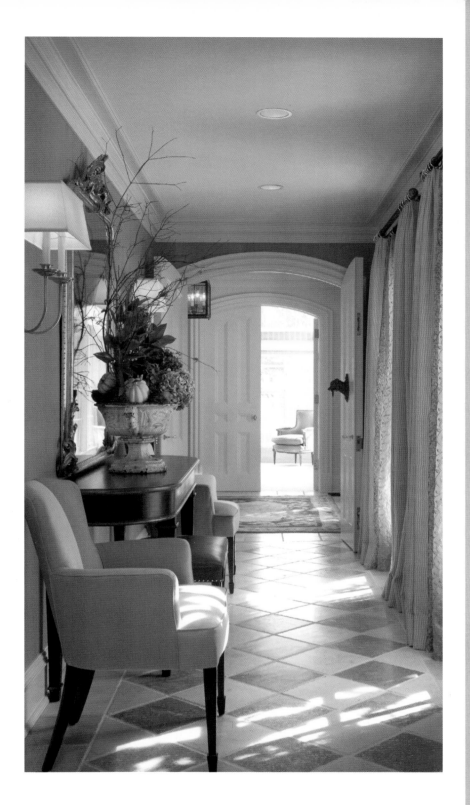

HOW DID TRACY BECOME INTERESTED IN INTERIOR DESIGN?

The daughter of two talented parents—a tactile mother with a great sense of aesthetic and a father with such fabulous three-dimensional vision that he could have easily been an architect—Tracy took an interior design course in high school and was instantly hooked.

WHAT IS THE HIGHEST COMPLIMENT THAT SHE HAS EVER RECEIVED?

One client conveyed that Tracy's harmonious designs tremendously improved the closeness of her family because everyone loved spending time at home.

WHAT IS SOMETHING THAT MOST PEOPLE DO NOT KNOW ABOUT TRACY?

Perfection runs in her family—Tracy's grandfather won an Olympic Gold Medal for his diving talent.

WHAT ARE TRACY'S FEELINGS ABOUT BAD DESIGN?

Insightfully, she believes that sometimes bad design is the gateway to truly innovative trends and styles.

DOES SHE ENJOY READING?

Tracy regularly goes through at least a book or two each week and loves the work of both Augusten Burroughs and Anita Shreve.

WHAT ARE HER GREATEST PERSONAL INDULGENCES?

She loves fine art, Kevin Reilly light fixtures and staying in beautifully designed hotels such as Morrocco's famous Aman.

WHAT COLOR BEST DESCRIBES HER?

Because of its warmth, she likens herself to Farrow & Ball's "Hardwick White" paint color—a really neutral light taupe/blue/gray.

HICKMAN DESIGN ASSOCIATES, LTD.
Tracy Hickman
900 North Franklin, Suite 102
Chicago, Illinois 60610
312.642.7379

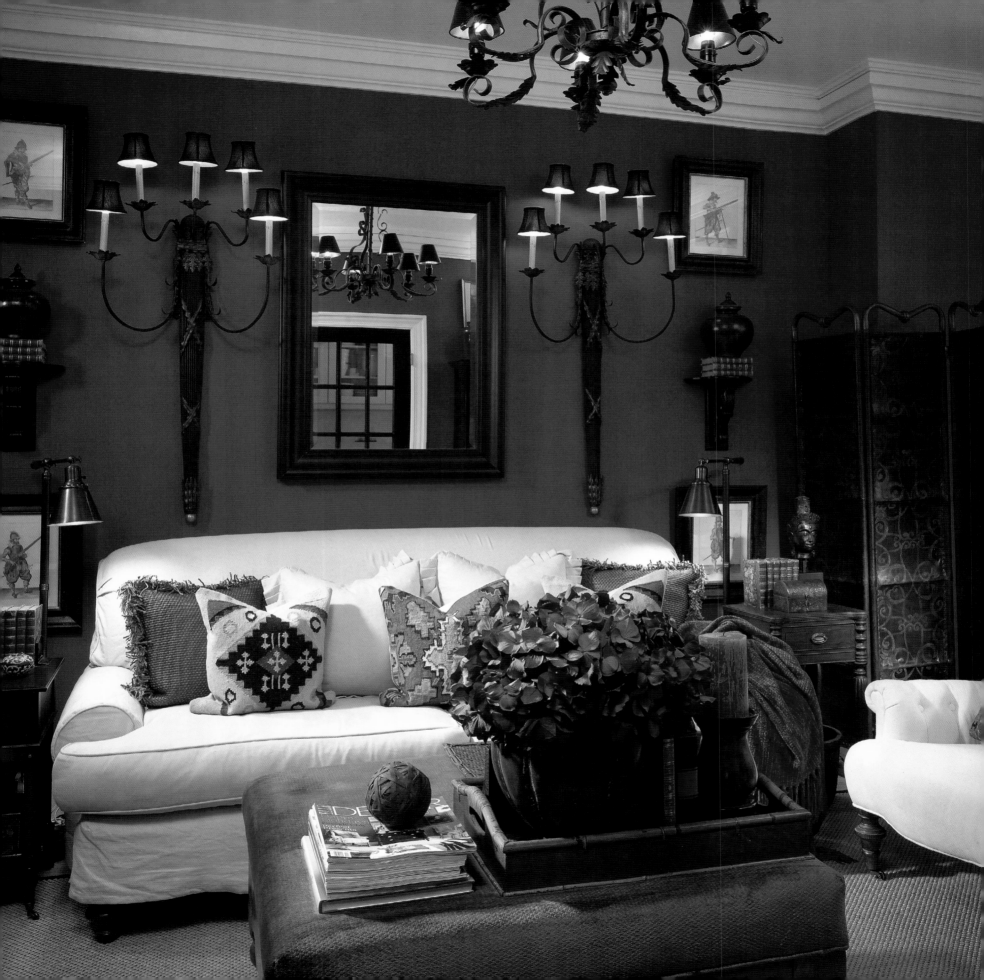

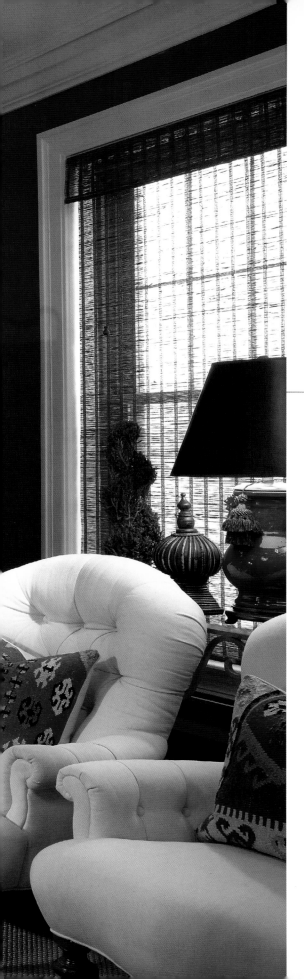

GREG JENNINGS
GRAYSTONE HOME

Greg Jennings—a big-picture expert and design principal of Graystone Home—seamlessly orchestrates the design and production of elegant interiors so that clients can wholly savor the experience of making design selections along the way.

An Indiana University/Purdue University theatre major, Greg learned the fine details of composition and lighting as he intended to design theatre and movie sets. His professional career, however, took him through a natural progression of direction shifts, first to visual merchandising, then store planning and eventually to his true passion for residential design, and with each venture Greg acquired skills that have proven invaluable to his design repertoire. In the commercial retail planning industry, he learned to create settings that appeal equally to men and women and mastered spatial design, balance, scale and lighting.

Clients have the benefit of experiencing Graystone Home's beautiful Clark Street showroom that is decorated in a relaxed elegant style to which everyone can relate. Contemporary clients are drawn to the mixture of interesting textures while admirers of more traditional design appreciate tonal richness and classic layering. Graystone Home designers are well-established and proficient in a variety of styles and enjoy creating interiors that look meticulously acquired.

LEFT:
Rich red walls, white linen upholstery and black accents set the stage for this intimate and inviting den which showcases unique accessories collected from numerous travels.
Photograph by Tony Soluri

Graystone Home offers a complete spectrum of services from layout to finishing decorative accents. Hand selected showroom offerings include a wonderful assortment of furniture, artwork in many mediums from local and international artists, one-of-a-kind throw pillows, accessories, linens, upholstery fabrics and rugs.

Early in Greg's interior career, he and a client had searched far and wide for the perfect rug to no avail. When the client asked him to design a custom textile for her home, Greg candidly expressed his apprehension since he did not have firsthand experience in that particular area of design. She expressed her confidence in Greg's abilities because she truly loved everything he had designed. From that experience, Greg has learned to cherish risk-taking opportunities, because he successfully selected the type of yarns, determined the color pattern, collaborated on the design and the client was thrilled with her custom Greg Jennings rug.

The most challenging project to date resulted in the start to finish design of a 1930s Hollywood interpretation of Spanish styling in an Albuquerque setting. Since New Mexico homes are traditionally boxy and darkly colored to blend into their environment, Greg wanted to create something unique yet neighborhood appropriate. He designed the home to feature exquisite ornamental detailing on the exterior and introduced wainscoting, exaggerated mouldings and contrasted stains between the floor, doors and trim on the interior. It is for brilliant designs such as this that Greg has been featured in the *Sun Times*, *Chicago Tribune*, *Chicago Free Press* and on ABC 7.

Specializing in custom residential interiors from 1,000-square-foot condos to vast 10,000-square-foot homes, Greg appreciates the variety of projects in which he is involved. Smaller projects are exciting because ideas quickly become tangible, yet large scale projects offer a very satisfying level of depth and complexity. Regardless of a project's size, Greg implements his signature layered look by mixing patterns, colors and textures.

ABOVE:
The fireplace is an exceptional vintage cast plaster piece from 1920, salvaged and refurbished. It anchors one side of the living room.
Photograph by Tony Soluri

FACING PAGE:
The living room glows with warm colors and sumptuous fabrics. It mixes antiques, flea market finds and custom pieces to create a classic pied-á-terre.
Photograph by Tony Soluri

Although the living room of his private Lakeshore Drive residence overlooks the beautiful park and lake, Greg's favorite room is the intimately-sized den at the back of his house. Friends and family also seem to gravitate to the room because it is very warm with rich red walls, white linen upholstery and dark walnut furniture. Greg strives to create interiors that welcome his clients as perfectly as this room invites him.

Greg credits his creative abilities to parents with excellent taste who had their home professionally decorated every three to five years for as long as

he can remember. His childhood bedroom reflected an Indiana upbringing with a traditional blue and white, preppy, All-American theme that suited him well at the time. Since Greg had the opportunity to live in such an assortment of styles, he truly appreciates and understands them all. Whether clients want contemporary, traditional or something in between, Greg enjoys pulling design elements together to create genuinely unique living spaces.

Q&A
more about greg ...

WHEN GREG IS NOT DESIGNING, HOW DOES HE SPEND HIS TIME?
He enjoys exploring the beautiful city of Chicago by visiting museums, art galleries, privately owned boutiques and flea markets to gain design inspiration. Greg always has his eye out for special finds for his own home and those of his clients.

WHAT COLOR BEST DESCRIBES HIM?
An Aquarian, Greg has always felt that blue describes him well because it is a tranquil yet sunny and energetic color.

HOW DO GREG'S FRIENDS DESCRIBE HIM?
Greg is enjoyable to be around, a loyal friend and hopeless romantic.

WHAT ARCHITECTURAL STYLE DOES HE FIND PARTICULARLY DISTRESSING?
So much of the city's new residential construction is very bland, without exterior ornamentation or aesthetics of surrounding neighbors. It is especially obvious, because these eyesores are often located near Chicago's exquisite brownstones erected at the turn of the century.

WHEN GREG IS CONFRONTED WITH TEDIOUS INTERIORS, HOW DOES HE ADD INTEREST?
He loves to add character with a wealth of trim in luxurious widths, from crown mouldings to baseboards, door frames and wall mouldings.

GRAYSTONE HOME
Greg Jennings
2937 North Clark Street
Chicago, Illinois 60657
773.388.9992
f: 773.388.9993
www.graystonehome.com

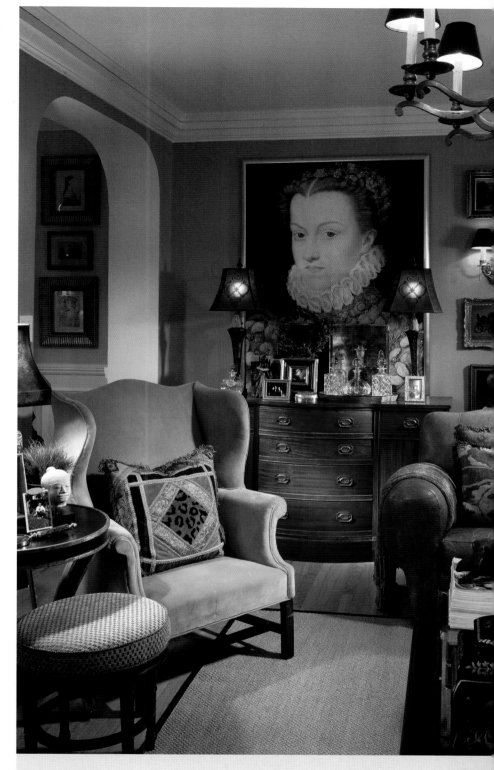

ABOVE:
A custom painting of an Elizabethan woman overlooks a buffet, set with crystal decanters to create a bar for entertaining in the living room.
Photograph by Tony Soluri

FACING PAGE:
A hand-carved four-poster bed dominates this master bedroom. Antique leather bound books, oil paintings and classic fabrics lend the room an Old English feel.
Photograph by Tony Soluri

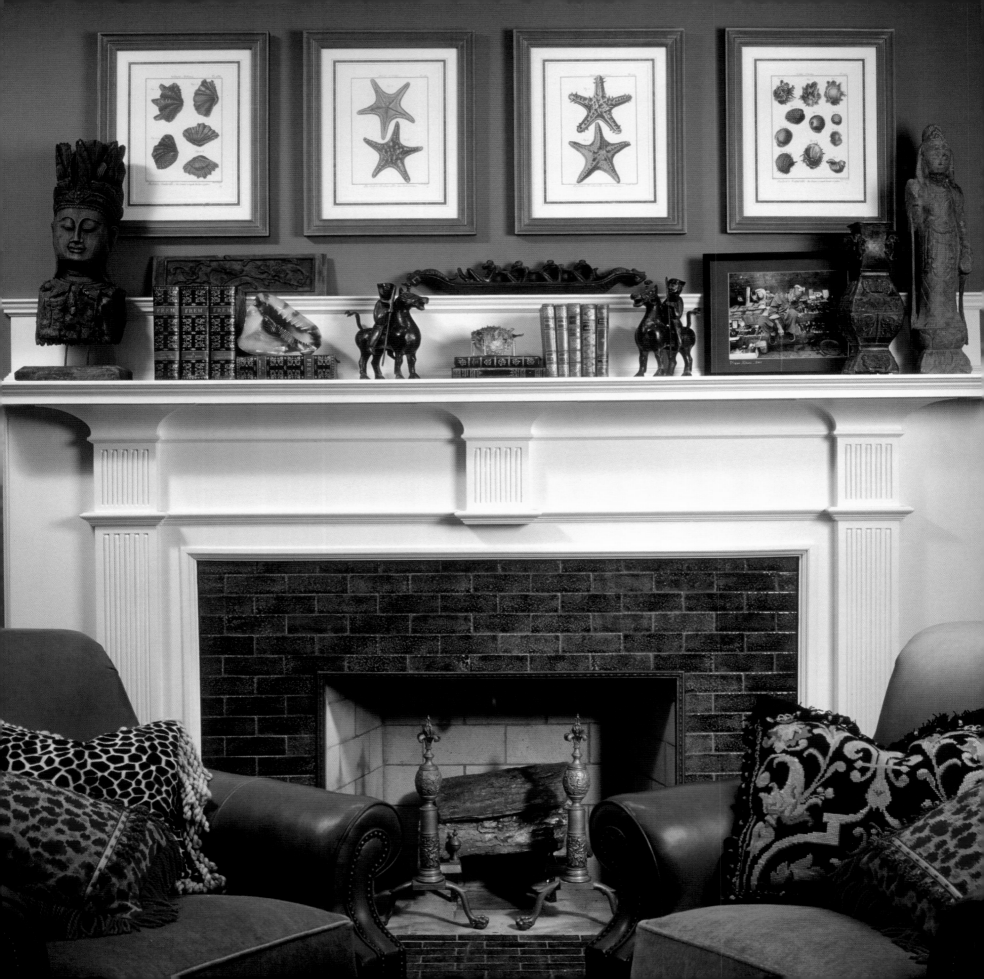

MARSHA JONES

MARSHA JONES INTERIOR DESIGN LTD.

Striving to capture the essence of each homeowner's dreams, Marsha Jones believes that successful interiors must at once be beautiful, livable and match the characteristics of those who live there. Her ultimate design goal—to make each client's heart sing—is achieved by creating spaces with good energy that will positively influence the way in which families live. Marsha's style celebrates the spirit of timeless, sophisticated and distinctive design.

A portrait of her firm's diversity, each area of the design studio—a restored vintage cottage with clapboard siding and a wrap-around porch—represents a different avenue of possibilities. The eclectic entrance features upholstered walls in a steel blue linen fabric with a French settee and iron chairs, while the main area has a modern flavor with clean white sheers and a stainless steel chandelier above the dark mahogany work table. Marsha's office is decorated to mimic an old Parisian style, the kitchen features salmon bamboo vintage wall paper with shell lighting, while her design associates' top floor work area reflects yet another look with retro Moroccan décor. Although each space is unique, the studio has a timeless flow with universally bright, fresh colors and elegant lighting.

Always ahead of the game, Marsha Jones has been designing personality-expressive interiors for more than two decades. Her design experience reaches from her earliest creative expressions through her highly successful career as a licensed professional designer with an established reputation for developing high-end interiors for Chicago's most astute clientele.

Marsha works with clients through all stages of design, from preliminary architectural drawings to finishing decorative touches. Although she values each step of the lengthy process, she most enjoys the big picture because anything is possible. Based in Chicago's nearby suburb of Wheaton, Marsha has also designed vacation homes nationwide, from Florida to Colorado, Arizona, Michigan and Wisconsin.

ABOVE:
A mural of pale taupes, creams, grays, and salmon create a backdrop for the dark walnut table made specifically for this oval dining room.
Photograph by Jesse Walker

FACING PAGE:
"Marsha shows her skill at arranging a still-life tableau above the fireplace mantel in the master sitting room. She creates eye candy out of what could be a dead space by combining leather-bound books, Asian sculptures and a series of prints of seashells with a few of the real thing in a slightly asymmetrical arrangement," says Mary Daniels of the *Chicago Tribune*.
Photograph by Jesse Walker

The first and most important step of Marsha's creative process is the interpretation of the client's desires. When the ideal design direction has been determined, Marsha and her team work with clients to select "the star of the room,"—which is usually a main fabric—because the appropriate selection of color and pattern is essential to creating a pleasant and comfortable atmosphere that also reflects the client's character. Yet these steps are just the beginning of the design journey during which Marsha guides her clients to their perfect home.

The southern-inspired sunroom is Marsha's favorite place to spend time in her own home. Fond of designing seasonal color schemes, she loves gazing out the windows in the summer, as she is surrounded by soft tones of pink, white and green. Floral accent pillows are like little jewels in the space as they pull the whole room together in a soothing harmony conducive to sipping coffee each morning.

Marsha has appeared several times on HGTV's popular program "Interiors by Design" with Chris Madden. For the show's wine design episode, she developed a sleek climate-controlled cellar with tasting tables set against a Tuscan countryside mural.

Published in a variety of magazines, including *Traditional Home, Window Style, Designer Kitchens & Baths, Chicago Home & Garden, Design Times* and *Decorating with Architectural Details*, Marsha is widely recognized for her belief that design goes well beyond aesthetics to encompass all aspects of life.

ABOVE:
The black screen accentuates the classic design.
Photograph by Jesse Walker

FACING PAGE:
Two matching settees covered in taupe silk with wood accents invite conversation, while bamboo iron mirrors flank the fireplace to add light and depth to the room.
Photograph by Jesse Walker

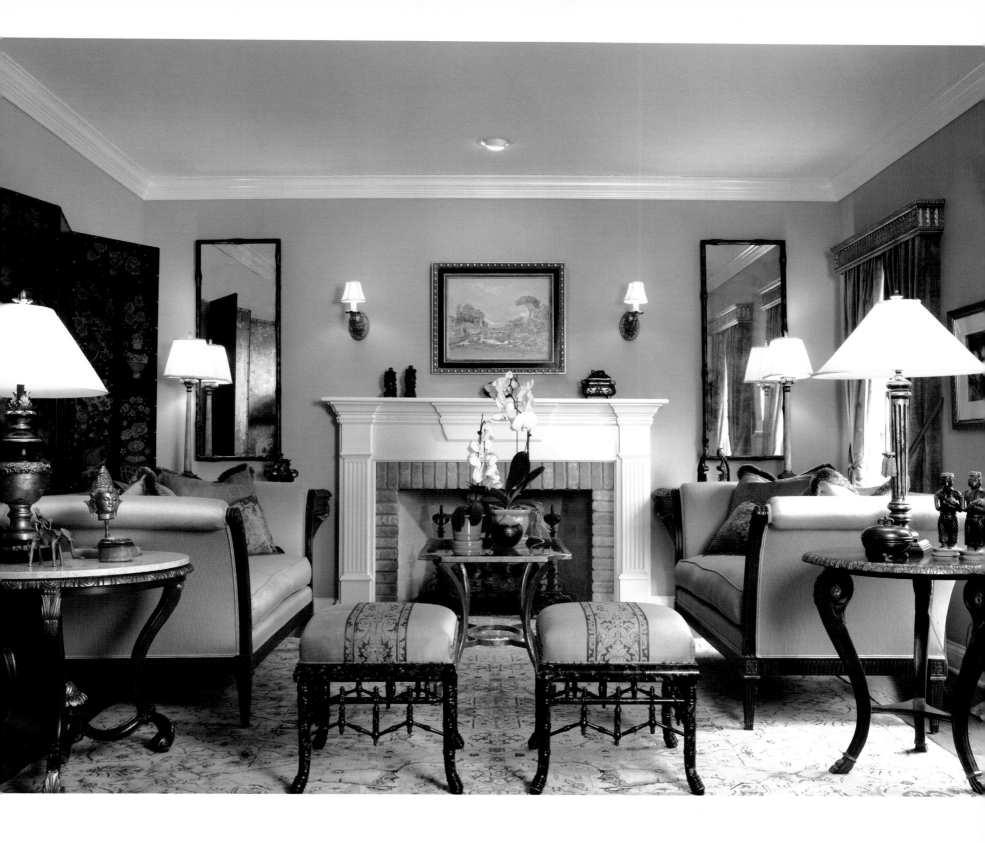

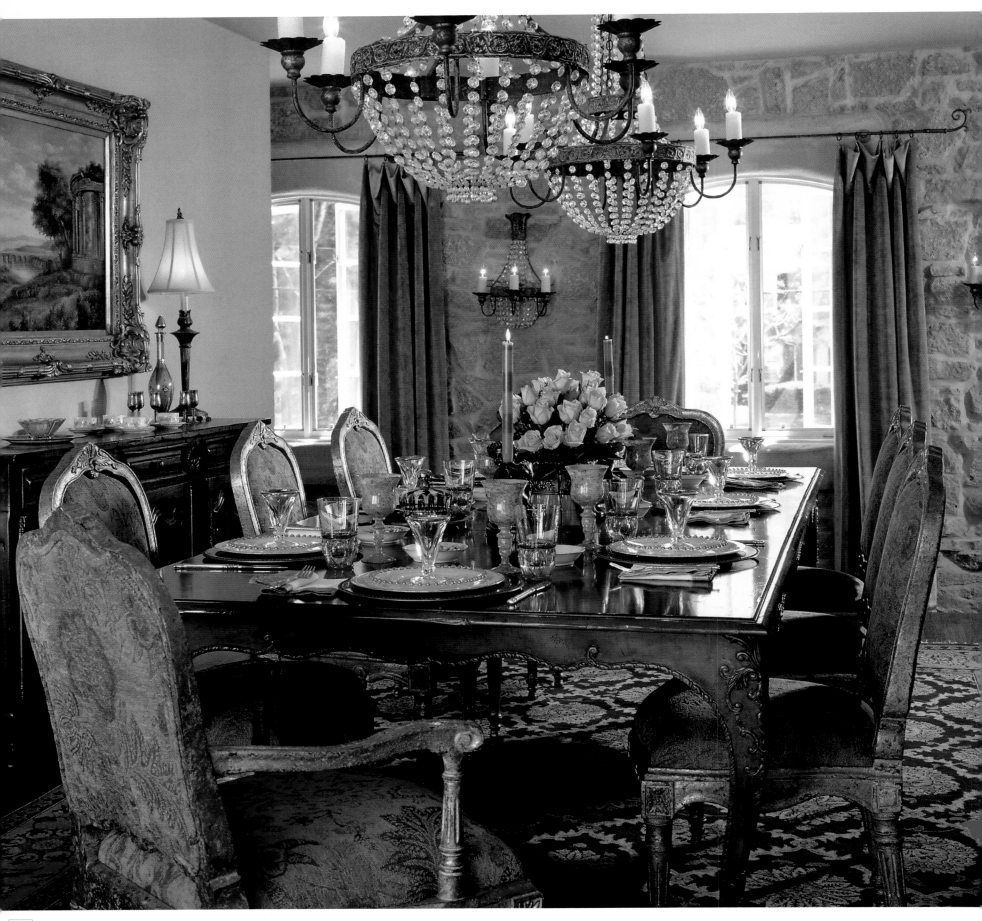

Q&A

more about marsha ...

WHAT COLORS BEST DESCRIBE MARSHA?
Pink represents her passion for design, while green serves as a reminder to stay grounded. As a designer, she feels that creating incredible interiors is not enough; she must direct each project smoothly and professionally to its conclusion.

HOW DO MARSHA'S FRIENDS SEE HER?
Having watched her build a successful business, they see her as an inspiration and one of her closest friends followed suit by transforming art from a hobby into a lucrative tile company.

WHEN SHE IS NOT WORKING, WHAT DOES MARSHA DO FOR FUN?
She loves spending time with her family and traveling to world destinations to explore the diversity of life and design.

WHAT IS THE MOST AMAZING PLACE THAT SHE HAS VISITED?
Villa Cimbrone in Ravello, Italy, where Gretta Garbo once lived. Marsha enjoyed viewing the villa and the gardens, but it was the balcony, "Terrace of Infinity," that took her breath away with its view of the Almalfi Coast and the villages clinging to the sides of the mountains down to the crystal blue Mediterranean Sea.

MARSHA JONES INTERIOR DESIGN LTD.
Marsha Jones
324 South Hale Street
Wheaton, Illinois 60187
630.665.4615
f: 630.665.4830
www.marshajones.com

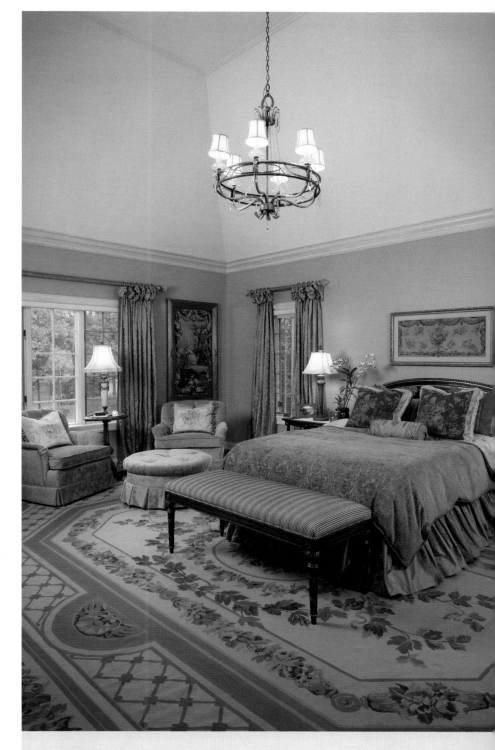

ABOVE:
Timeless French blue walls and fabrics complement the Aubuson rug, from Stark Rug & Co., while touches of antique pillows and wall hangings found in a Paris flea market create a tranquil feeling in this master bedroom.
Photograph by David Schilling

FACING PAGE:
Hanging from iron rods, velvet drapes soften the stone wall while iron and crystal Niermann Weeks sconces add a touch of elegance. A reproduction antique French Baker dining table mixes with encrusted gold chairs covered in tapestry both beautiful and functional.
Photograph by Jesse Walker

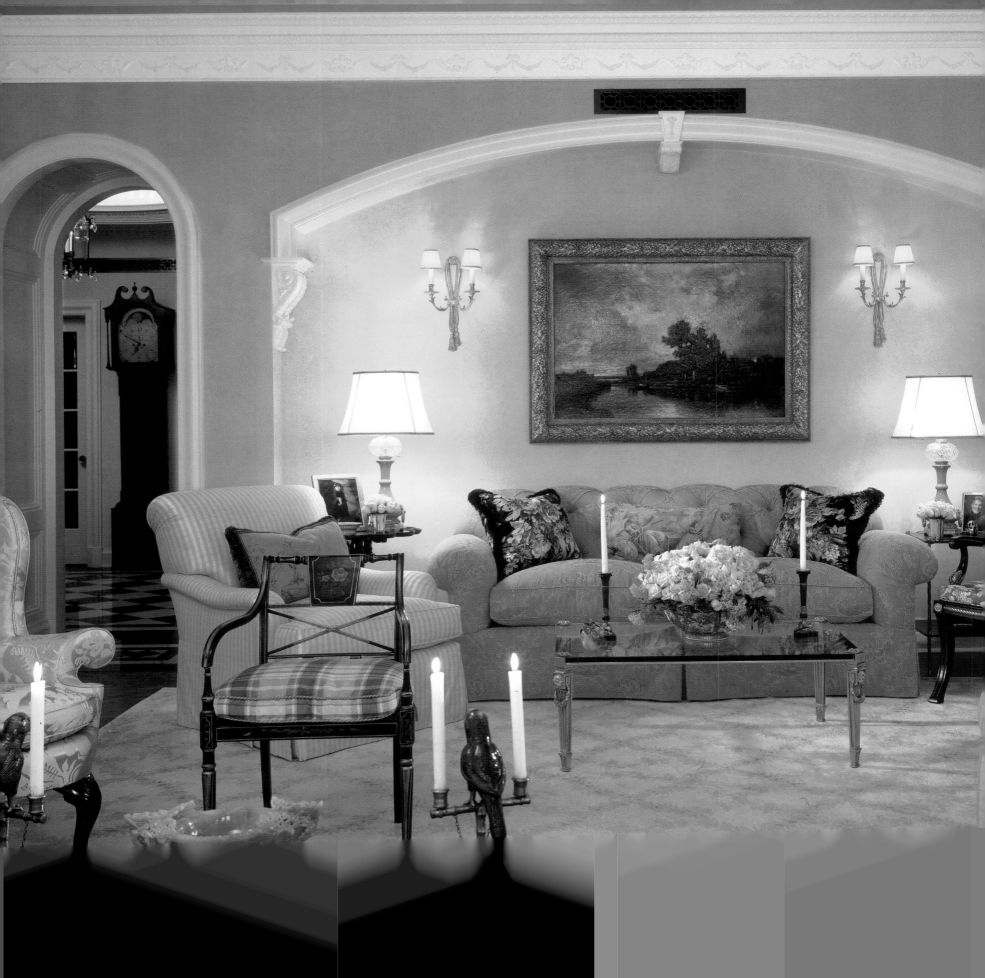

KENT KIESEY

Kent Kiesey has been interested in interior design since he was a very small child, when his mother gave him the opportunity to select a wall covering for his bedroom. To make the room more interesting, he chose an olive green and white polka dot pattern for the ceiling and a trellis pattern for the walls.

From that moment on, Kent's mother was his biggest fan, always encouraging Kent to express his creativity. Now Kent's fan club stretches from coast to coast. Kent recalls his mother's exquisite taste as a source of inspiration for his own style, which was more fully developed through his education at The School of the Associated Arts.

First obtaining a B.A. in psychology, Kent went on to pursue a degree in interior design under the direction of noted designer Dean DuVander. A very encouraging mentor, DuVander entertained in his own home; he also organized field trips to historical houses to demonstrate high-quality design from a classical era. Through lecture, discussion and sincere interest, DuVander supported Kent in developing a unique traditional style. The one-on-one time he received in college influenced his later decision to remain sole proprietor of Kent Kiesey Interior Design.

LEFT:
This living room features yellow silk check on the chairs, a blue and white linen rug by Stark, exuberant Tuscany yellow colored walls and a pair of antique celadon vases with custom silk shades.
Photograph by Tony Soluri

Chicago suits Kent's lifestyle nicely, although he is grateful for his small town Iowa roots. It took Kent a few years to fully embrace city life, but since 1975, Chicago has been home. Kent was selected as the only designer from the city of Chicago to be featured in *Scalamandré: Luxurious Home Interiors*, which was published to celebrate the company's 75 years in America. Scalamandré is a highly prestigious fabric house, founded by Italians with exceptional taste; therefore, it is quite an honor to be numbered among the interior designers with whom they associate.

Kent has a passion for fabric and oftentimes he begins a project by explaining the mood which will result from different fabric selections. A calm demeanor and inward exuberance separate Kent from many of his peers, who are often overtly excited and sometimes intimidating. His design preferences lean toward a traditional style with contemporary overtones, but his abilities stretch far beyond those limits. The common thread weaving through all of Kent's work is a low-key setting which boasts quiet color with "sumptuous and sophisticated simplicity."

One of Kent's favorite projects was a Georgian brick house built in 1911. To ensure that her tastes would be properly accommodated, the owner gave Kent a test of purchasing a lamp for her entryway. The winning lamp, red antique opaline with a silk shade, must have been perfect because that project was the start of a relationship which has lasted over 25 years. Kent's intuition told him that she was looking for formal warmth, and he delivered.

Kent's ultimate goal for any project is that when you walk into one of his rooms, "you feel like they're wrapping their arms around you." Through employing discerning taste in choice of fabrics, lighting, color, texture and placement of furniture, each of the elements work together like a symphony. One item should not dominate; else a feeling of quiet intimacy has not been achieved.

ABOVE:
The banquet in this breakfast area is covered in Anna French cotton. The sky blue strie walls have a hand painted rose border that matches the oval mirror that has hand painted roses.
Photograph by Tony Soluri

FACING PAGE:
This comfortable family room has a sectional corner sofa that is covered in Anna French cotton fabric. An antique map cabinet has been converted into a coffee table. The walls are hand painted in a panel motif with the slanted ceiling painted in a subtle floral motif.
Photograph by Tony Soluri

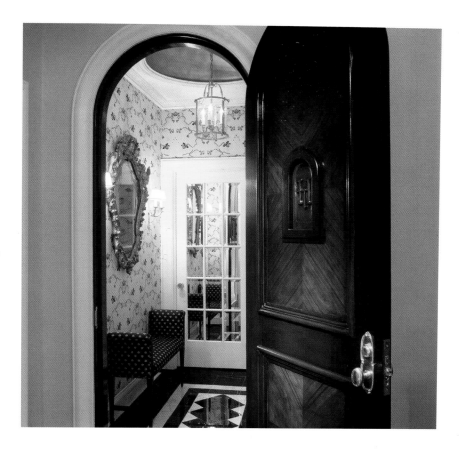

WHAT IS THE MOST UNUSUAL PROJECT IN KENT'S DESIGN PORTFOLIO?
Kent was commissioned to design and build a library with bamboo accents throughout the room. Bamboo covered a variety of surfaces from bookcases to baseboards, trim, arched openings and even radiator covers!

WHAT ARCHITECTURAL ELEMENT WOULD KENT ELIMINATE FROM THE WORLD?
Low ceilings are difficult to work with because they stifle design possibilities and make people feel trapped.

WHAT IS KENT'S BIGGEST PERSONAL INDULGENCE?
Bissinger's chocolate candy. Kent has been a chocolate connoisseur since he was a child.

OF ALL THE COLORS IN THE RAINBOW, WHICH BEST DESCRIBES KENT?
Red is his personal favorite, but he appreciates them all for the variety of emotions which they can create.

Most designers prefer neutral colors in their own homes, but Kent appreciates the invigorating quality of color throughout his life. His own home is designed with a Mediterranean color scheme of taxi cab yellow, red and a bit of mango orange in grayed-down hues. He appreciates a stimulating environment that is still conducive to relaxation.

In Kent's spare time, he enjoys traveling to Europe to be refreshed with the atmospheres of Paris and London. Kensington Church Street has inspirational shopping opportunities as many of the boutiques have been in business for quite some time and have a timeless quality. Kent loves adding antiques or vintage reproductions to a room because they add a sense of authenticity to any project. Although Kent is young and vibrant, his personality has the quality of a priceless antique, and the residual nature of his clientele is a testament to the brilliance of Kent's designs.

ABOVE:
This private elevator vestibule's walls are upholstered in floral silk moiré. It contains an 18th century antique Italian shield shaped mirror, gold leaf dome and a pair of gilt bronze wall sconces.
Photograph by Tony Soluri

FACING PAGE:
This elegant dining room features custom plaster molding, a plaster arch opening, an antique Agra Oriental silk rug and 18th century English chairs.
Photograph by Tony Soluri

KENT KIESEY INTERIOR DESIGN
Kent Kiesey
431 West Oakdale Avenue
Chicago, Illinois 60657
773.528.9301

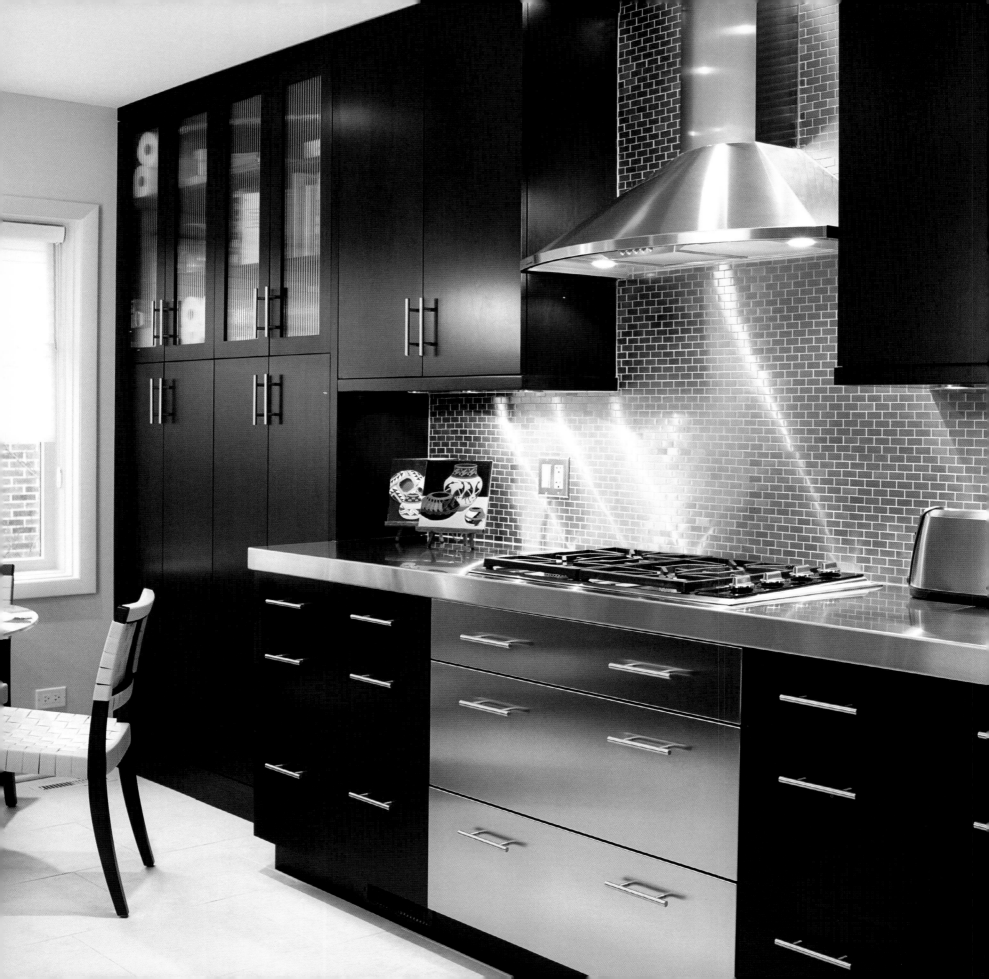

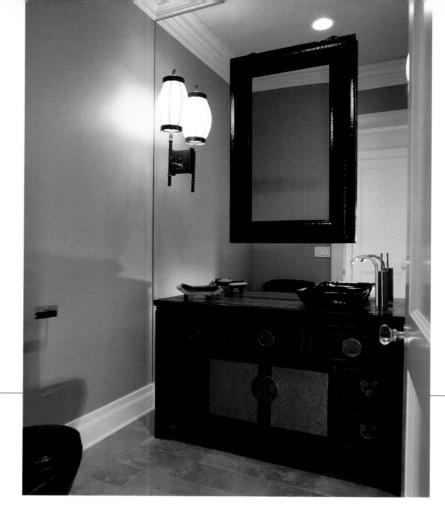

BETH KOPIN

KOPIN INTERIORS

Not content to excel in just one facet of home design, Beth Kopin has quite literally been doing it all for legions of grateful and amazed clients. Renowned for her fabulous interior design, Beth's firm, Kopin Interiors, offers a complete list of wide ranging design services. However, it is her comprehensive knowledge of the entire process beginning with the blueprint stage—including layout analysis, light plans, textile and furniture selection and the staging of those fine accessories which make spaces truly unique—that sets her apart. Although accomplished in interior design, space planning is actually her strongest suit; clients have aptly given her the nick-name "The Space Planning Goddess." From architectural space planning and drafting complete blueprints to interior design, this uniquely talented interior designer's services extend beyond the anticipated into the extraordinary.

Preferring to draw all blueprints by hand, Beth is often commissioned in the framing stage of construction to redesign entire layouts and she has redrawn plans of some of Chicago's most prominent architects. Sketch pad in hand at every meeting, she believes superior design can only be achieved through the mind, spirit connection only possible through hand drawings. Beth believes free association encourages artistic freedom and is much more productive than distressing over plotting and entering data on a CAD machine (Computer Aided Design). Of course she holds scale and function highest on

her list of importance, three or four possible plans take shape during every meeting and it is usually the marriage of these designs that gives birth to the perfect and completely original final product. She likes nothing more than painstakingly mulling over a difficult floor plan, using three rolls of tracing paper, coming up with a solution and making it look easy.

Beth's education at Harrington Institute of Interior Design and her experience as the busy mother of three have given her priceless insight to the world of design. She knows how things in a home should work and designs floor plans accordingly with anticipation for the inevitable: functional yet beautiful kitchens, expansive closets and practical mud

ABOVE:
This chic powder bathroom features a vintage antique Asian cabinet which was retro fitted into a vanity. An Asian mirror is mounted on a mirrored wall adding depth. Soft olive complements the picholine stone flooring.
Photograph by Mike Kaskel

FACING PAGE:
This total renovation created a brilliant, very contemporary kitchen. The espresso cabinets bring warmth to the predominately stainless steel space. The stainless mini brick mosaic backsplash adds an interesting focal point.
Photograph by Mike Kaskel

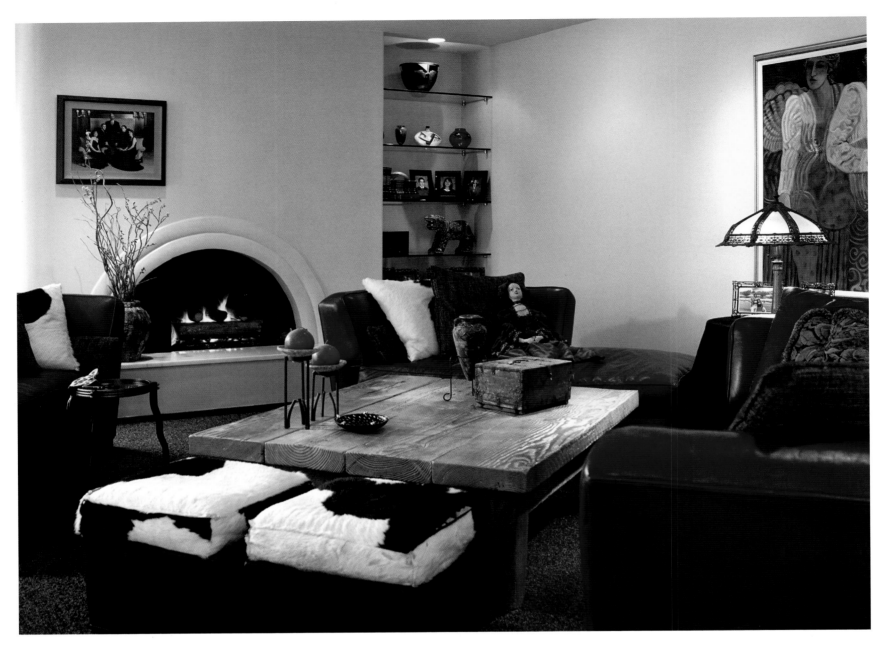

rooms. She addresses daily living spaces with her clients and emphasizes lighting plans before designing the millwork and much more. And as if this one-stop dynamo doesn't have her hand firmly placed in enough of the entire process, she is also a general contractor who has renovated her own home and those of her clients. Not only do her designs from small projects to large encompass an interior designer and architectural perspective but also a builder's perspective which leaves no opportunity for design or interpretation error.

Although Beth is personally drawn to eclectic design, she appreciates absolutely all styles and relishes the challenge of incorporating the best use of existing or potential space with her clients' needs and tastes. Her design portfolio includes everything from "empty-nester contemporary" to traditional, transitional and Old World style décor. With the expertise to

brilliantly redirect the color palette of one room, rehabilitate the interior of a 20,000-square-foot estate or design an entire home from the ground up in conjunction with an architect, Beth's capabilities and interests are unique and always engaging.

For Beth, there is no greater joy than drafting a two-dimensional plan and facilitating its evolution into a tangible three-dimensional masterpiece to be enjoyed for many years to come. It's what makes all her hard work worth it and the icing on a very beautiful cake.

WHAT IS BETH'S LEAST FAVORITE BUILDING MATERIAL?
Ceramic that tries to imitate natural stone. It doesn't make sense to use stone-looking ceramic, when the price of natural stone is so reasonable.

ON WHAT PERSONAL INDULGENCE DOES BETH SPEND THE MOST MONEY?
Coats. Beth has over two dozen, because with such a long winter, a good coat can make a bigger fashion statement than a nice outfit.

WHAT IS THE MOST VALUABLE LESSON THAT BETH HAS LEARNED?
Sometimes things simply do not go according to plan, but there is always a solution found in part by re-strategizing.

HOW DOES BETH PERFECT LAYOUTS?
In one instance of existing architecture, Beth corrected a layout situation by reversing the stairwell flow to create a scenic view at each level. She cares not only about how interiors look from every angle, but how they function.

WHERE DOES BETH LIKE TO TRAVEL?
Beth enjoys traveling all over the world because it is abundant in conjuring personal inspiration. She has traveled extensively throughout the country, Europe and the Middle East. Beth loves all art and, in fact, during her travels makes it a point to acquire pieces for her collection from notable local artists because creative people inspire her. She loves a variety of mediums, including neon and mosaic, and has a Barbara Gallagher oil painting over her sofa. Most memorably, Beth loved her experience chartering a sea plane to visit a secluded fjord, where she dipped her feet into the crystal-clear icy ocean. Next up for Beth? Alaska.

ABOVE:
This condominium foyer features an inset mosaic stone area rug, a unique Feneri hand-dyed silk pendant fixture and an antique hand-carved African chair. The walls were hand-finished in a monochromatic camel/chocolate faux to soften the space while keeping it elegant.
Photograph by Mike Kaskel

FACING PAGE:
A view into the great room of the designer's residence, which is located on a wooded ravine, Beth achieves a decidedly casual yet sophisticated gathering place for her family. Choosing eclectic pieces, including her coveted Barbara Gallagher painting, she has achieved her vision. From the custom-made russet red leather Holly Hunt sofas to the rustic coffee table (made from the timber of reclaimed vintage barn beams) Beth discovers the perfect blend of contemporary and vintage elements.
Photograph by Mike Kaskel

KOPIN INTERIORS
Beth Kopin, Allied Member ASID, NKBA
150 Cary Avenue
Highland Park, Illinois 60035
847.926.0233

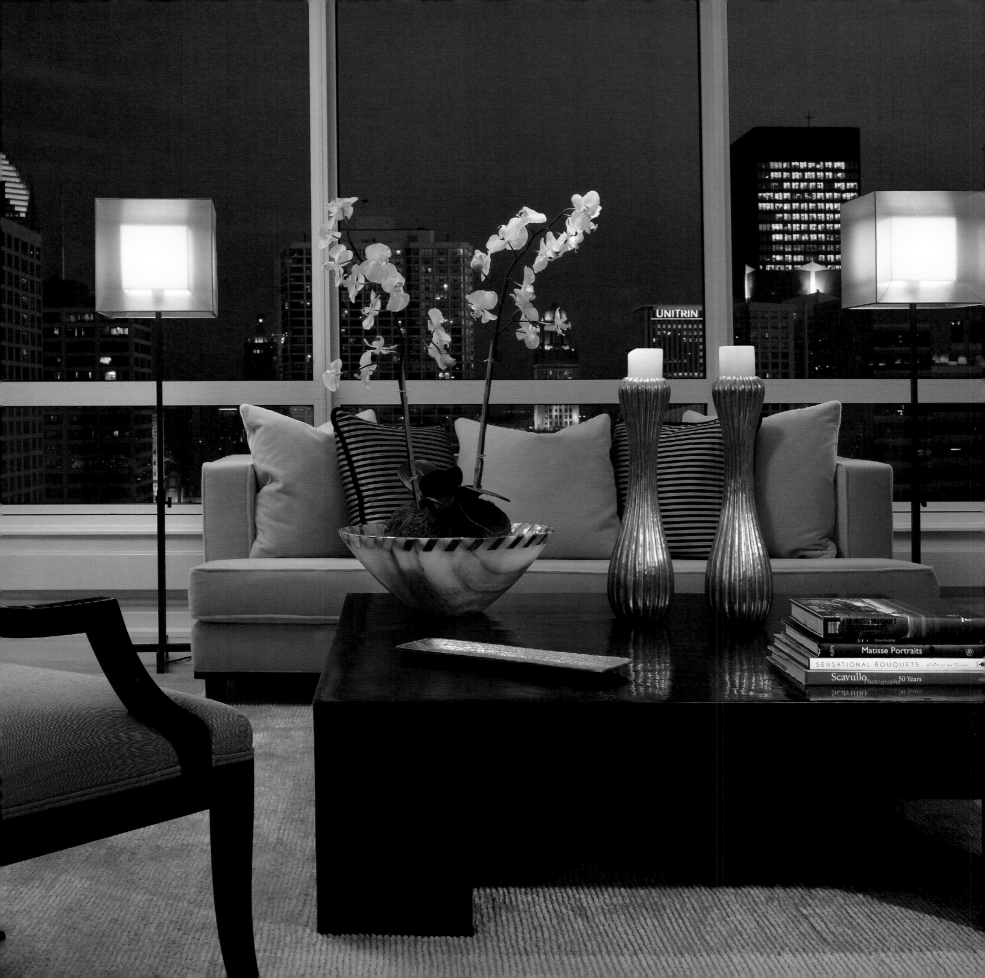

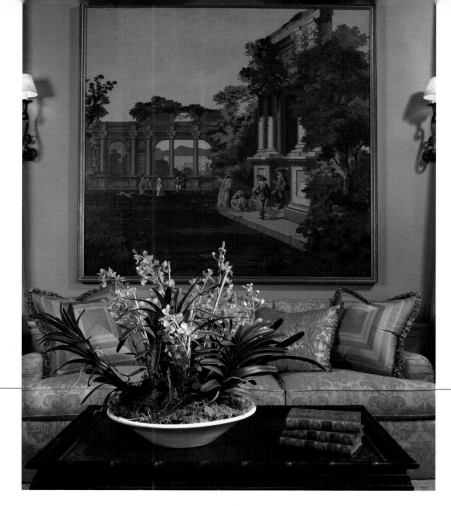

SUSAN KROEGER

SUSAN KROEGER LTD.

Attentive to the specific needs and style preferences of each client, Susan Kroeger's passion for interior design radiates in the beautiful spaces that she creates from her Winnetka, Illinois studio.

As a native of the Midwest, she understands the prudence of her clientele and respects their investment by designing interiors that will be enjoyed long after the project is complete. To achieve a polished and timeless look, Susan visits extensively with clients to ascertain what styles they find appealing and how they wish to use each space of their home; from these pleasant conversations emerges a design direction which may vary from traditional to modern or seamlessly blend the best of both stylistic genres.

Since Susan views the design process as a journey, she strives to make each step pleasurable by involving clients in as many decisions as they would like to be a part of. She patiently works with clients, educating them about the reasoning behind her suggestions and soliciting their valuable input. Residents love the final destination—their custom interior—and truly enjoy living in the personality reflective spaces which Susan has created with them.

While each aspect of design is significant, Susan is particularly revered for her brilliant use of color, whether the space is elegantly neutral with splashes of color or saturated in a luxurious hue. Although the established designer believes that there is no such thing as a wild color, she respects the wishes of her clients by presenting them with several options—from conservative to bold—and then explaining the effect that each color-way will have on the design. Susan encourages patrons to take their time when selecting a palette and notes that clients often surprise themselves with their choice.

The process of introducing a variety ideas and allowing them to percolate in the minds of her clients until they arrive at an informed decision is a philosophy of patience evident in every aspect of Susan's work. She provides comprehensive services from space planning through finish out

ABOVE:
Old World elegance, created by a classic yet rich color scheme, sets the stage for timeless comfort.
Photograph by David Schilling

FACING PAGE:
The design of a sophisticated living room is further enhanced with views of a glamorous cityscape.
Photograph by David Schilling

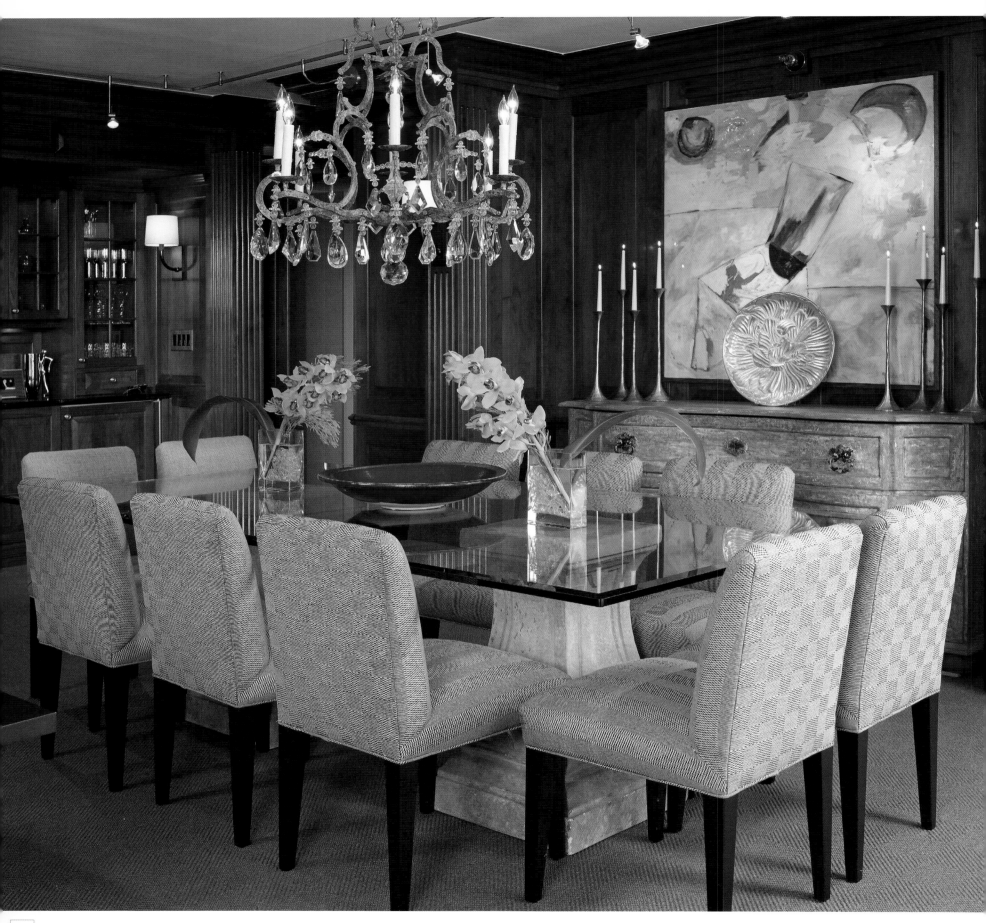

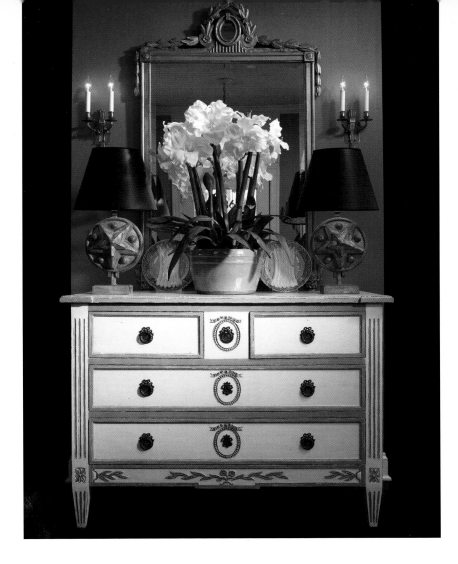

and her unique shop, Susan Kroeger for the Home is a great resource for beautiful furniture and accessories not otherwise found in Chicago.

Particularly known for her exquisite style, color selection and ability to tell each client's story through interior design, Susan Kroeger has attracted the attention of numerous design publications, which have featured her work extensively. While she loves designing in Chicago, her experience of over 20 years and exclusively referral based clientele have taken her across the country, from Louisiana and Tennessee to California, Florida and New York. Clients instantly take notice of the passion and personal care with which Susan designs.

ABOVE:
Visual and stylistic balance was achieved by selecting a bold backdrop to bring the combination of antique and modern elements to life.
Photograph by David Schilling

FACING PAGE:
An eclectic combination of color and textures sets the stage for dramatic dining.
Photograph by David Schilling

HOW IS SUSAN'S PASSION FOR DESIGN EVIDENT IN HER PERSONAL LIFE?
As a hobby, she enjoys the process of renovating houses and then reintroducing them to Chicago's astute real estate market.

WHAT COLOR BEST DESCRIBES HER?
Coral is vibrant, playful, upbeat and nicely complements Susan's features.

WHAT IS SUSAN'S GREATEST INDULGENCE?
She collects fine, exotic jewelry, of which her favorite piece is an emerald ring designed by an artist friend.

WHERE DOES SUSAN LIKE TO TRAVEL?
She finds warm weather to be particularly pleasurable, so California and the Carolinas make great weekend getaways, yet for longer trips, Susan appreciates spending time in Paris, southern France and Italy.

SUSAN KROEGER LTD.
Susan Kroeger, ASID
886 Green Bay Road
Winnetka, Illinois 60093
847.441.0346
f: 847.441.0356
www.susankroeger.com

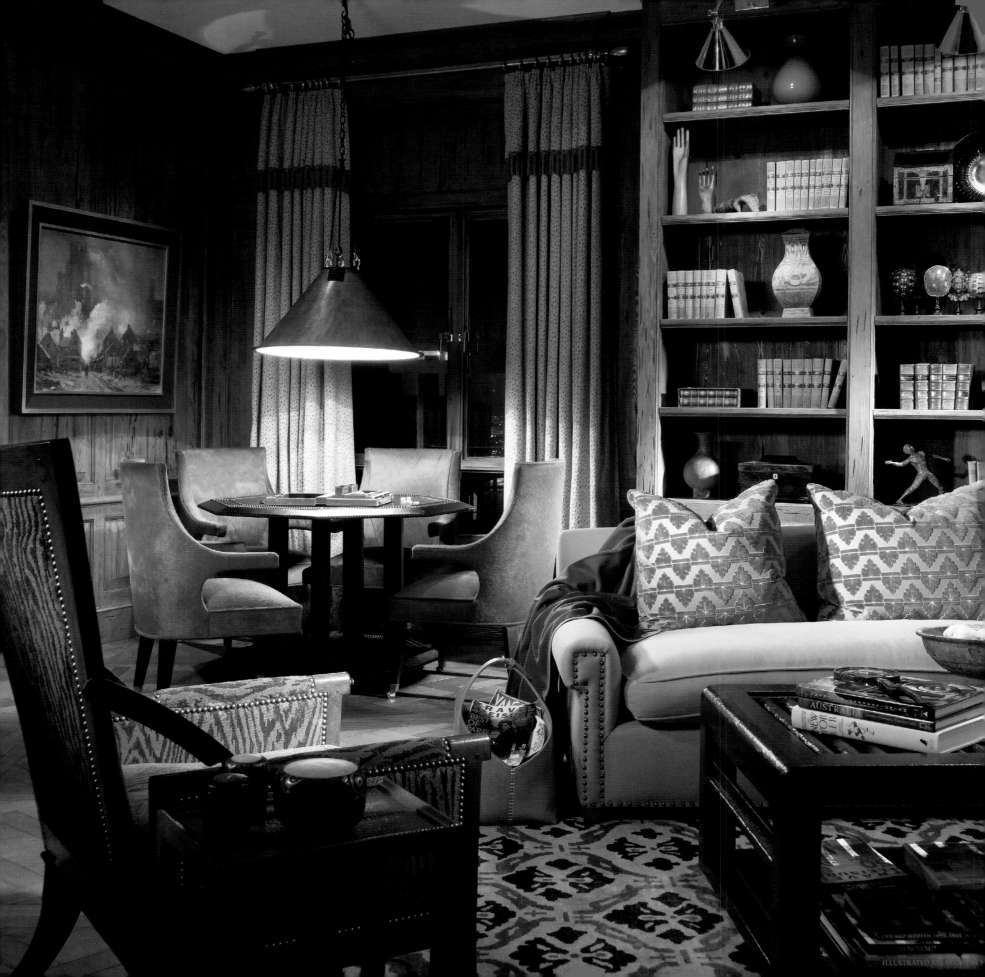

JESSICA LAGRANGE

JESSICA LAGRANGE INTERIORS, LLC

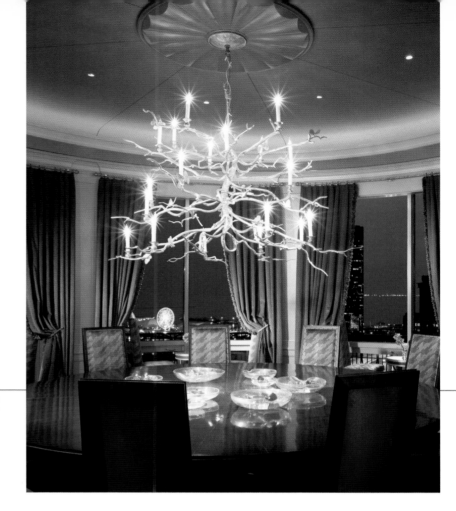

Recognized for quality and an unsurpassed level of service, Jessica Lagrange Interiors (JLI) is a design firm located on Chicago's prestigious Michigan Avenue. Each client's personal taste dictates a project's aesthetic, yet a common thread of classical elegance weaves throughout Jessica Lagrange's impressive portfolio.

Whether the project involves completely renovating an estate or working with a client to select drapery for just one room, Jessica Lagrange enjoys the variety that her career offers. Jessica has impressive commercial design expertise—including a 30,000-square-foot conference center in Santiago, Chile—yet her greatest passion lies with the intimate nature of designing high-end homes.

Talented interior designers, architects, a business manager and a resource librarian comprise the team led by principal Jessica Lagrange who joined the field of design in the late 1970s when she earned a B.A. in interior design from The School of the Art Institute of Chicago. A professional in every sense, even though her firm has the internal resources to accomplish nearly any design task, she does not hesitate to request the assistance of consultants who specialize exclusively in fields such as fine art collecting, kitchens design lighting, and landscape design to fulfill a particular project's

needs. In addition, the firm utilizes the latest drafting technology to present drawings and ideas to both clients and the esteemed architects with whom they work.

Jessica Lagrange Interiors has an excellent working relationship with the architectural firm Lucien Lagrange and Associates. The autonomous companies don't just share an address; Jessica and Lucien share a home as husband and wife with their two children and appreciate each other's unique perspectives on design.

Clients are pleased to learn that the 2,000-square-foot studio of Jessica Lagrange Interiors conveniently features a comprehensive library of the latest products: beautiful fabrics, furniture, flooring and beyond. The

ABOVE:
Lake Shore Drive pied-á-terre, dining room.
Photograph by Tony Soluri

FACING PAGE:
Lake Shore Drive pied-á-terre, library.
Photograph by Tony Soluri

conference room, which hosts formal presentations and impromptu lunches alike, features a large antique table and is accented with modern light fixtures and seating. It represents the essence of JLI's creative philosophy, combining traditional elements with contemporary detailing.

JLI caters to the unique needs of clients to reflect their luxury lifestyle with a pleasing blend of clean architectural lines, classical furnishings and subdued color and texture. However, when bold colors are called for, Jessica and

her team members do not hesitate to make a powerful statement. Jessica's imaginative designs have appeared in numerous publications, including: *Metropolitan Home*, the *Chicago Tribune*, the *Robb Report*, *Design & Architecture* and *Chicago Home*.

She has visited countries throughout Europe and South America—for pleasure and design research—and enjoys finding specialty items for her clients wherever she goes. Her personal collections include shagreen furniture

more about jessica ...

HOW WOULD JESSICA'S FRIENDS DESCRIBE HER?
They would convey that she is perfectly suited for her service-oriented interior design career because of her personable and outgoing nature.

IN JESSICA'S HOME, WHAT IS HER FAVORITE SPACE?
Even though the interior is exquisite, she enjoys relaxing and entertaining in her European-style backyard because; with its shade trees, ivy-covered brick walls, beautifully planted vegetation, limestone walkways and water feature, it feels like an extension of her home.

WHOSE ARCHITECTURAL DESIGN DOES SHE MOST ADMIRE?
Jessica is quite fond of David Adler's work because he was a multi-talented man and his classic designs still look fresh today.

HOW DOES JESSICA RECOMMEND ADDING INTEREST TO SMALL SPACES?
She has fun using over-the-top finishes and fixtures. As an example, in a 10,000-square-foot city apartment's powder room, she commissioned artisans to apply eglomisé—gold leaf behind glass—which created a jewel box effect and a feeling of fresh European elegance.

and accessories, antique silver, African masks and assorted bronze pieces. Jessica prefers to display these treasures in groupings to create casual yet impressive focal points in various rooms of her charming 1884 Louis Sullivan home. She uses the same approach for displaying her clients' collections as a reflection of their personal style and experiences—always Jessica's ultimate goal in creating a home.

ABOVE:
Gold Coast residence, kitchen.
Photograph by Nathan Kirkman

FACING PAGE:
Edgewater Beach residence, living room.
Photograph by Nathan Kirkman

JESSICA LAGRANGE INTERIORS, LLC
Jessica Lagrange
605 North Michigan Avenue, 4th Floor
Chicago, Illinois 60611
312.751.8727
f: 312.751.8728
www.jessicalagrange.com

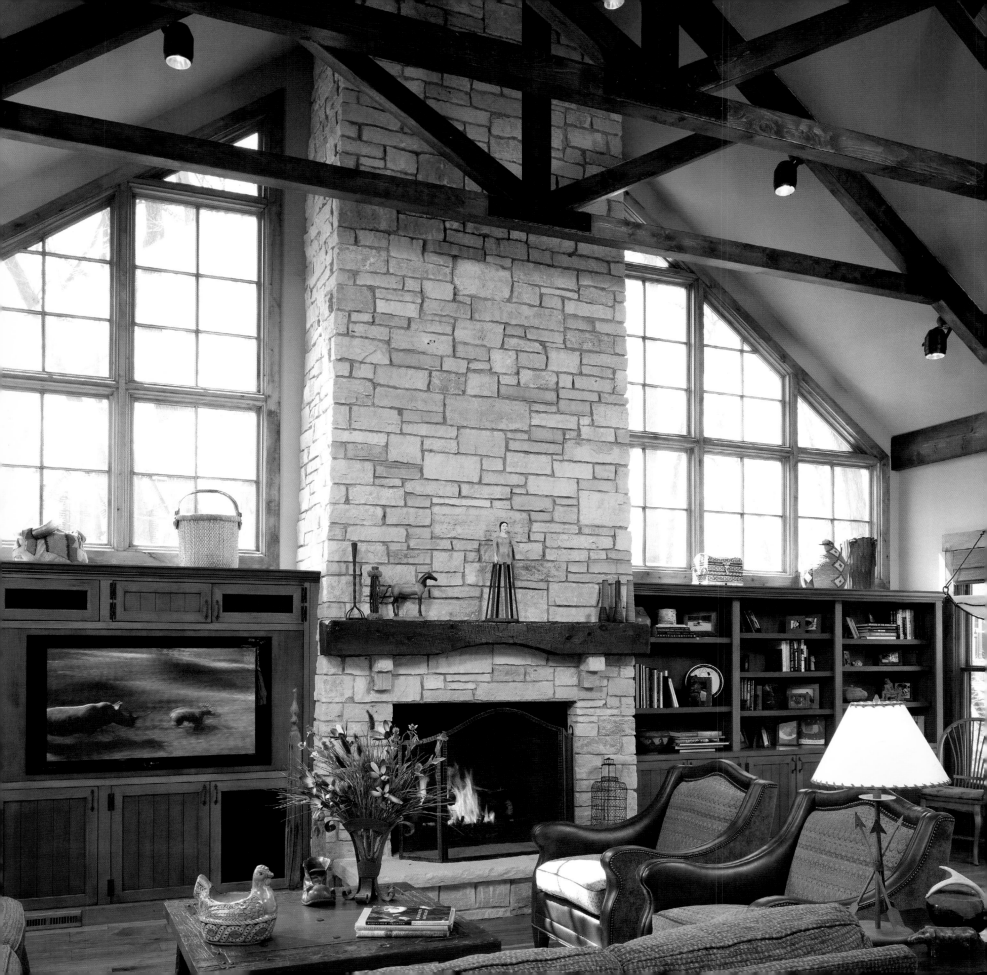

KAREN
LASKER-GOLDBERG

K. LASKER-GOLDBERG DESIGNS, INC.

Interior design is a sensual experience for Karen Lasker-Goldberg, whose signature style involves combining interesting materials and personally designing furniture to translate each client's dream into a reality.

Karen's interest in three-dimensional expression goes back to her days as a sculptor; because of that artistic background and personal understanding of different mediums, she never hesitates to bring interesting materials into her clients' homes. Among other combinations, she has united ultra suede with steel band chairs and designed window treatments with silk, marble and a steel rod.

Having studied at The Art Institute of Chicago, Karen holds master's degrees in fine art and interior architecture. Since Karen is both an artist and a knowledgeable draftswoman, clients view her expanse of capabilities to be quite beneficial. She is well-versed in a full spectrum of styles and often combines the elegance of contemporary lines with antique, primitive or artisan crafted objects.

Karen's diverse portfolio includes everything from a modern loft that required intricate space planning to a historical row house with English traditional charm and an impressive 14,000-square-foot Colorado residence, which she designed from architectural inception through interior design.

An active member of the Chicago arts community, Karen has been recognized in several books, magazines and newspapers for her innovative residential and commercial designs since establishing K. Lasker-Goldberg Designs in the 1980s.

She believes that many factors contribute to a successful interior: client-designer relationship, space planning, lighting, furniture and the coordination of various surface materials. By carefully considering and planning each detail of the design, Karen creates interiors that fulfill her clients' vision of comfort and beauty.

K. LASKER-GOLDBERG DESIGNS, INC.
Karen Lasker-Goldberg, ASID
1869 Eastwood Avenue
Highland Park, Illinois 60035
847.831.5868
f: 847.831.5871
www.klaskergoldberg.com

ABOVE:
Sophisticated great room functional for entertaining guests at the media center as well as an intimate grouping around the fireplace. Flashes of color in a tranquil palette.
Photograph by Rich Sistos

FACING PAGE:
Dramatic soaring architecture with functional built-in cabinets surrounded by comfortable earthy furniture—a tribute to light, texture and color.

SUZANNE LOVELL

SUZANNE LOVELL, INC.

Suzanne Lovell creates peaceful atmospheres through her unique architectural approach to interior design. Each project is truly one-of-a-kind, carefully designed, crafted and executed to reflect the client's personal style. Suzanne sees her own home as a scrapbook of her life, comprised of very intimate details and she designs for her clients with that philosophy in mind.

A firm believer that architecture and interior design should be integral from start to finish, Suzanne provides a complete spectrum of design services from interior architecture, renovation and custom millwork, to custom furniture, textile design and antique and auction sourcing. Through extensive travels, she has formed a global network of talented artisans and craftspeople who facilitate her boundless creativity.

Most exceptionally, her firm recently imported large quantities of Vals Quartzite from Switzerland to grace the walls and floors of a 9,250-square-foot Chicago penthouse. Long, two-inch by six-foot strips of the exquisite material were painstakingly laid like a wood floor; in one day, only three pieces could be installed. Balancing texture and color, they designed custom 10-foot high steel doors with blue glass to reflect sky throughout the space, creating an inviting home with the credibility of great architecture.

Her innovative designs come from a culmination of her life experiences. She studied with Swiss-German architect Olivio Ferrari and earned a Bachelor of Architecture degree from Virginia Polytechnic Institute and Virginia State University. Suzanne is very observant and enjoys taking time to ponder what elements make places or things beautiful. The accomplished designer expresses that she cannot simply ask ideas to show up, they come on their own, even if they are not applicable until years later.

Suzanne's favorite retreat within her own home is the library that overlooks a beautiful park. Earth tones and vibrant splashes from a colorful photograph surround family treasures that are displayed within. She loves to spend time reading books such as *The Art of Innovation: Lessons in Creativity from IDEO, America's Leading Design Firm* by Tom Kelley—from her comfortable chair in the personality-reflective space.

ABOVE:
The unique combination of American and Chinese artifacts creates a welcoming entrance into the great room of this country home. The stairwell is flanked by a pair of Chinese Well Buckets, along with a pair of American fan-shaped architectural elements.
Photograph by Tony Soluri

FACING PAGE:
Once an abandoned artillery shed, the Romanesque arched windows allow the building to become all about light. Asian antiques highlight the room and bring a soulfulness to the vast space. A 1943 charcoal drawing by Matisse rests on top of the media cabinet.
Photograph by Tony Soluri

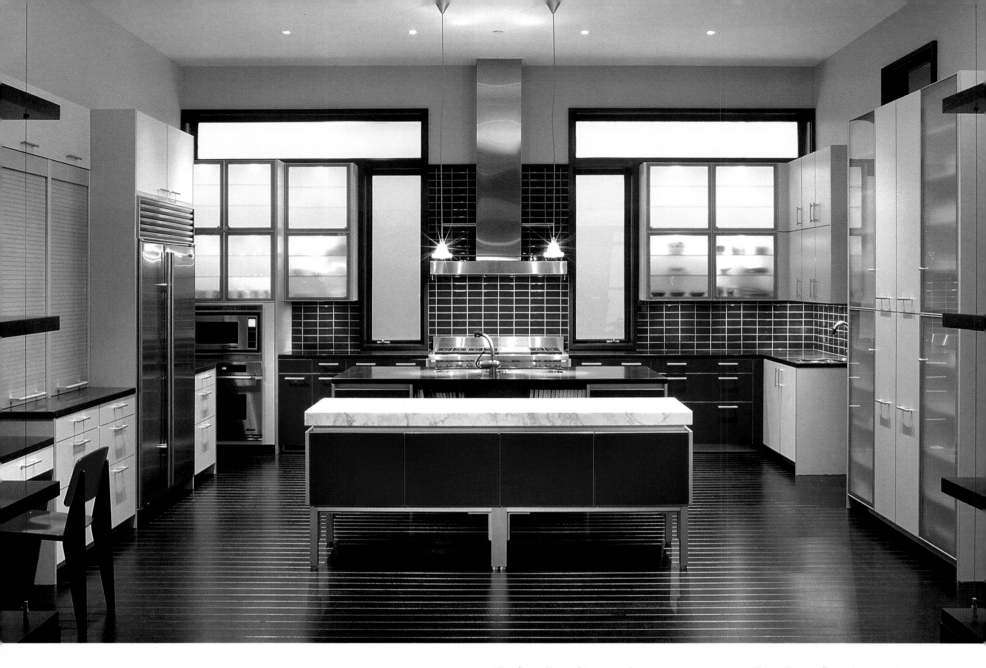

The founding of Suzanne's newest company, Twill Textiles, reflects her passion for textiles and interior design. She and her business partner Sam Kasten—one of America's leading hand weavers of custom fabrics and rugs—were both trained in the Bauhaus aesthetic, and their collaboration has resulted in the creation of a graphic yet modern collection of textiles for the home. True to the sophisticated experience of hand weaving, they embrace traditional and timeless patterns in a natural color palette and also include a selection of environmentally friendly fabrics.

With over 20 years of experience, Suzanne has been widely published, and notably, *Architectural Digest* featured her in their *Top 100 Designers and Architects* list. Striving to design interiors "that respect the expression of the architecture and, with subtle consistency, weave object and texture together to create spirited elegance," clients appreciate her diverse creative interests because she has such a tremendous foundation for inventive designs.

ABOVE:
Banquettes were added to two corners of the sunroom to create a breakfast nook perfect for family gatherings. Green Italian spongeware place settings and an antique crewel work cloth finish out the table.
Photograph by Tony Soluri

FACING PAGE:
This master suite is a serene combination of custom furniture and Asian antiques. Pairs of doors were crafted to fit within the original arches on three sides of the room to allow natural light and the magnificent landscaping to fill the room.
Photograph by Tony Soluri

Q&A
more about suzanne ...

WHAT PHILOSOPHY HAS SUZANNE DEVOTEDLY MAINTAINED OVER THE YEARS?

Her two-fold philosophy includes an architectural approach and commitment to taking design personally by becoming familiar with each client's dreams.

PROFESSIONALLY, WHAT IS THE HIGHEST COMPLIMENT THAT SHE HAS RECEIVED?

Suzanne conveys that there is no greater feeling than hearing clients say, "I love where I live," in acknowledgement that the designer has captured the essence of their personality and breathed sensibility into their home.

WHO HAS MOST INFLUENCED SUZANNE'S CAREER?

Greatly impacted by the classic design sensibility of Coco Channel and Diane Vreeland, she pays greatest homage to her family for instilling in her the value of craft and a deep appreciation for the study of the decorative arts.

WHEN SHE IS NOT DESIGNING, WHAT DOES SUZANNE DO FOR ENJOYMENT?

She loves to travel with her husband and two children. Fly fishing and bicycling adventures further expand her world view.

SUZANNE LOVELL, INC.
Suzanne Lovell
225 West Ohio Street
Chicago, Illinois 60610
312.595.1980
f: 312.595.9295
www.suzannelovellinc.com
www.twilltextiles.com

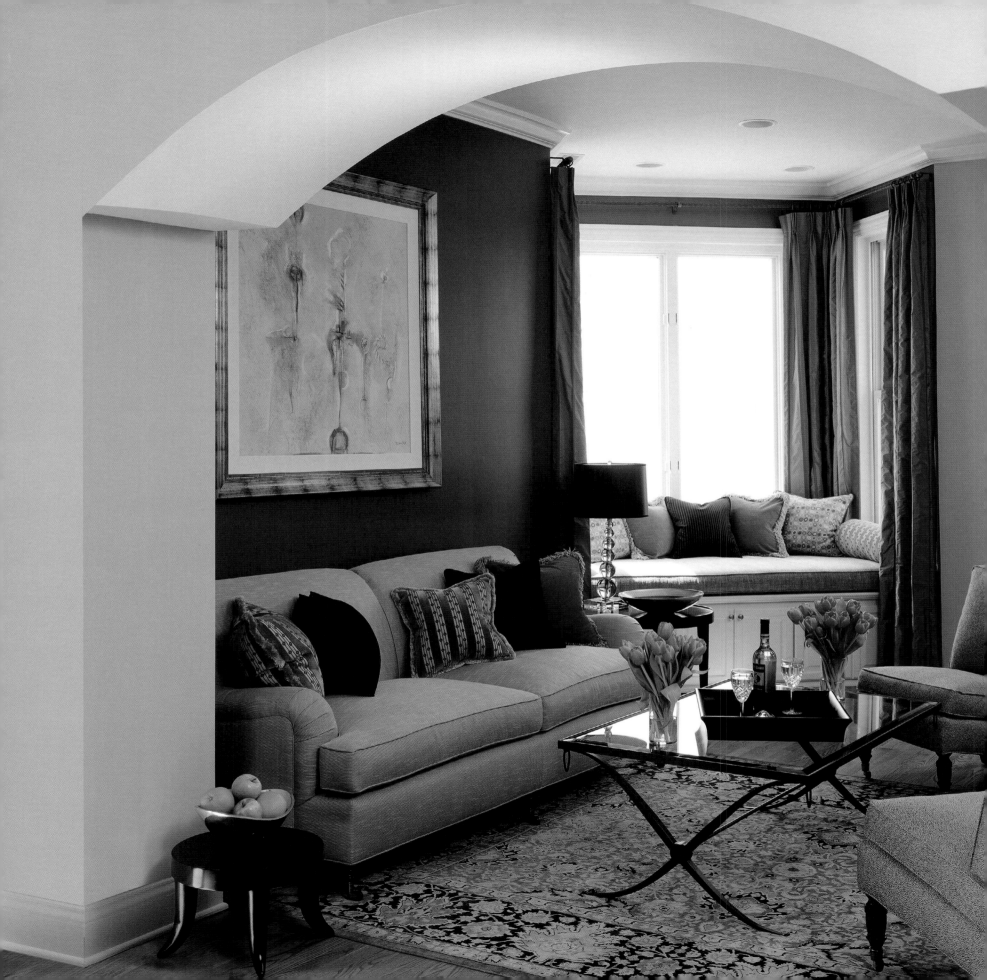

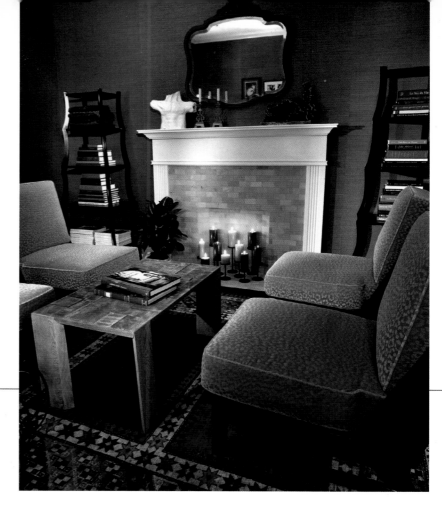

MOLLY McGINNESS

MOLLY MCGINNESS INTERIOR DESIGN

Extremely personable and easy to work with, Molly McGinness specializes in creative yet classic designs for residential spaces. Although Molly's personal design taste combines modern pieces with antiques, she works with each client to reveal a distinct and uniquely beautiful style.

Molly has a fascinating educational background, first obtaining a B.A. in International Affairs from George Washington University in D.C., living in Japan, and then earning a second degree from the Harrington Institute of Interior Design. She worked with both a residential designer and a kitchen/bath firm, where she gained valuable experience before opening Molly McGinness Interior Design in 2001.

She finds joy in the entire creative process, but selecting interesting furnishings to make a room truly distinctive is her favorite part. Oftentimes, her ideas incorporate a mixture of old and new items to present a collected appearance and make the house feel like home. Molly appreciates the challenge of designing in a variety of styles, but she usually avoids trends and promotes classic décor with eclectic variations.

She advocates the wonderful quality of intimate spaces in which everything has a purpose. Molly featured the original architectural details of an 800-square-foot apartment by creating a clutter-free space with rich, warm colors and taking advantage of natural sunlight from the eastern exposure.

A professional member of the American Society for Interior Designers, Molly is NCIDQ-qualified and enthusiastic about new design opportunities. Molly enjoys working with people who are open-minded and trusting of her style and ideas.

MOLLY MCGINNESS INTERIOR DESIGN
Molly McGinness, ASID
3511 West Wrightwood Avenue
Chicago, Illinois 60647
312.213.0357
f: 773.395.2707

ABOVE:
An intimately sized library/living area features a pair of bookshelves chosen for their height and unique lines. Mohair chairs and grass cloth walls make the room inviting while an antique mirror painted with red lacquer adds a burst of color.
Photograph by Doug Snower

FACING PAGE:
Infused with sunlight, rich colors and award-winning custom draperies accentuate the casually elegant living room's architecture. The window seat, adorned with luxurious pillows, serves as a focal point while a beautiful Oriental rug unites the space.
Photograph by Casey Sills

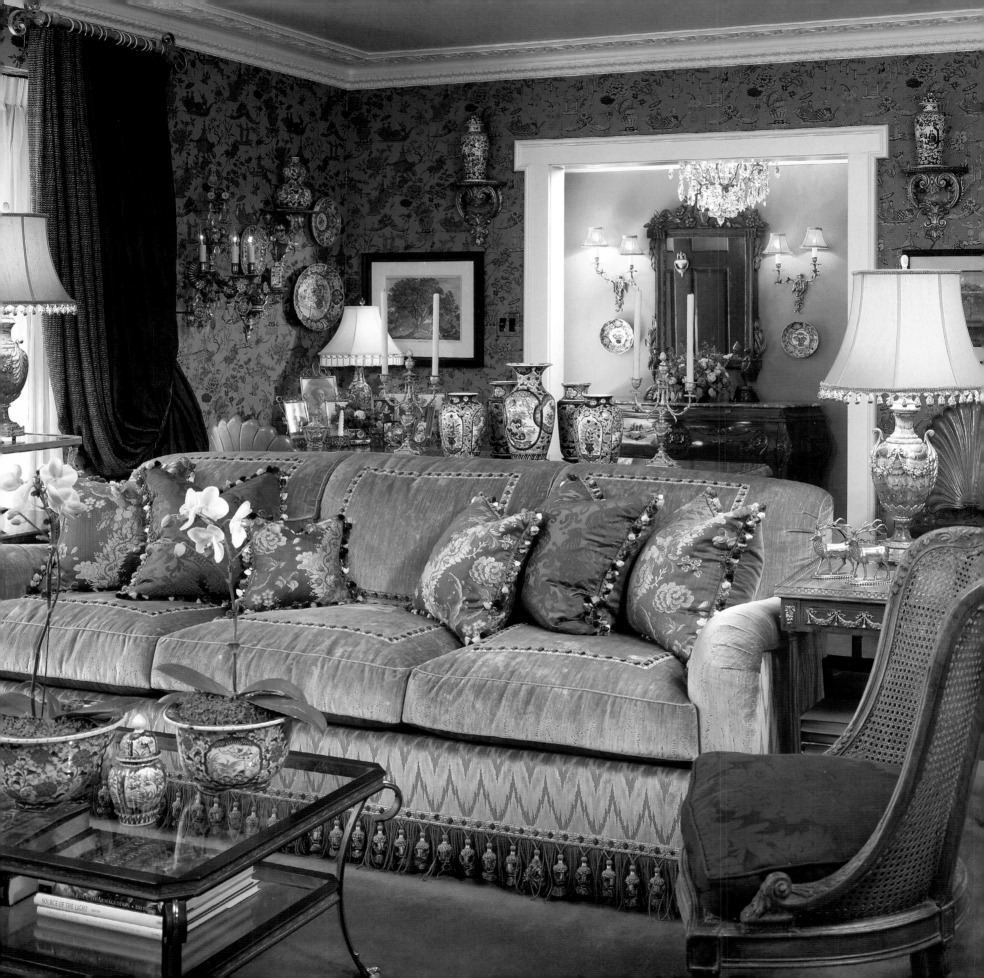

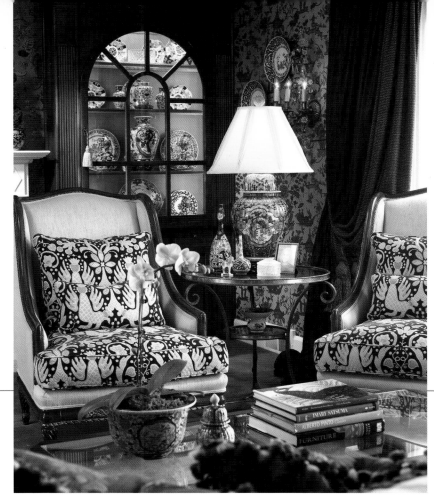

JASON MOORE
JASON MOORE & ASSOCIATES

Jason Moore is truly gifted in the fine art of creating customized environments. The son of a well-known designer, it could be said that he was born into the world of interior design. Before opening his firm in 1994, he worked as a staff designer at his family's furniture store. It was there that he learned about the demands of the design industry, as well as furniture integrity and quality and how to make sensitive yet adventurous decisions for his clients, many of whom continue with his firm today.

Since its inception, Jason Moore & Associates, located in Chicago's Lincoln Park, has overseen projects in Illinois, Florida, Wyoming and the West Indies. Moore has the benefit of drawing inspiration from projects in the Caribbean and the mountain west, and brings the color, warmth and comfort of those diverse settings to his design work. His customers are universally attracted to the accents that remind them of being on vacation without leaving home. Moore's passion for European interiors and antiquities makes his look decidedly eclectic, as he believes classic design styles are better mixed than matched.

Color is essential to Jason's design work and he uses it boldly and unerringly. He has painted ordinary oak cabinets a bright coral, giving them new life and making them an integral part of the room's design. Likewise, he has painted living room walls a nearly shocking, yet elegant chartreuse green

as a backdrop to a client's collection of period furniture and gold picture frames. He is known for adventurous combinations of color and pattern that create lively yet sophisticated environments and pairs that approach with a strong appreciation for traditional design and the understanding of Midwestern sensibilities. The resulting rooms are at once unexpected and reassuring.

Primarily, Jason Moore & Associates focuses on its clients' personal residences, but on occasion they extend their talents into commercial work. Notably, they are currently restoring the clubhouse of a 1920s golf club to its

ABOVE:
A large Imari temple jar lamp is the centerpiece of a corner arrangement with more porcelain displayed in the custom cherry cabinet behind.
Photograph by Tony Soluri

FACING PAGE:
An important collection of Japanese porcelain and antique French furniture guided the design of this opulent yet comfortable living room.
Photograph by Tony Soluri

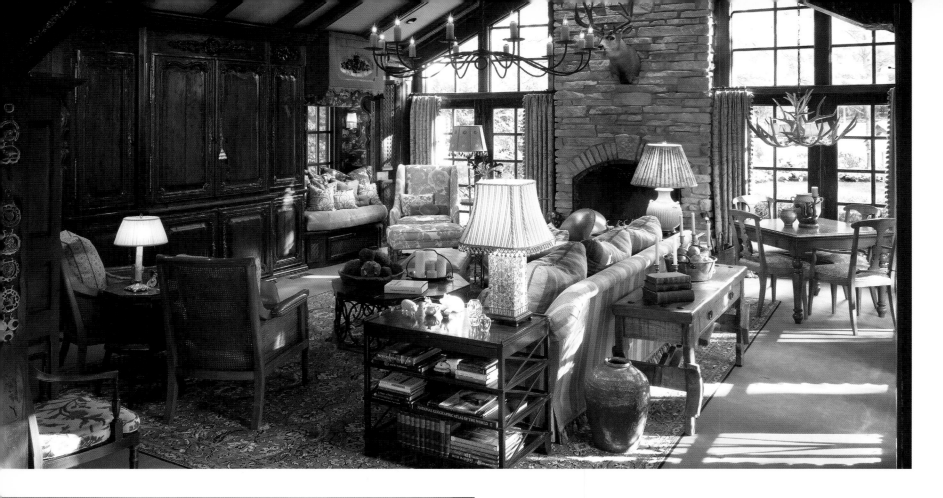

original splendor. Whether he is designing an opulent French living room or a contemporary urban office space, attention to detail and affinity for luxury are Jason's trademarks.

Jason's clients find his guidance and discerning eye invaluable as he guides them through each step of the design process. Jason has maintained the philosophy that all the beautiful furniture in the world does not make a beautiful room. The "bones" of a room must be made beautiful at the very beginning by improving the room's symmetry and structural basics, renovating as necessary and adding architectural details. Jason derives great satisfaction from seeing a client grasp the vision of their home's potential as the elements of his design, planning and foresight come together. Jason values his relationship with his clients. He knows that it is this joint effort that allows his ideas to take shape and transform each space into a uniquely wonderful room.

Q&A
more about jason ...

HOW IS JASON'S PERSONAL RESIDENCE DESIGNED?
Fond of comfortable elegance, Jason describes his Lincoln Park home as a jewel box with lots of antiques, oriental rugs and squishy sofas.

WHEN HE IS NOT DESIGNING, HOW DOES JASON SPEND HIS FREE TIME?
He enjoys preparing French cuisine with a Caribbean flair to entertain friends.

HOW DO CLIENTS AND FRIENDS DESCRIBE HIS PERSONALITY?
They describe Jason's personality as magnetic because he is fun, enthusiastic and very conscious of building lasting relationships. People often tell him, "Oh, I just love you," even if they have not known him for very long.

WHAT DOES HE FIND BENEFICIAL ABOUT MAINTAINING A SMALL DESIGN FIRM?
Clients appreciate Jason's personal involvement in every step of the design process. Since he lives just next door to his office space, he is extremely accessible and likes being able to provide great service.

JASON MOORE & ASSOCIATES
Jason Moore, Allied Member ASID
1901 North Freemont, Suite 2B
Chicago, Illinois 60614
773.755.2027
f: 773.755.2718

ABOVE:
An Italian walnut veneered secretary is filled with a collection of Chinese Blue & White porcelain. An 18th century chinoiserie ink well and a pair of Sevres pitchers decorate the desk top.
Photograph by Tony Soluri

FACING PAGE TOP:
Custom-designed and hand-carved walnut paneling adorn this family room and conceal the entertainment center. Oversized furniture and unique seating options accommodate the clients' many family gatherings.
Photograph by Tony Soluri

FACING PAGE BOTTOM:
The sitting area in this master bedroom invites with the warm glow of antique sconces and table lamps, making this a lovely place for the clients to read.
Photograph by Tony Soluri

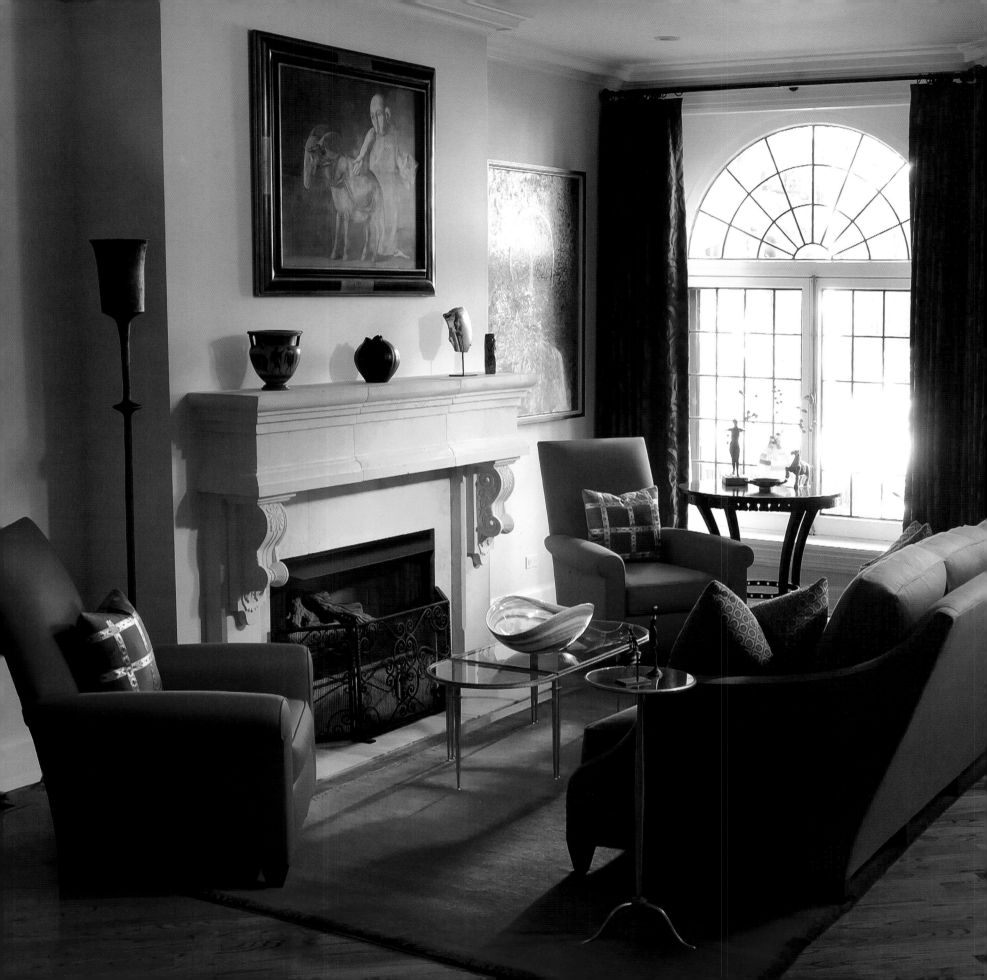

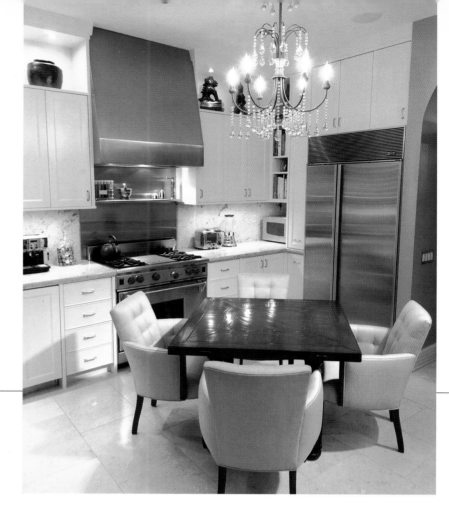

MARY ANN MURPHY
MURPHY DESIGN

Translating fashion trends into the world of interior design has been highly instrumental in the development of Mary Ann Murphy's urban chic style. She reads everything she can find—from old novels to the latest magazines—and always has about 12 inches of ideas stacked on her desk, patiently waiting for their moment in the design spotlight. Each design is completely unique and clients appreciate her readiness to try new things.

Mary Ann enjoys working with new construction but is also fond of renovation projects as she lives in a 120-year-old original Queen Anne home on Chicago's Gold Coast. With services reaching from site selection to implementing the finishing decorative touches, the most exhilarating part of designing interiors is figuring out how to reflect her clients' interests in their homes.

The ability to quickly yet accurately assess a client's personality and design accordingly has become a Murphy Design signature. One of her many specialties, Mary Ann designs exquisite closets with beautiful glass doors, a comfortable dressing area, mahogany cabinets from floor to ceiling, lighted shoe cases, hidden drawers and plenty of storage for seasonal items. Regardless of clients' style preferences, antique mirrors and an elegant chandelier are universally cherished. These sanctuaries have exceeded 10-foot by 20-foot but could be as intimate as transforming an extra bedroom.

After studying at Harrington, she immediately established her own company in 1993 and within her first year was commissioned to design an 8,000-square-foot home's interior. Mary Ann Murphy continues to build lasting relationships with her clients, who often remark, "this feels like me."

MURPHY DESIGN
Mary Ann Murphy
980 North Michigan Avenue,
Suite 1400
Chicago, Illinois 60611
312.214.4909
f: 312.214.4929

ABOVE:
Antique Asian accessories, from Chicago's Golden Triangle, are featured atop custom cabinetry by CJS. A Charles Pollack table and Holly Hunt chairs are illuminated by the elegant chandelier.
Photograph by Paul Doughty, Pkdog Inc.

FACING PAGE:
A vibrant Odegard floor covering and Donghia sofa and chairs call attention to the circa 1940 French coffee table, acquired from Pavilion Antiques in Chicago. Ceiling to floor draperies further enhance the majestic ambiance.
Photograph by Paul Doughty, Pkdog Inc.

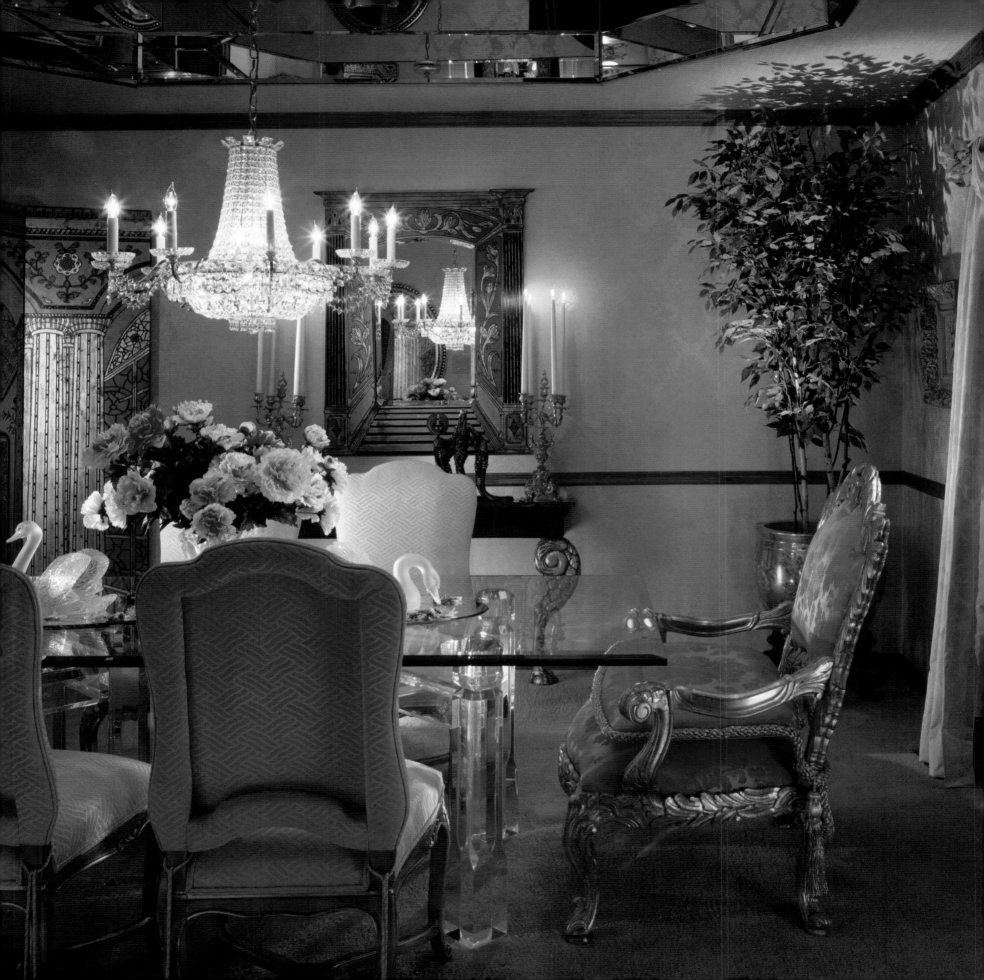

GWEN E. PARDUN

PLUNKETT HOME FURNISHINGS

Patrons of Gwen E. Pardun's interior design through Plunkett Home Furnishings appreciate the convenience of great service and quality home décor in a centralized location. Over the company's 75 successful years in business, Plunkett has expanded to a Missouri location and six Chicagoland stores, the 85,000-square-foot Northbrook flagship of which is home to lead designer Gwen E. Pardun.

Gwen fondly recalls accompanying her grandmother to visit friends in their antique-filled historical homes and being completely enthralled with the interiors. Having studied at The Art Institute of Chicago and then Harper College, Gwen's experience spans over three impressive decades, during which time she has participated in numerous show houses. Her work has been published in several sections of the *Chicago Tribune*, and *Ebony* magazine featured her design for the residence of Connie and the late Walter Payton.

The distinguished designer's own home embodies the essence of her eclectic design style. Gwen's living room features her mother's piano doll atop the antique baby grand, a decorative Asian screen, Salvador Dali artwork, wine colored draperies and an heirloom china breakfront secretary that encases meaningful travel mementos. Just as she surrounds herself with items of personal significance, Gwen works closely with clients to determine "what they're married to," and integrates meaningful belongings in residences.

Over the course of her design career, Gwen has developed the talent of visualization. While she walks around the Plunkett showroom with clients, she graciously presents them with a variety of possibilities and ideas to suit their individual needs. When Gwen becomes familiar with their preferences and plans their home's layout, she is able to picture the space and design in her mind, rearranging furniture and accessories until the perfect solution is attained.

PLUNKETT HOME FURNISHINGS
Gwen E. Pardun, Allied Member ASID
885 Sunset Ridge Road
Northbrook, Illinois 60062
847.714.1000
c: 847.946.8797
f: 847.714.1001
www.plunkettfurniture.com

FACING PAGE:
In this elegant dining room light cascades down from a mirrored octagon ceiling through a Strauss crystal chandelier down to a glass column table flanked by a gold leaf host and hostess chairs in rose damask.
Photograph by Hedrich Blessing

ABOVE:
This living room features a beautiful Marge Carson tasseled sofa in a light sage green bouclé with pillows in iridescent salmon and paisley that anchor an Erte picture, a gold and silver LaBarge cocktail table, and French chairs with touches of gold leaf.
Photograph by Gary Gnidovic

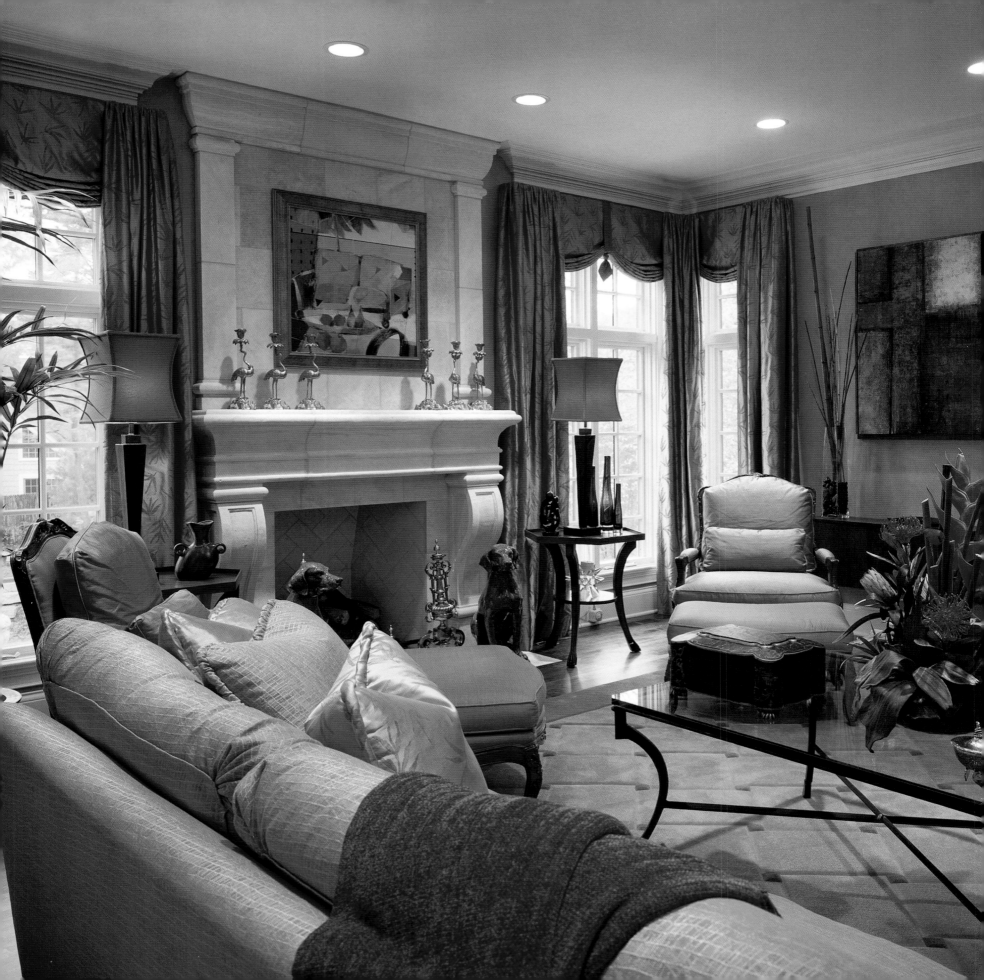

JOHN PAUL REGAS

J.P. REGAS & ASSOCIATES

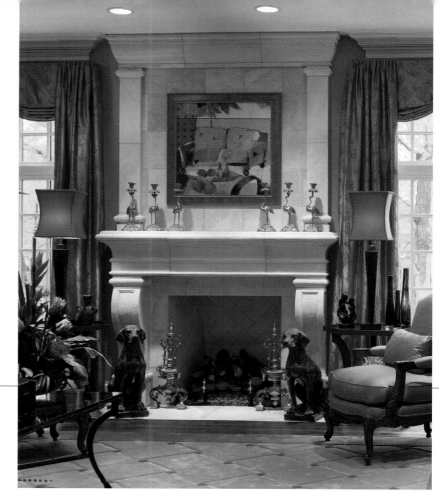

With over 40 years of interior design experience, John Paul Regas's creative services encompass conceptual drawings, detailing, lighting, landscape and interior design. J.P. Regas & Associates is known for grand traditional and first-class period homes, but the company's comprehensive portfolio also includes institutional and contemporary styling.

Impressively, John Regas has never needed a business card. Right out of high school, he opened an antique shop on Clark Street and has never had a slow day. John studied at The Art Institute, but credits his greatest source of knowledge to his first clients, Mrs. Wertz-Haney and Mrs. Faye Levinson, and the many other friendships which he has developed along the way.

John surrounds himself with great clients and team members, including his invaluable design assistant Marcus Nunemacher. Everyone at J.P. Regas & Associates has a positive attitude and works hard to accomplish the many tasks of each project. John has a company philosophy of bringing design to as many places as possible, so the team was excited to design a boat. Shiny mahogany, large columns and exquisite drapery framed the amazing space, and the perfectionist client loved the magnificently upscale floating apartment that felt like an old east coast yacht.

With a firm belief that each house has a soul which simply cannot be captured on a computer, John provides conceptual drawings and contracts architects to finalize the structural details. The experience of working closely with architects for so many years, has heightened his ability to sketch concepts from structure to landscaping, lighting, and of course interior space planning.

ABOVE & FACING PAGE:
Rich fabrics in shades of spice and cinnabar and inviting furnishings make this North Shore family room a perfect spot to enjoy a warm fire in a cold, Midwestern winter evening. Fabrics by Bergamo and Donghia; cocktail table by Sarreid; custom area rug by Fabrica; lounge chairs and ottoman by Hickory White.
Photograph by Scott Shigley

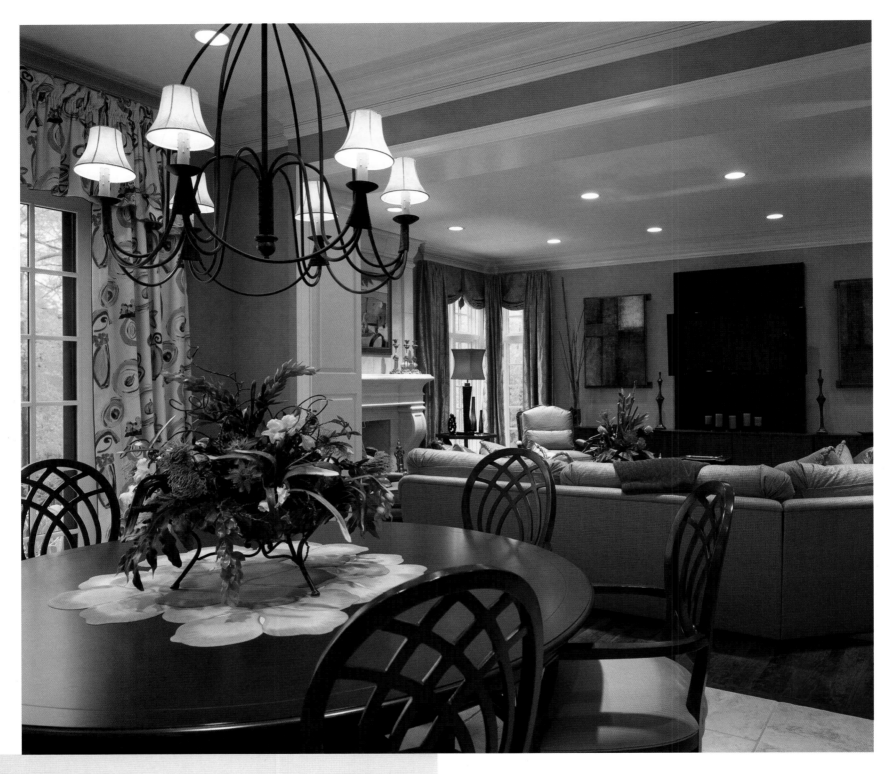

ABOVE:
This Glencoe kitchen/family room is designed in an open concept, great for both quality family time and entertaining friends. Kitchen window treatment fabric by Kravet; floral arrangement by J.P. Regas & Associates.
Photograph by Scott Shigley

FACING PAGE:
The client's family heirloom pieces were refinished and reupholstered in warm tones of cinnabar and accents of gold to create this formal library. Drapery fabric by Kravet.
Photograph by Scott Shigley

Interior design is not easy, with unreliable vendors and a million details to remember, but John appreciates each experience. For a project in New York, John arranged for 5th Avenue to be closed for an hour and a half while a custom staircase was craned up the side of a building. John's vision of the ribbon-like staircase meant that it could not be built on site, but rather than compromising his design, John organized the involved delivery and installation.

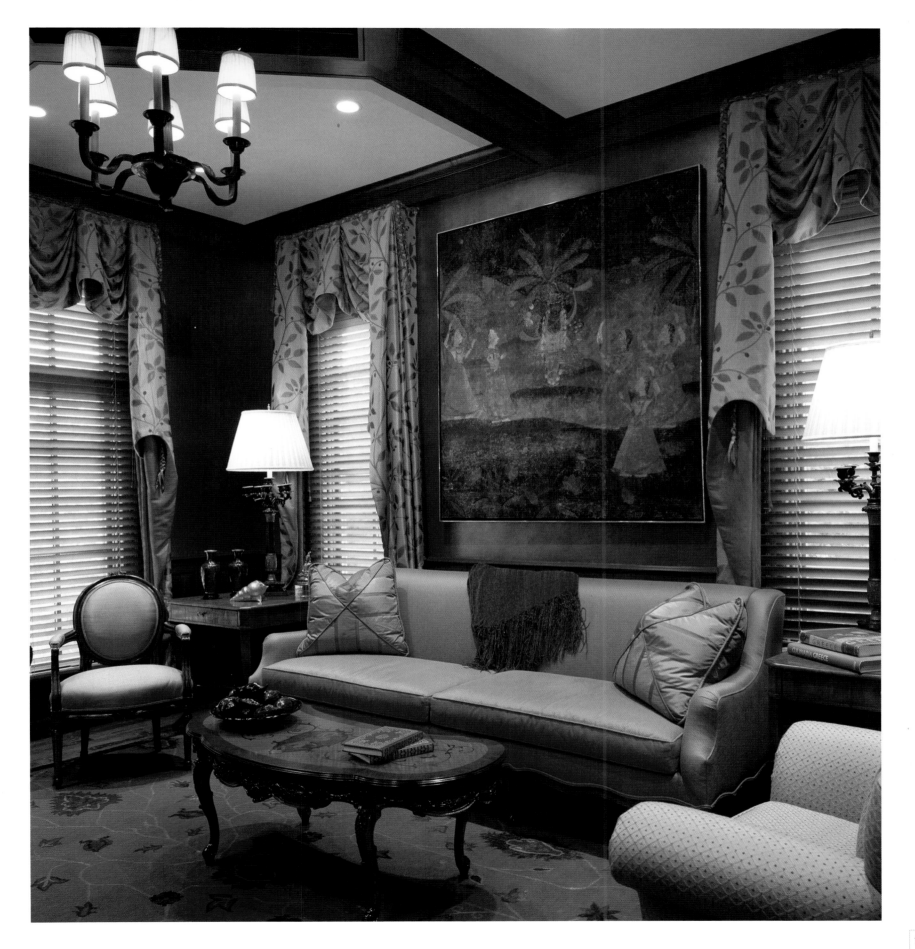

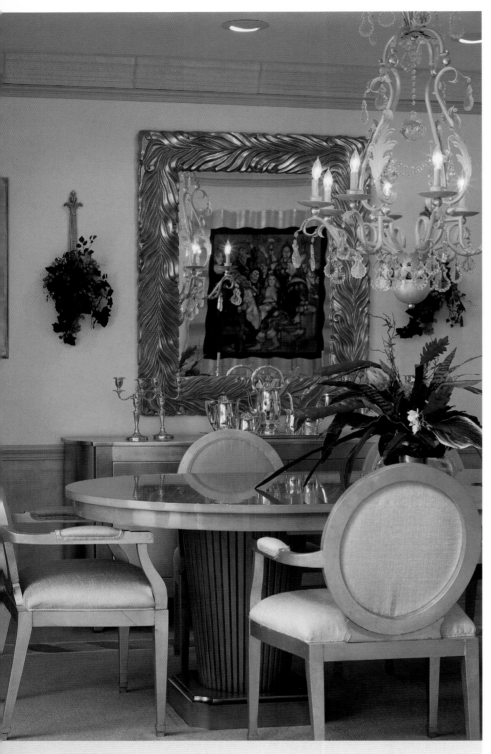

When confronted with an unrealistic request, John embraces the challenge. For design inspiration, John takes walks each day; without interruptions, he can visualize and dream. John imagines himself living as his clients so that he can meet their individual design needs. The most meaningful compliment that John has received came from a client who said, "you took us on a journey and we came to a great place." John is a great listener and an expert at refining clients' style by organizing their tastes and presenting them in reflective settings.

He formerly owned a 16,000-square-foot David Adler home, which nicely reflected his own design preferences and passions. Twice each day, tour groups stopped to admire the impressive structure, one of only 18 remaining homes of the original 54 in the Chicago area. The home—which John admired as a child but never dreamed of owning—boasted 14 luxurious baths and 11 fireplaces. John spent many years restoring the French-style home to its original splendor and proudly sold the home only because he felt that it needed a family and he needed a new renovation project.

Actively involved in the community, John hosted scores of glamorous charity events during the time that he owned the historically significant Adler mansion. The charity events were often limited to only 200 lucky invitees, but 400-person turnouts proved to be uncommon. Born to Greek parents, he generously gives of his time and talent to the Hellenic Museum and Cultural Center, the nation's first museum dedicated to preserving Greek immigrants' experiences. Additionally, John works with the Service Club and promotes various Alzheimer affairs, through elaborate galas with an exceptional guest list.

ABOVE:
This opulent, contemporary Deerfield dining room is resplendent in neutral fabrics and soft silver leaf finishes. Dining table by William Switzer and chairs by J. Robert Scott.
Photograph by Scott Shigley

FACING PAGE:
The original Jamali above the lounge chair is a striking addition to this luxurious master suite. Spread and pillow fabric by Barbara Beckman.
Photograph by Scott Shigley

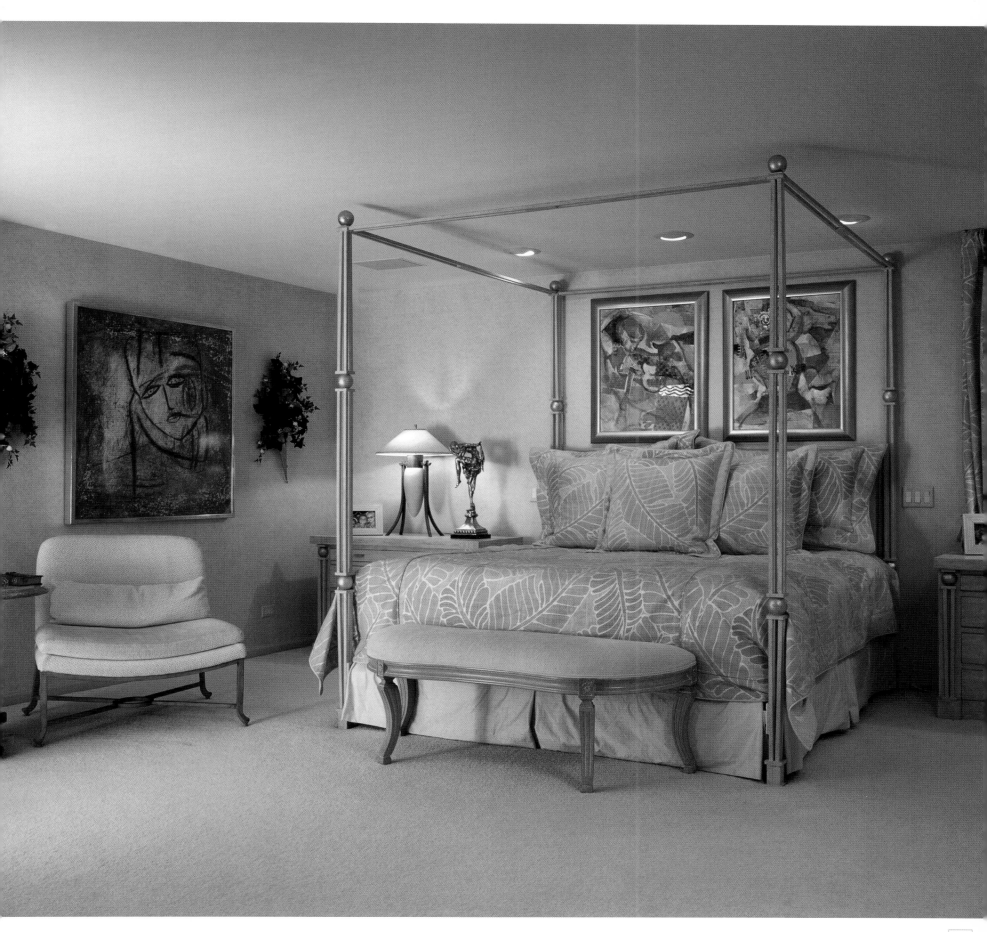

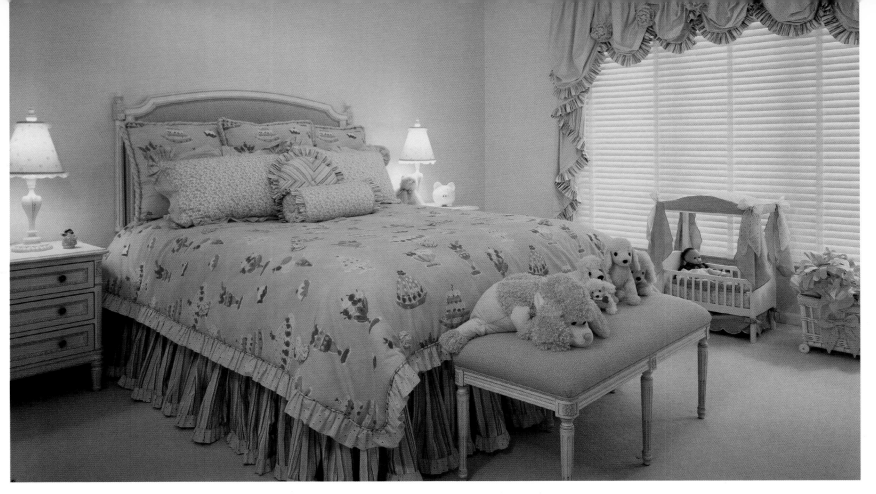

John is a very likeable person, adored by his diverse clientele. One woman commented about John's sixth sense: He can create beauty out of anything. The accomplished designer sees things that other people cannot even imagine, consistently raising the client's level of awareness and appreciation to new heights.

John Regas embraces change because otherwise, life is boring. Nothing is more rewarding for John than seeing the finished product of his creative labors. John sincerely believes in the young and focuses a great deal of time and energy in mentoring budding designers. He truly lives by an ancient Greek philosophy that you have to make something better each day, so that by the end of your life, you can say that you have lived to the fullest.

FACING PAGE TOP:
Osborne and Little's Sundae Best fabric was used as the foundation for the décor of this little girl's room fit for a princess. Furniture by Louis Solomon.
Photograph by Scott Shigley

FACING PAGE BOTTOM:
What young girl wouldn't like to have a sleep over with her best friend in this room? Combination of fabrics by Schumacher, Scalamandré and Manuel Canovas.
Photograph by Scott Shigley

Q&A
more about john ...

WHAT SEPARATES JOHN FROM HIS COMPETITION?
He is not competitive. Clients come to John because they admire his work and he accepts projects based on the potential for a great working relationship. If clients are open to good change, then things will go smoothly.

HOW DO JOHN'S FRIENDS DESCRIBE HIM?
Anyone who knows John would convey that he is a great friend who would help anyone in need. John is an upbeat, positive person who enjoys building meaningful friendships.

WHAT COLORS BEST DESCRIBE HIM?
He loves turquoise and cinnabar colors because they are reminiscent of warm memories. John appreciates clean colors that have not been grayed down.

WHAT ARCHITECTURAL ELEMENT WOULD JOHN ELIMINATE FROM THE WORLD?
John is not crazy about bi-level homes because the whole idea is confusing to the eye and the flow never seems to work quite right.

WHO IS HIS FAVORITE ARTIST?
John loves the work of Florida sculptress Kathy Spalding. His Spalding piece features a beautiful, large angel who romantically looks down to a koi pond. John likes the intricate detail of each tiny feather and admires Kathy for her creativity.

J.P. REGAS & ASSOCIATES
John Paul Regas, ASID
1133 West Van Buren Street
Chicago, Illinois 60607
312.829.0400
f: 312.573.9777

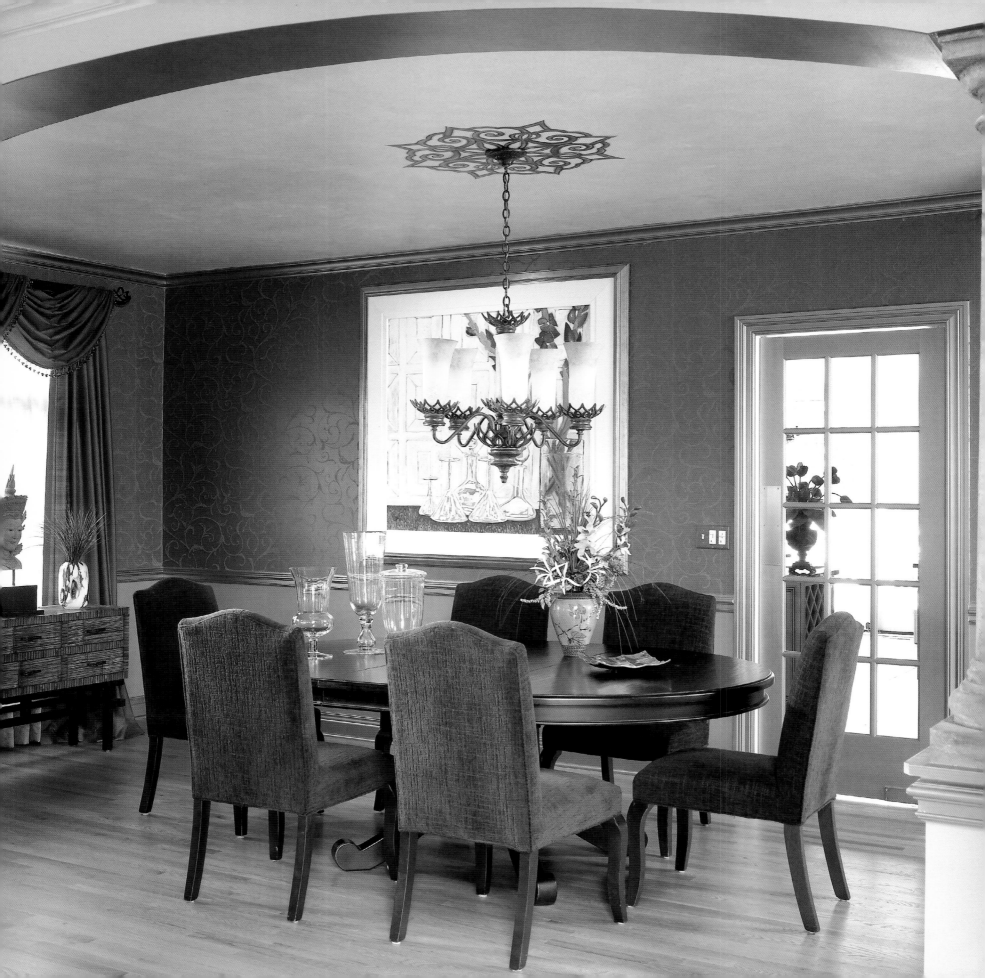

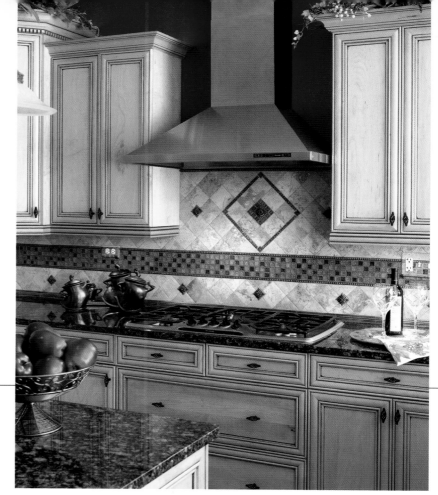

MICHELE REICHL

INSIDE DESIGN INC.

"Jazzing things up," is Michele Reichl's specialty. She appreciates the challenge of combining a variety of styles from traditional to contemporary in her designs. Clients recognize the ease with which she draws out their hopes, ideas, and personality to implement creative ideas in their homes.

Interested in design since an early age, Michele's passion continued to flourish through the encouragement of her parents, and she ultimately earned a degree in housing and became a professionally certified member of NCIDQ.

With a client-centered approach, Michele harmoniously employs the characteristics of a room—the warmth of hardwood floors, look of aged leather, reflection of metal, feel of suede, or finished detailing of crown moulding—to tell each client's personal story. Since Michele feels that the essence of her designs comes from the evolving relationship between client, space and designer, she listens with the intensity of a close friend and picks up on the smallest nuances to fully capture her clients' spirit.

Inside Design offers a full range of services from designing new spaces to updating existing interiors through customized furniture, lighting, accessorizing and solving decorating dilemmas. She frequently refers to her time in London and Paris for architectural and design inspiration. Clients esteem Michele for her delightful personality, mélange of life experiences and belief that anything is possible.

INSIDE DESIGN INC.
Michele Reichl, ASID
1150 Valley View Drive
Downers Grove, Illinois 60516
630.515.9311
f: 630.515.9313
www.insidedesigninc.com

ABOVE:
This unique kitchen design consists of a jeweled, glass tile covered backsplash that creates a distinctive environment with a mixture of metal and a high polished travertine finish.
Photograph by Tony Soluri

FACING PAGE:
This traditional dining room is lent a modern flair through the unique color combination of coppers, teals and violets features. A hand painted medallion emphasizes the chandelier and then, the wallpaper and drapery bring this room together as a whole.
Photograph by Tony Soluri

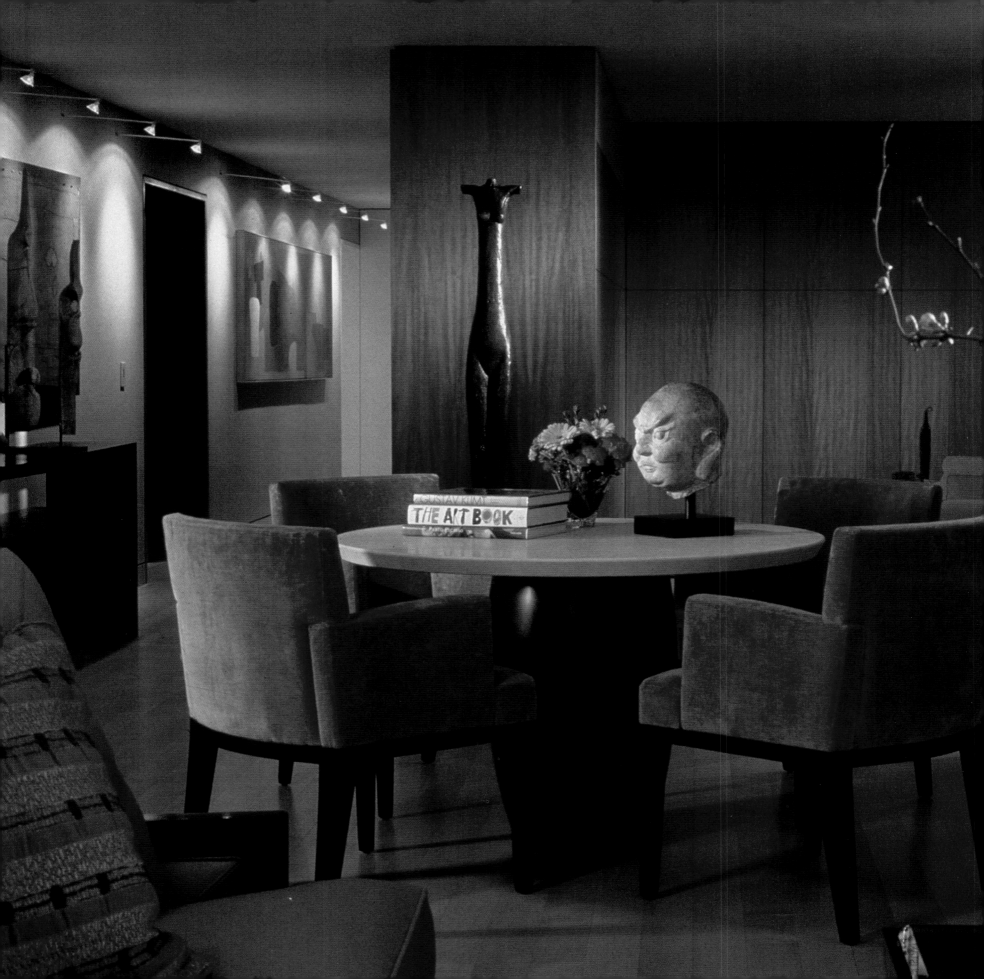

RICHAR

RICHAR INTERIORS, INC.

A native of Canada, Richar never expected to be living in Chicago, but the city truly echoes his vibrant personality and sense of style. Richar envies anyone who can curl up to a good book for relaxation, because his mind runs a million miles a minute. He lives and breathes creativity.

Richar is the recipient of numerous awards from prestigious organizations, but the highest compliments come from colleagues and return clients. Richar advocates the value of a classical education, but feels strongly that "you can't learn to act without a stage." Once the fundamental elements of design have been learned, the creative process requires intuition, which can be perfected only through constant contact with new situations. A self-taught designer, Richar entered the industry in an untraditional fashion, assisting renowned designer Bruce Gregga for four years prior to establishing Richar Interiors in 1982. He also worked with James Callahan who introduced him to Chicago through recurring business trips to the area.

Richar enjoys traveling to gain a greater appreciation for the many flavors of international design. He especially takes pleasure in transforming found objects into creative works of art. Richar feels that adaptive repurposing of such objects gives a home a personal and collected touch.

He emphasizes the importance of accessorizing, because some people spend millions of dollars on their homes and then overlook the final details that could really make a "wow" statement. Richar's philosophy is: "Live well ... surround yourself with beautiful things. Art and object d'art are food for the soul."

A client meeting with Richar for the first time will be pleased to know that Richar has a small but extremely talented staff and personally directs the design process. Richar is very hands-on in every aspect of the process. Clients applaud Richar Interiors for smooth and efficient project management. While he works all over the country, Richar is especially fond of designing

ABOVE:
Eclectic dining room in a Gold Coast highrise.
Photograph by Tony Soluri

FACING PAGE:
Contemporary game area in a Gold Coast duplex.
Photograph by Tony Soluri

in Chicago because of its eclectic nature and resource availability. Richar is an approachable designer who takes great joy in listening to his clients and engaging in a partnership to create dramatic spaces which truly reflect their lifestyle. Richar feels that a successful project is the result of a collaborative effort between the client, designer, architect and builder.

Richar suggests that to select an interior designer, it is wise to choose someone based on talent, not necessarily for their particular style. He finds that his most original work results from situations in which he has never been placed. Richar was once commissioned to design an entire home with a South African theme. Although he had never experienced South African culture, Richar leapt out of the box and created something spectacular. Richar is particularly inspired by challenging projects such as small spaces and projects he has not previously navigated.

One of the most interesting designs in Richar's comprehensive portfolio is a private jet. He started with the FAA fire codes to establish appropriate materials which would also lend themselves to the client's aesthetics. Black is among Richar's favorite colors to work with, so he selected a custom black carpet with a unique design offset by taupe leather upholstery. Black plexi-glass walls were used at each end of the cabin to create the illusion of a larger space. The result was a sleek area, inside and out, conducive to relaxation.

Another exciting project involved a 26,000-square-foot home on the upper peninsula of Marquette, Michigan. Granot Loma was featured in a 1995 issue of *Architectural Digest* for Richar's fabulous work, which encompassed complete design and restoration to accentuate the space's historical character.

ABOVE:
Contemporary Asian influence in a River West penthouse surrounded by Japanese Terrace Gardens.
Photograph by Trends Publishing International, architect/designer, Perkins & Wills
Photograph by John Umberger

FACING PAGE TOP:
Tailored contemporary master suite in a Lincoln Park residence.
Photograph by Francois Robert, Michigan City, Indiana

FACING PAGE BOTTOM:
Contemporary great room in Lincoln Park residence.
Photograph by Francois Robert, Michigan City, Indiana

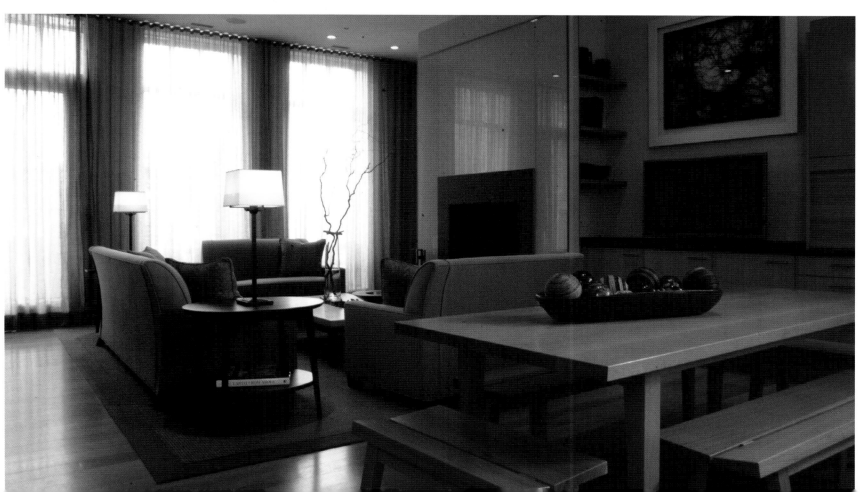

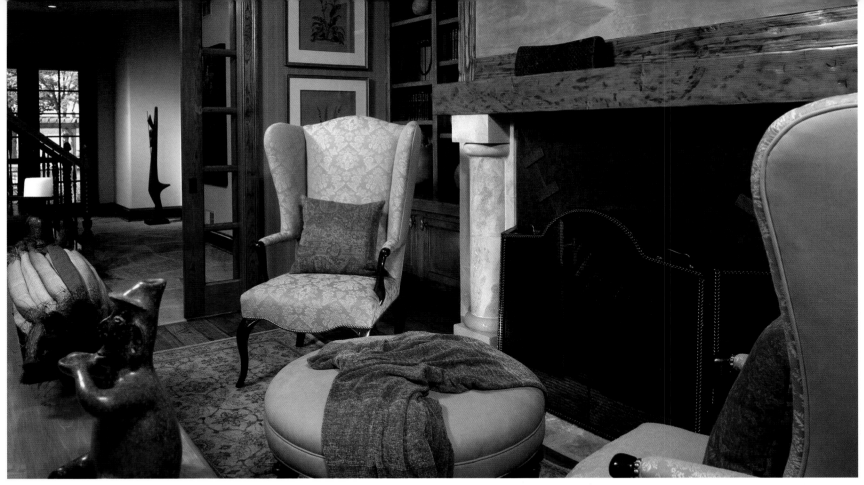

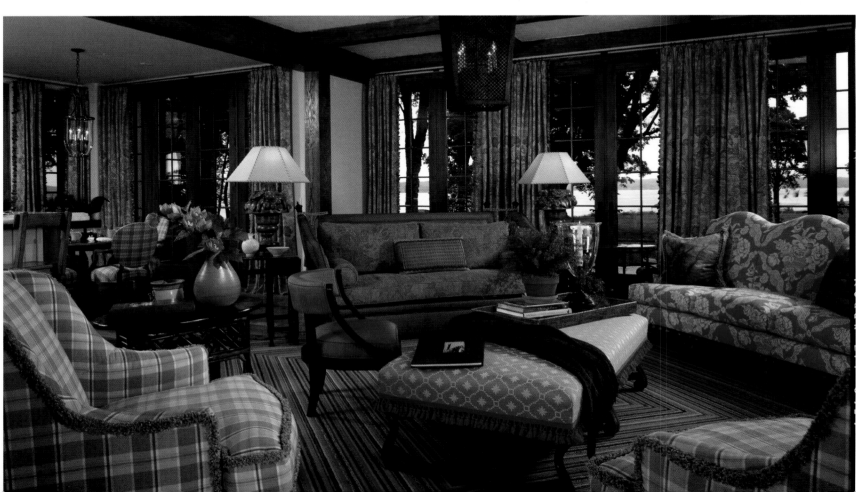

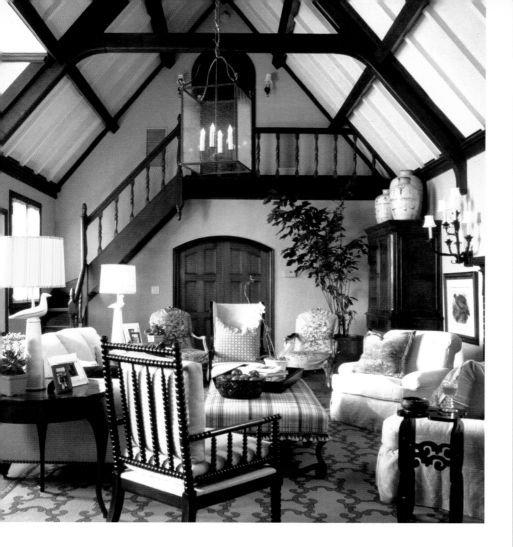

ON WHICH PERSONAL INDULGENCES DOES RICHAR SPEND THE MOST MONEY?

Art, object d'art, watches and vintage automobiles.

WHAT SINGLE THING WOULD RICHAR DO TO BRING A DULL HOUSE TO LIFE?

A bucket of paint is a safe choice that goes a long way. If the architectural elements are dull, paint can oftentimes compensate for the lack of interest.

YOU WOULDN'T KNOW IT, BUT RICHAR'S FRIENDS WOULD TELL YOU...

He is a child at heart who loves to clown around and be real with people. Richar is very down to earth and considers himself a regular guy, but everyone agrees that although he might be an ordinary guy, Richar has a sense of style which exceeds extraordinary.

WHAT ARCHITECTURAL ELEMENTS OR BUILDING TECHNIQUE WOULD HE ELIMINATE FROM THE WORLD?

Low ceilings and faux materials. Richar feels that well-made materials add incalculably to the space's atmosphere.

He jokes with friends about creating a reality show entitled "Constructive Criticism," in which the Richar Team would politely show up at the door of unsuspecting homeowners and offer polite suggestions for creating a lovelier atmosphere. The goal of this experiment would be to simply make the world a little bit more beautiful.

Upon entering any room designed by Richar, the viewer is overcome with a sense of warmth, richness and quality. Although Richar's portfolio is quite diverse, encompassing styles from classical to contemporary and eclectic, each of his works is uniform in the high-class result and breathtaking ambience.

ABOVE:
Traditional Country French living room in a Lake Forest home.
Photograph by Unknown as in the Chicago Tribune House and Garden feature

FACING PAGE TOP:
Traditional library in Lake Geneva, Wisconsin.
Photograph by Francois Robert, Michigan City, Indiana

FACING PAGE BOTTOM:
Traditional great room in Lake Geneva, Wisconsin.
Photograph by Francois Robert, Michigan City, Indiana

RICHAR INTERIORS, INC.
Richar, IIDA
1327 West Washington, Unit 106
Chicago, Illinois 60607
312.455.0924
www.richarinteriors.com

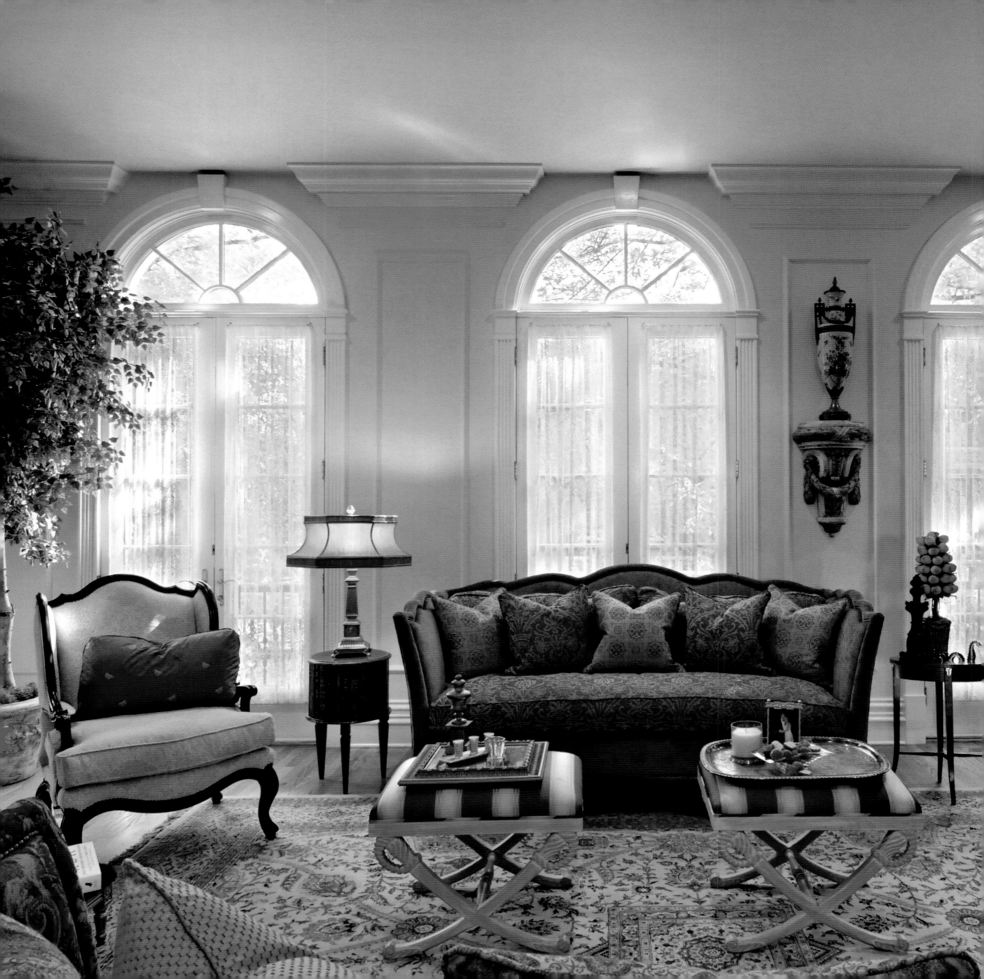

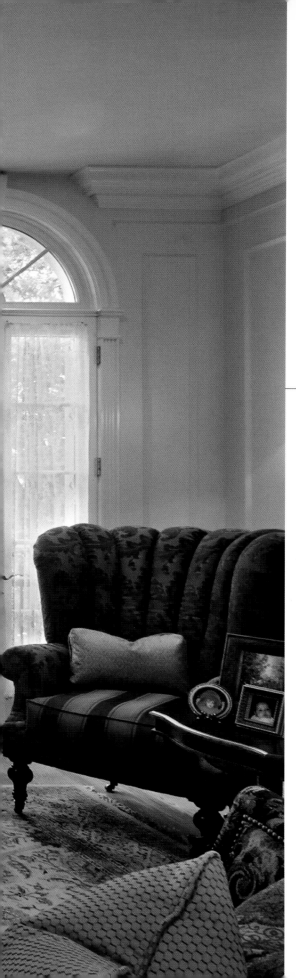

VAN H. ROBINSON

DESIGN DECISION LTD.

It started with Lego sets at the age of five. Van Robinson fondly recalls childhood memories of creating houses from building blocks and rearranging the furniture of his mother's living room. Van was truly born to be an interior designer.

A self-made man, Van's entrepreneurship began with a business of training and showing high-powered Arabian and American Saddlebred horses. Van's father would have preferred to pass down the family trucking business, but was able to appreciate the free spirit which he saw in his 18-year-old son.

Out of aesthetic necessity, his work with horses evolved into designing sitting areas for his clients at the professional shows. Each client rented several 12-foot by 12-foot stalls and Van conducted the teardown of the stall walls to form large spaces conducive to entertaining. Draperies were hung, plants and furniture rented, lighting installed and parties planned. For the National Championships one year, Van brought in a pianist to perform on the grand piano each evening. Clients who annually spent thousands of dollars to keep a horse required accommodations equal to the comfort of their upscale homes. This high-quality atmosphere was established in only one or two days, enjoyed for a week and disassembled for transfer to a new location.

LEFT:
This living room defines eclectic with the use of Old World detailing in the mouldings, new furniture mixed with antiques and multiple fabrics to create an overall feeling of opulence.
Photograph by Robert Harshman

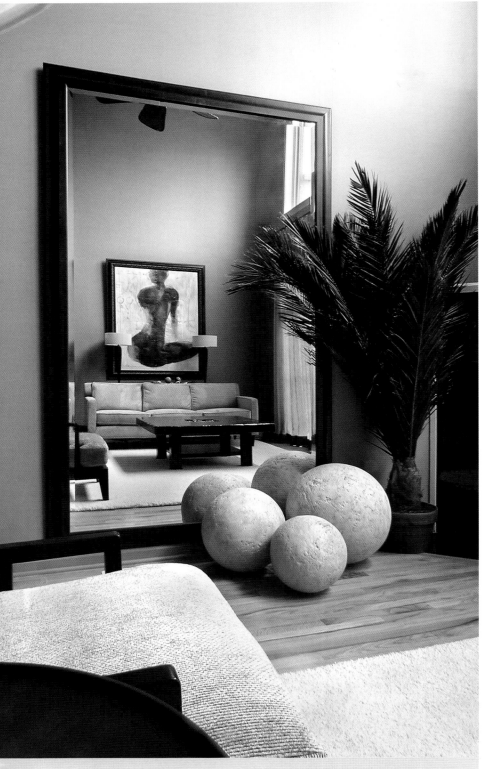

After producing 28 shows per year for 25 years, Van sold his Colorado farm and transitioned to interior design on the Chicago scene, which he values for its diverse architecture and clientele. Van Robinson has made quite a name for himself in the industry, primarily for his creative project management and uncompromising work ethic. A self-taught designer, Van has grown immensely through client feedback; he is an excellent listener with remarkable communication skills.

Van's transitional style combines texture, rich color and "a whole ton of whimsy." He has an adage that with our nomadic society, furniture should be carefully selected with long-term utility in mind. Hence, he rarely designs custom-sized furniture for a specific room. Instead, Van prefers to lighten a serious space with small accessories. An upscale living room in Lincoln Park was given a fun twist with a Loch Ness monster figurine; quite the conversation piece.

The accomplished designer can impart good taste to his clients, but he feels that it should not be an exact replica of his personal preference. Van's goal is to translate his clients' lifestyle to their living spaces.

Van's home features a 1920's style Art Deco room, which offers Van a sanctuary for relaxation, reminiscing and entertainment. The walls are dark chocolate, accentuated by silver leaf walls, ceiling and crown moulding. Van designed a three-inch stripe of cobalt blue applied just below the crown, followed by an additional piece of moulding to create a vintage European club feel. Rich draperies of sheer, gold, crushed silk juxtaposed underneath raw burlap give this room a warm feeling. The walls are covered with trophies, photographs and other mementos from his days of showing horses.

Not only is Van an accomplished horse showman and designer, but he is an excellent chef who loves to entertain. Uninspired by his family meals while growing up, Van learned to cook out of self-defense and finds joy in preparing dinner six nights a week to share with his life partner Glenn Lezon. The seventh evening is always reserved for their date night. Glenn manages Design Decision Ltd.'s records in addition to his finance career. Van expounds: "We make such a great team because I'm decorative and he's useful."

ABOVE:
"Zen-like" best describes this living room. The use of an over scaled mirror and unique accessories along with simple, clean lines complete the contemporary, modern feel.
Photograph by Robert Harshman

FACING PAGE:
A master bedroom has to be defined in fabrics and luxury. This is evident here with the use of Venetian plaster walls combined with antiques, rich texture and amazing lighting.
Photograph by Robert Harshman

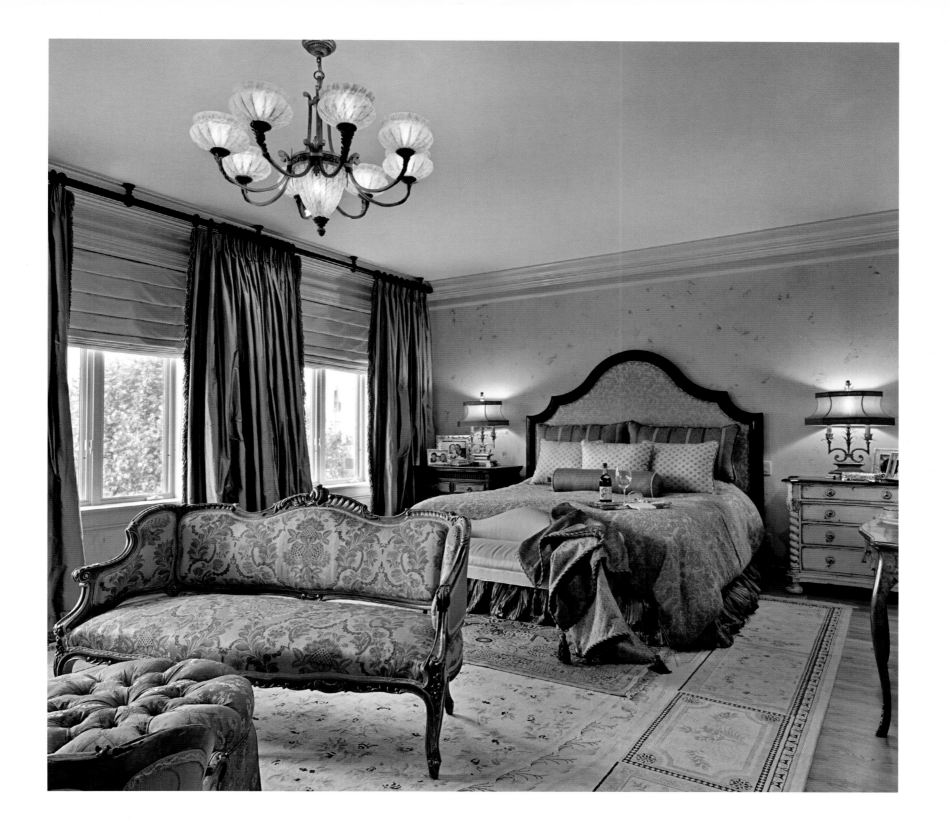

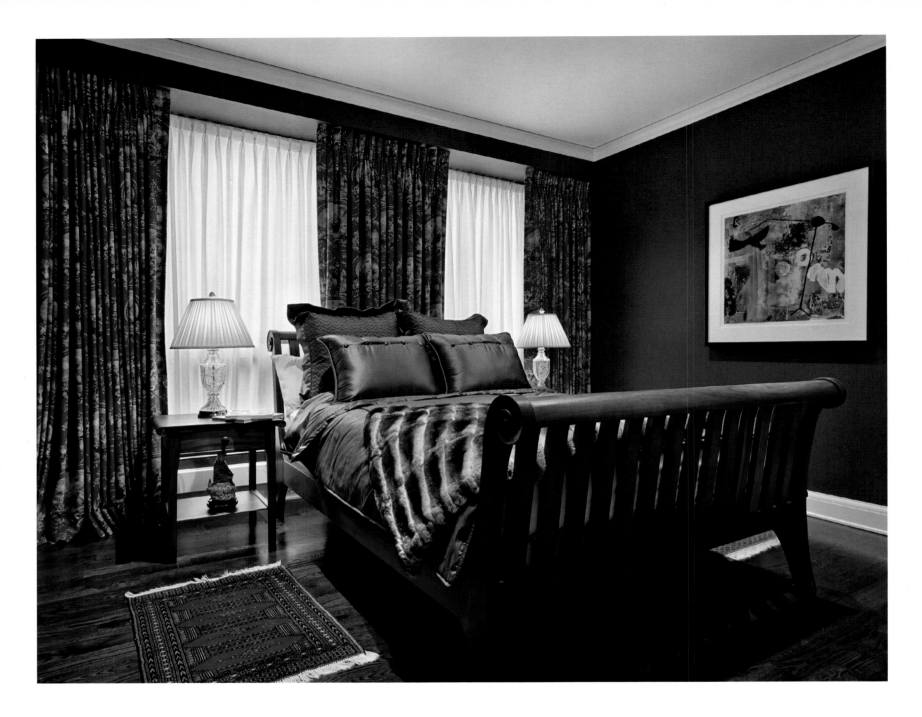

Christmas is Van's favorite holiday for which to decorate. His suburban Denver upbringing is preserved with an attention-getting, nine-foot tall tree. The tree exhibits over 2,000 carefully placed ornaments, some of which were his grandmother's from the 1920s and '30s. The eclectic tree displays fresh eucalyptus and roses and is brought to life with warm colored lights. The project takes Van about 16 hours to complete and is the center of attention at his annual cocktail party. Invitations are coveted as the guest list is ever growing and changing.

He enjoys entertaining and designing because both situations bring people together; Van appreciates diversity and the life experiences which make each of us unique and beautiful. Instilled from birth with an entrepreneurial spirit, Van Robinson is a jack of all trades.

Q&A
more about van ...

WHAT DO CLIENTS SAY ABOUT VAN?

He is their "secret weapon." Van's creative techniques yield spectacular results. He does not hesitate to use 15-20 different fabrics in a room.

ON WHICH PERSONAL INDULGENCES DOES VAN SPEND THE MOST MONEY?

Van is an art enthusiast. He collects vintage prints and artwork, which feature horses, women's riding apparel or Italian Greyhounds. Since Van has shown Italian Greyhounds and has a love for horses, he values a pair of working sketches by renowned artist George Ford Morris. Another favorite is an 1871 print by Godey; it features a group of women sitting sidesaddle on horses, surrounded by children and an Italian Greyhound. This print hangs over Van's whirlpool tub where he loves to spend time reading a good book, like Anne Rice's *Out of Egypt* or *The Historian* by Elizabeth Kostova.

WHAT IS VAN'S IDEAL WINDOW TREATMENT?

Something that feels like it is part of the room. The most successful window treatments utilize contemporary treatment of traditional fabrics. Many of Van's clients are young professionals who are often intimidated by drapery. He agrees that, "nobody wants window treatments that look like their Great Aunt Mabel's," but encourages them that great window treatments can turn an okay room into something sensational.

HOW DID VAN DESIGN HIS FIVE-FOOT BY FIVE-FOOT POWDER ROOM?

Fire engine red on two walls, opposite red satin fabric finished in box pleats. Van loves the "jewelry box" feel created by 10-inch crown moulding, which pulls the high ceiling down to a more intimate level. A vintage architectural column houses a table lamp to create additional warmth. The ceiling boasts textured tin which has been gold-leafed and then antiqued to feature a fabulous chandelier.

DESIGN DECISION LTD.
Van H. Robinson
1716-F East 54th Street
Chicago, Illinois 60615
773.484.5921
www.designdecisionltd.com

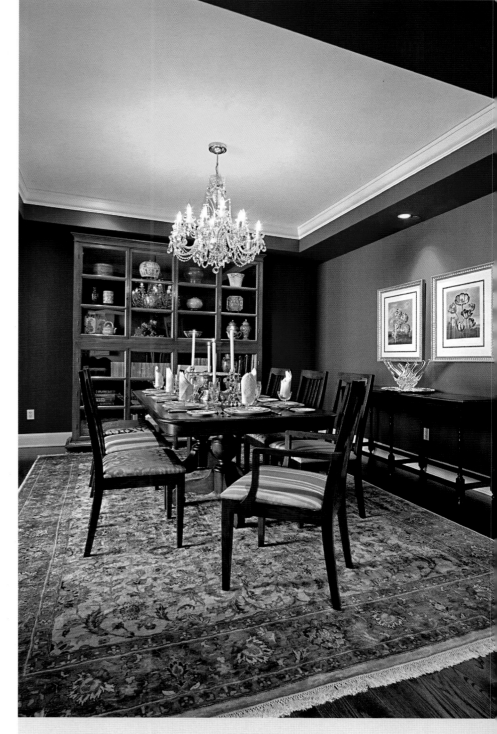

FACING PAGE:
The brilliant selection of color, texture and opulence makes this room the perfect getaway for clients and guests alike. Designer Van Robinson feels that everyone should have the luxury of wrapping up in a chinchilla throw.
Photograph by Robert Harshman

ABOVE:
Representative of the life experiences that each guest brings to the table, a different fabric is used on each of the eight chairs in this inviting dining room. A combination of elements—from long-cherished to newly selected in finishes from crystal to wood—adds to the intimacy of this lakefront condo's entertainment space.
Photograph by Robert Harshman

SANDRA SALTZMAN

SANDRA SALTZMAN INTERIORS

A mélange of different periods and styles, Sandra Saltzman's designs speak for themselves. Though projects are catered to the needs and preferences of her clients, Sandra is known for exquisite furnishings, art selection, conceptualization and understanding of scale and perspective.

With a design career spanning over two decades, she initially worked with several major design firms and then built a sizeable company for herself. Sandra's personal approach is well-suited for the intimate setting of her design atelier, which allows maximum creative freedom, located on Astor Street, a National Historic Landmark.

Light and water are among the accomplished designer's favorite colors; the color of light represents a plethora of hues while the visual serenity of water creates space and provides a soothing ambience. Since she personally finds comfort in design derived from natural elements, this theory is often translated into her clients' environments.

Uniquely, Sandra possesses color memory, meaning that she can see a color and retain a vivid recollection of it for days. This intrinsic talent is particularly beneficial when she is researching design options for clients. She believes color to be extremely important because of its prevalence in all facets of design: walls, textiles, wood stain, stone and accessories.

Historical reference is ubiquitous in her designs due to a remarkable background in anthropology, archaeology and art history. Sandra's personal collection of art runs the gamete from antiquities to modernism in various mediums. Clients appreciate her intellectualized approach because they know that she thinks through each element and does not employ randomness. Each object is selected for a purpose and she expertly combines antiquities with modern pieces to create beautiful spaces.

ABOVE:
A large Khmer gray sandstone Guardian Head 12th century B.C., Angkor Thom, Bayon Dynasty, is featured beside a Christian Liagre library that displays objects d'art from the client's private collection.
Photograph by Brian Briggs

FACING PAGE:
A sweeping view over the pool and deck through to the historic J. Wyman Jones house circa 1858 is further complemented by the suite of custom Michael Taylor chaise lounges, textiles by Perennials.
Photograph by Brian Briggs

The company has been working globally for the better part of its existence, as Sandra has worked extensively in Chicago and throughout North America, Europe, Asia and Australia. She relies heavily on cultural details and historical fact to substantiate her creative process and elucidates that there are no parameters which she does not find interesting. Involved in a wide array of projects from single rooms to spaces exceeding 15,000-square-feet, size is not a criterion for accepting design commissions. Rather, she focuses on what she can achieve for each client.

Knowing that she has the ability to enhance lives through her profession is the most rewarding aspect of being an interior designer. A memorable project involved the complete space renovation for a housebound client, who needed to remain at the location throughout the entire remodel. While many designers turned down the difficult project, Sandra embraced the challenge and brought comfort and sensibility to the client's life through beautiful imaging. The grateful admirer conveyed feelings to Sandra: "You changed my life."

TOP:
Custom Orkney chairs from Richard Mulligan and Sabi benches from Jiun Ho flank the client's 10-foot dining room table, which invites friends and family to gather in the pool house. Ambient lighting is further created through an exquisite Kevin Riley chandelier. All textiles are by Perennials.
Photograph by Brian Briggs

BOTTOM:
The second in a pair of Guardian Head sculptures is presented between Dennis & Leen Porter chairs in the great house living room. The view, enfilade, continues through to the grand entry hall where additional antiquities are displayed.
Photograph by Brian Briggs

Q&A

more about sandra ...

WHAT BOOKS HAS SANDRA READ RECENTLY?

She enjoyed art historian James Lord's book, *Picasso and Dora: A Personal Memoir*, in which the author describes the great artist's life through his association with Dora Maar. Keeping close to her interests in anthropology, books such as *Genghis Khan and the Making of the Modern World* by Jack Weatherford have given her further insight and show that her taste in literature is as varied as her stylistic abilities.

IN SANDRA'S HOME, WHAT IS HER FAVORITE ROOM?

The master bedroom has a soothing ivory background with saffron detailing to emphasize a portion of her extensive private collection of museum quality art and objects.

WHAT IS THE MOST IMPORTANT LESSON THAT SHE HAS TAKEN TO HEART?

Sandra has found that listening to her clients and being patient are the most valuable traits which she has developed over her impressive career.

WHERE DOES SANDRA ENJOY TRAVELING?

She enjoys many different retreats from the serenity of mountains to the ocean's excitement and finds strength in forces of nature. Additionally, travels to her resourcing mainstays—England, France, Italy, China and other scenic countries—have provided pleasurable working vacations.

SANDRA SALTZMAN INTERIORS
Sandra Saltzman
1430 North Astor Street
Chicago, Illinois 60610
312.642.8381
f: 312.642.8402

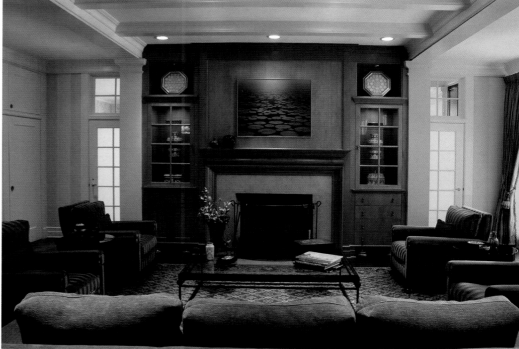

TOP:
Rare and unique 19th century botanical specimens from Kate Hendrickson Fine Arts grace a trompe l'oeil wall of this symmetrical dining room. A Corbin chandelier hangs above the oversized elliptical table. Both table and sideboard are custom designed by New Classics.
Photograph by Brian Briggs

BOTTOM:
An antique needlepoint rug from Stark grounds the composition of this living area which is connected to the dining room pictured above and demarcated by the direction of ceiling coffering. Chairs; Dessin & Fourinr. Textiles; Larson.
Photograph by Brian Briggs

INEZ SAUNDERS
AMY ROSENGARTEN

SAUNDERS/ROSENGARTEN INTERIOR DESIGN, INC.

Inez Saunders and Amy Rosengarten create timeless interiors that reflect the lifestyle of their clients. They pride themselves on their ability to develop unique solutions and define, interpret and edit their designs making every space functional and special.

Catering to a client's desire for a sophisticated entertaining area, Inez and Amy designed a living room that incorporates classic modern pieces such as Barcelona chairs and ottomans anchored by a Mies van der Rohe sofa, all of which are upholstered in black leather. A metal base coffee table with black absolute granite top centers the seating area while a custom black maple cabinet with sandblasted glass top, illuminated from within, repeats the sand blasted full-height doors throughout the space.

LEFT:
Modern pieces are blended into this classic living area.
Photograph by Tony Soluri

Mindful of each patron's art and objects, custom bookshelves were carefully designed for a home library to display a pottery collection at seated eye-level for optimal viewing. The contemporary space features sleek, black maple bookshelves that warmly envelop an Eileen Gray sofa with an Eames lounge chair and ottoman.

Attention to each room's orientation figures prominently in their designs. A traditional English library features a spectacular city and Lake Michigan view,

while providing a backdrop for both media viewing and entertaining. Custom mahogany millwork surrounds the entire room while matching ceiling beams house low-voltage lighting. Centered in the space is a pair of distressed caramel leather sofas each with its own Christian Liagre coffee table. Chenille tapestry throw pillows provide pattern and texture for the room.

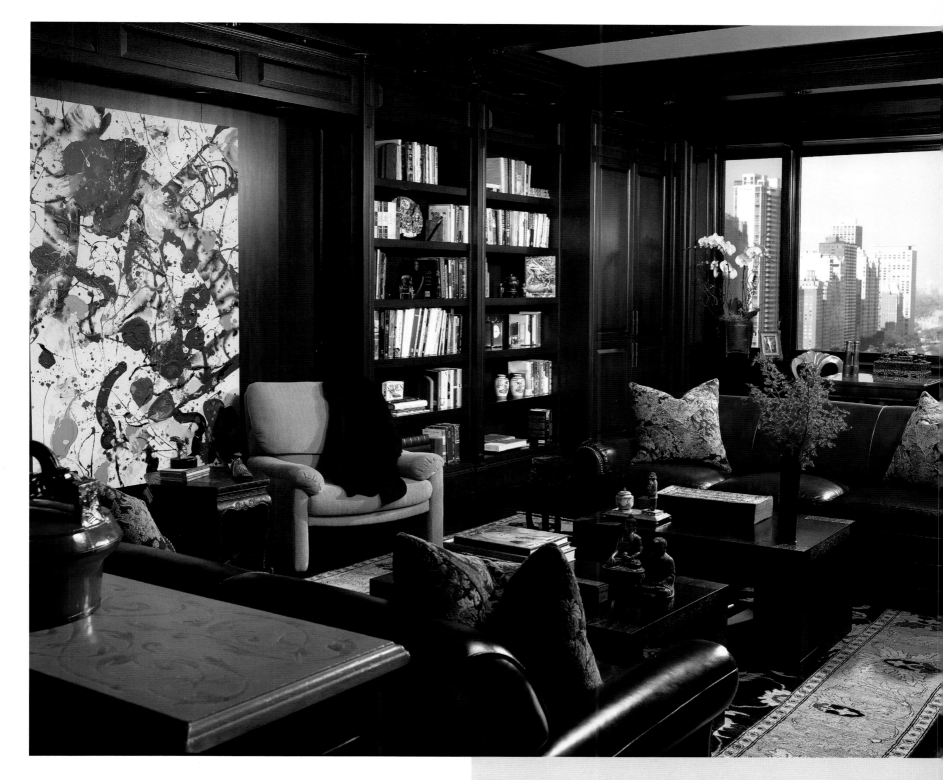

ABOVE:
A traditional English library features fabulous views from a comfortable seating arrangement.
Photograph by Tony Soluri

FACING PAGE:
Custom bookshelves are the focal point of a modern home library.
Photograph by Tony Soluri

An Old World dining room showcases a 13-foot hand-planed, stained walnut table with a substantial apron. Matching carved European chests flank an arched doorway leading through a butler's pantry and into a French Provincial kitchen beyond. Stained crown moulding hides an indirect lighting system which illuminates the vaulted ceiling. Woven espresso-colored grass cloth shades are punctuated by white gold-leafed wall sconces with frosted glass diffusers.

Natural maple floors provide a stunning canvas for a transitional living room and dining room. Arctic blue chenille sofas face a satin nickel coffee table with sandblasted glass top. Dakota Jackson lounge chairs complete the seating area and offer a view of the limestone fireplace with electrified candle-like wall sconces. The dining area beyond showcases full-height mahogany cabinets connected by a limestone and mahogany buffet. Dakota Jackson dining chairs upholstered in taupe leather surround a mahogany dining table.

ABOVE:
Transitional style unites the defined living and dining spaces.
Photograph by Tony Soluri

FACING PAGE:
The décor of an Old World dining room accentuates finely detailed architecture.
Photograph by Tony Soluri

Each interior by Inez and Amy is unique, and their design of a casual card room is no exception. The selection of light and airy materials and finishes make this sky lighted casual room a unique space, complete with a built-in maple daybed that is upholstered in a textured taupe and gray cotton fabric. Natural maple wood flooring and cabinetry complement the clean lines of the furniture, and four taupe saddle leather chairs surround a maple game table with sandblasted glass top.

A formal living room serves as an intimate setting for carefully chosen elegant pieces. The deep espresso walnut floor provides a border for a wool and silk area rug, which anchors the furniture. Cream-colored mohair sofas frame a chinoiserie coffee table while upholstered wood armchairs, covered in a chenille tapestry, complete the grouping.

Several styles were combined to create a casual contemporary family room that provides a neutral palette for the client's eclectic artwork. The primary seating area includes a warm henna chenille sofa, two pairs of henna leather lounge chairs and a Philippe Hurel chocolate oak coffee table. Striped throw pillows provide color and a touch of whimsy to this inviting space.

Inez has been an interior designer for over three decades and feels privileged to have worked with Amy since 1989. Their mutual respect for each other has provided a firm foundation for a strong working relationship that clients appreciate.

ABOVE:
Eclectic design makes this card room successful.
Photograph by Tony Soluri

FACING PAGE TOP:
Carefully chosen elements comprise this formal living room.
Photograph by Tony Soluri

FACING PAGE BOTTOM:
Appropriate scale, texture and color bring this casual family room together.
Photograph by Tony Soluri

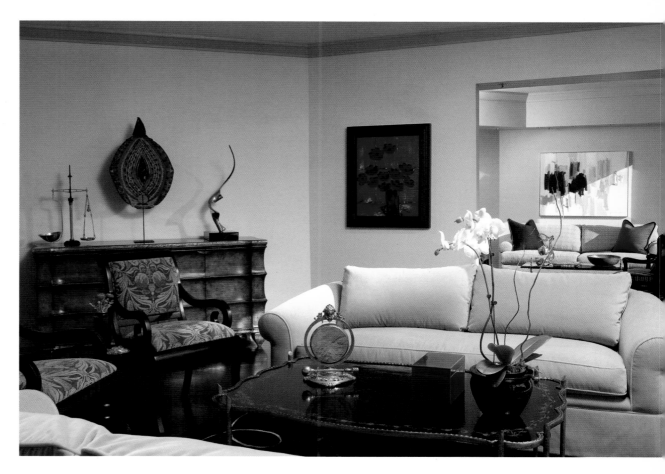

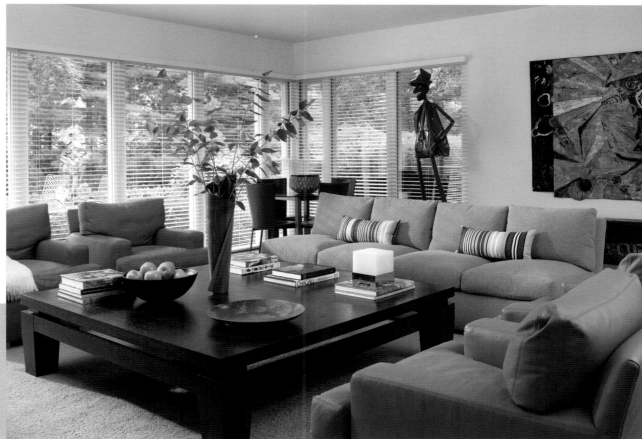

SAUNDERS/ROSENGARTEN
INTERIOR DESIGN, INC.
Inez Saunders
Amy Rosengarten
449 North Wells Street
Chicago, Illinois 60610
312.329.9557
f: 312.329.9093

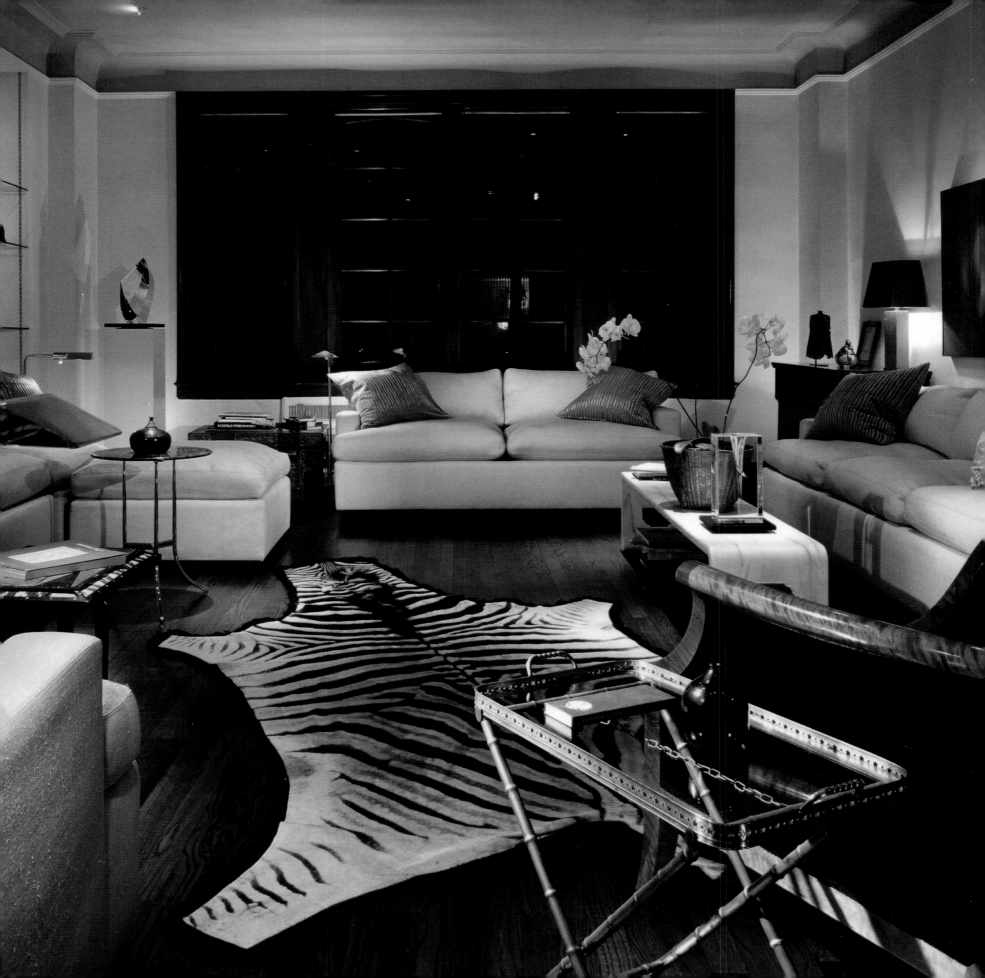

JANET SCHIRN

JANET SCHIRN DESIGN GROUP

Janet Schirn's designs are as diverse as the people with whom she works. Whether the project is commercial or residential, she creates spaces which are responsive to human beings. From many years of keen observation, Janet knows what makes people stop, look, sit or buy, talk or work and feel comfortable in their surroundings.

Influenced by the late John Dickinson's simple, yet imaginative designs, Janet reflects each client's style through a combination of antique and contemporary pieces. She is praised for her ability to, within one room, evoke different emotions in each viewer. Janet is particularly inspired by her travels to Southeast Asia because the people are very real and every creation, regardless of how simple or costly, is a beautifully indigenous expression.

A notably rewarding project came from a return client, whose first home was traditional and restrained. By the second house, the woman had a husband and two children, and her ability to express herself had been heightened. At least 17 different colors, varying in intensity from room to room, brought the house to life. In the family room, Janet created an intimate corner for reading and watching television which transitioned into a lighter, more open seating area for conversation.

Recognized with one of the very few Designer of Distinction awards presented by ASID, Janet advocates that design philosophy is important, but learning about people should take precedence. Janet habitually visits her clients unannounced; by catching them at unusual times she can understand how they truly live and design a functionally beautiful space accordingly. Her discoveries are very revealing of who the clients really are or who they want to be; Janet makes fairy tales, as well as real life, become visible actuality.

JANET SCHIRN DESIGN GROUP
Janet Schirn, FASID
220 East Walton Place
Chicago, Illinois 60611
312.222.0017

ABOVE:
Adventurous, glowing color, eclectic style sensibility and strong textural variation infuse warmth, comfort and invitation into this home that was remodeled from 1940.
Photograph by Nathan Kirkman

FACING PAGE:
The designer's home exemplifies qualities she values; this is a "larger-than-life" nightime home and entertaining milieu, complete with comfort, visual excitement and a melding of old and new that is 30 years old!
Photograph by Mary Nichols

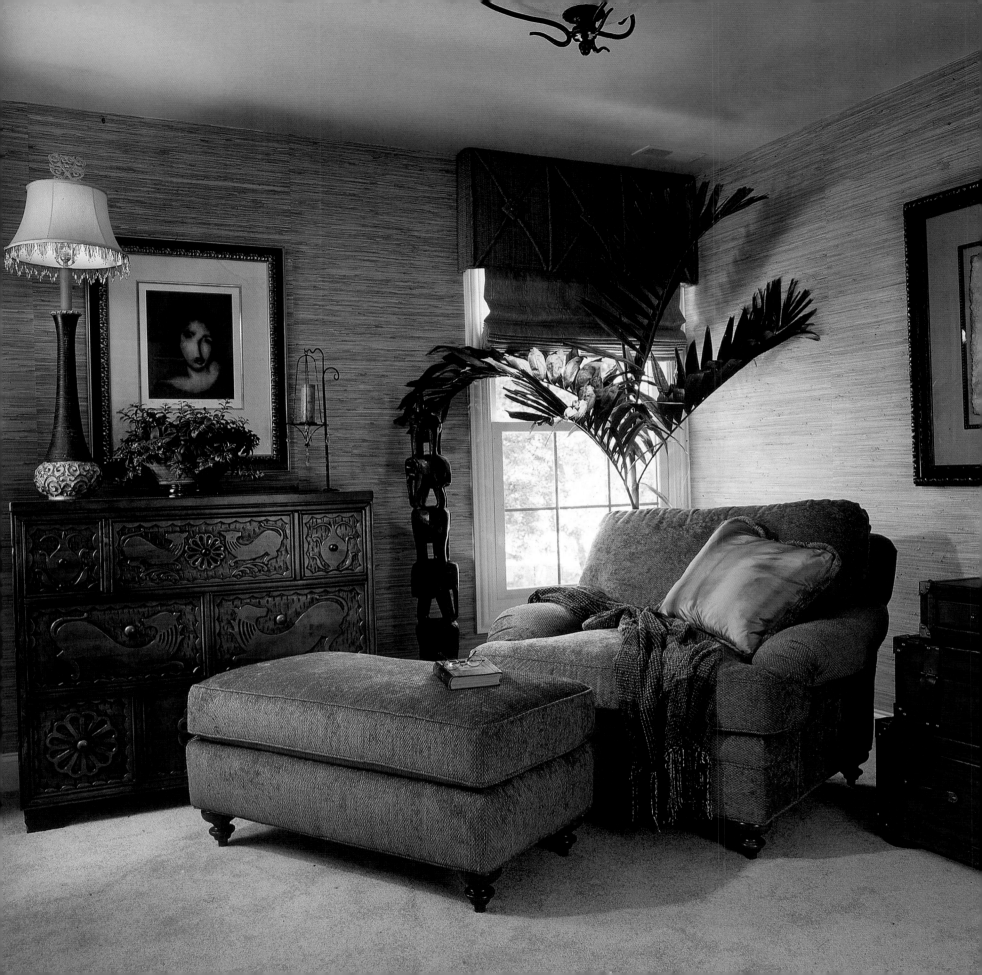

LOREN REID SEAMAN

LOREN REID SEAMAN & ASSOCIATES, INC.

For Loren Reid Seaman, a project is not complete until every detail falls into place with precision and meaning. With over 33 years of interior design experience, Loren and his team have acquired the expertise and an impeccable reputation for creating personalized spaces for a clientele with high expectations.

Their spacious 6,600-square-foot design studio provides creative inspiration for their clients and design team alike. Loren constantly refreshes the loft-like space with hand-selected accent pieces from around the world. In addition, clients have access to unique furniture from end tables to armoires, ranging in style from exotically ethnic to formal and decorative. With specialized knowledge of this furnishing genre, Loren previously owned a high-end exotic furniture store, where he designed a variety of tables, custom cabinetry and armoires in wood, stone, iron and other mediums. This rare experience of importing furniture took his career to another level and clients decidedly benefit from this "insider's" practical perspective.

Loren lives by the philosophy: "There is always something new to learn. Good taste is a constant, but styles and innovations change." Because Loren has worked with a healthy balance of residential and commercial

projects throughout his design career, clients benefit immensely from his comprehensive knowledge of uniquely implementing untraditional materials. He has been known to use interesting and unexpected elements such as reclaimed wood for table bases, wall dividers, mantles or even custom wall medallions to the awe of his astonished clients.

Even though industrial quality wall coverings are found in commercial catalogs, Loren feels they can be equally applicable in residential settings. Likewise, he brings the personal aspects of a home into commercial spaces because many companies desire soothing atmospheres to comfort their

ABOVE:
Dried grasses and a hand-carved leather screen add height and texture to an exquisite master suite.
Photograph by Rich Sistos

FACING PAGE:
A client's wishes were satisfied with this soothing retreat designed to bring natural elements indoors.
Photograph by Bob Mauer

customers. Through innovative use of materials and a solid understanding of their applications, Loren has bridged the design gap between residential and commercial interior design.

As one would imagine, Loren's own residence echoes his design philosophies. His home features a cedar contemporary style with a Californian infusion. Antique walnut travertine and down-filled upholstery provide a luxurious feel where he and his guests can truly relax. Loren chose a neutral yet warm backdrop for the living room to feature his exquisitely carved ceremonial chest and other pieces of art. He loves the work of Mary Hutchins and Richard Akers and has been collecting pottery since age 16. Loren's mother was surprised by her son's unique interests and impressed that pieces chosen many years ago still hold their charm today. The accomplished designer works with clients based on the principle that if you buy quality pieces that you truly love, the style will last and you will grow to appreciate the piece more with time.

Loren embraces the philosophy of bringing high quality to all of his design work. He suggests only well-made items for each client and creates designs that stand the test of time. Once the furnishings are in place, Loren brings a variety of finishing touches to the design. Accents are tastefully incorporated and clients are encouraged to live with the room to ensure it feels like them —a place where their memories will be made. Sometimes clients wish to leave a few empty spaces for future travel artifacts or photographs. Loren understands that once his design is finished, the residents need to be completely comfortable in their surroundings by making it their own.

ABOVE & FACING PAGE:
The warm, rich and textural space invites everyone in through a hint of Tuscan style and warm spice colors.
Photographs by Rich Sistos

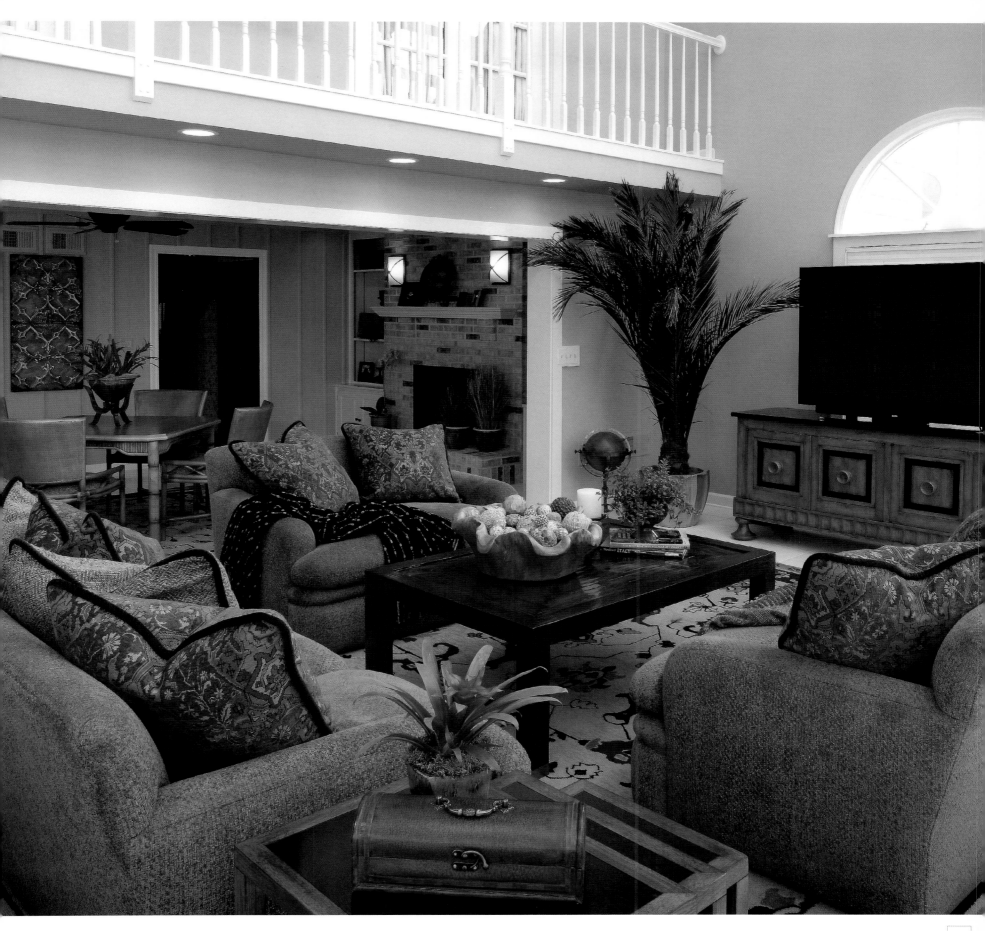

The initial consultation is often the most enjoyable aspect for Loren, and he is committed to guiding his clients through each stage of design. Over the years, Loren has mastered the art of keeping stress at bay by creating an open dialog between his clients so that all of their tastes and concerns are considered. He knows that no matter how well he plans, there can be a few challenges along the way. Since Loren cannot control lead times, construction delays, discontinuations or shipping problems, he has become a great problem-solver to make the design process as seamless as possible. He recognizes the level of trust his clients place in him and takes that responsibility seriously.

Through impeccable principles of customer service, the company has earned an impressive reputation. Loren Reid Seaman & Associates has been featured in the *North Shore magazine, Chicago Home Book, Chicago Tribune, Pioneer Press,* CLTV, ABC, NBC and the *Daily Herald.*

Whatever the project, Loren loves working with people. He is actively involved in HOME, an organization which benefits Chicago's elderly population. In addition, Loren has served two consecutive terms as the International Furnishings and Design Association's (IFDA) president and is still involved with a variety of other organizations. Peers refer to Loren as "the Dr. Phil of designers" because he is such an amazing listener and always has wonderful advice.

TOP LEFT:
Private, yet open the incorporation of a bowed glass wall maintains an open flowing feeling throughout this office space.
Photograph by Rich Sistos

TOP RIGHT:
This contemporary waiting area provides guests with a truly comfortable place to relax.
Photograph by Rich Sistos

FACING PAGE:
A bowed glass wall allows an open flowing feeling while still providing sufficient privacy for an office space.
Photograph by Rich Sistos

A sought-after personality and design expert, Loren has been the featured speaker at some of Chicago's most prestigious home shows. His topics range from fabric and color trends to the remodeling process and how to maximize resale potential. With a confident demeanor, Loren sets audience members and clients at ease, encouraging them to engage in conversation and ask questions. Loren appreciates and celebrates the tremendous gift of interior design talent he has been given and is only too happy to share it.

Q&A

more about loren ...

WHO HAS MOST INFLUENCED LOREN'S CAREER?

Roxann Nebren has been Loren's best friend since high school. He admires her creativity and appreciates that she encouraged him to pursue interior design.

HOW ARE LOREN'S DESIGN PHILOSOPHIES DIFFERENT THAN HIS COMPETITORS?

To Loren, genuinely getting to know his clients is crucial because he is building a lifetime relationship not simply completing "a job." As he views his clients' spaces, he "listens" not only with his ears but with all of his senses, to understand the practical everyday needs of his clients. He is as dedicated to the first step as he is to the finishing touch. Ultimately, Loren believes his interior designs, as with his client relationships, should last the test of time.

WHAT WORD WOULD LOREN LIKE TO ELIMINATE FROM THE DESIGN DICTIONARY?

Budget. Rather than determining an arbitrary dollar amount, Loren prefers an upfront dialog about the client's short and long-term goals and expectations. Loren wants to make sure that his clients are making conscious choices based on what they like, on pieces that they will enjoy for years to come. Loren's design philosophy is that trust and integrity are of the utmost importance. Knowing that the overall cost of a design project will fluctuate depending on the final selections, Loren always asks his clients what they feel comfortable spending. Whether the project must conform to a deadline or is ongoing over time, Loren works tirelessly to find ways to pull each space together, finding the best design plan, style and overall value.

WHAT MAKES EACH DESIGN UNIQUE?

Loren ascertains style direction from each client's lifestyle, personality and architecture of the home, sincerely endeavoring to make the right match in materials through each step of the design process. He portrays the best qualities of his clients in their spaces.

LOREN REID SEAMAN & ASSOCIATES, INC.
Loren Reid Seaman, ASID, IIDA, IFDA
1188 Heather Drive
Lake Zurich, Illinois 60047
847.550.6363
f: 847.550.6464
www.lrsinteriors.com

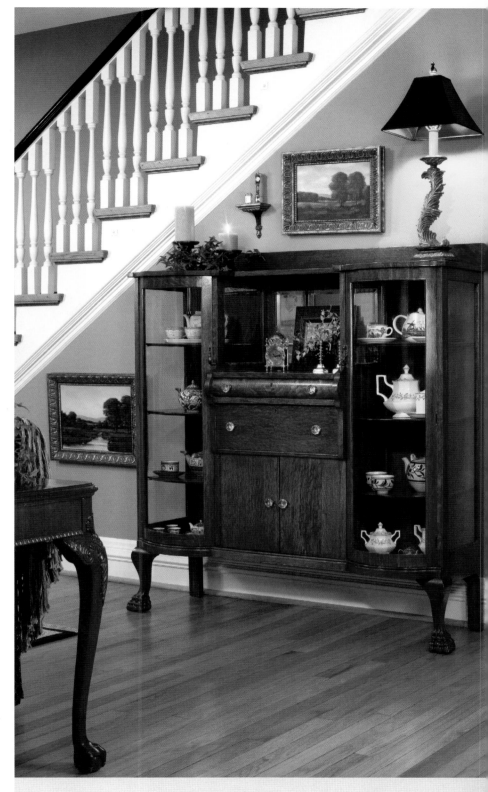

ABOVE:
Every detail is just as it should be to create a polished look.
Photograph by Rich Sistos

FACING PAGE:
Traditional elements, including a beautiful 84-inch round dining table, unite this space with the rest of the home.
Photograph by Rich Sistos

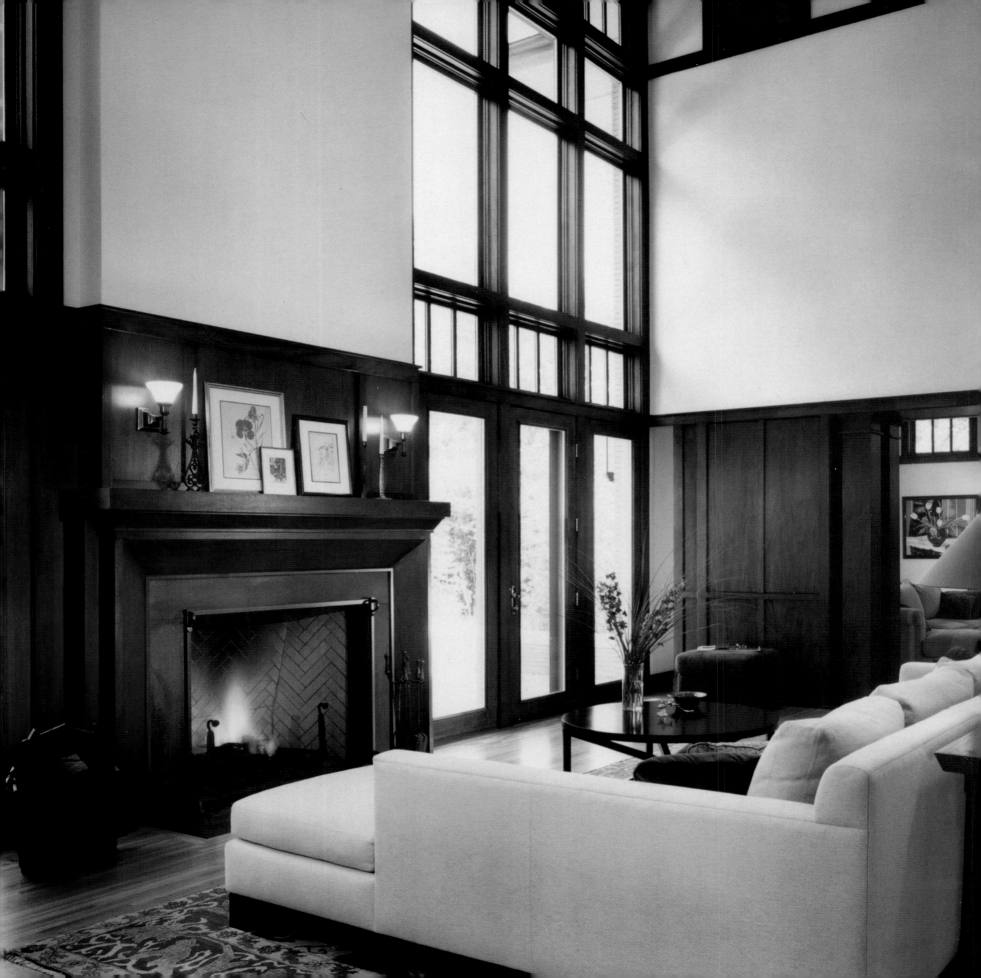

LINDA SEARL
ANN FRANCES BLOSSFELD

INTERIORS GROUP SEARL BLOSSFELD

A comprehensive design and architecture firm, Interiors Group Searl Blossfeld has the unique ability to express clients' styles by renovating existing spaces or creating from the ground up. Partners Linda Searl and Ann Blossfeld each have a master's degree in architecture and extensive experience with interior design. They design in a broad range of styles for residential and commercial settings, but universally enjoy bringing warmth to contemporary spaces.

Linda's interest in architecture dates back to fifth grade. Through some projects and experiences she had at an architecture firm in Chicago, Linda realized the value of interior design and its integral relationship to architecture. Since then, she has embraced interior design and has been able to incorporate both passions in her own company which was founded in 1985. At Searl Blossfeld, Linda is primarily involved with architecture but she and Ann are constantly working on projects together.

Ann directs the interiors division of the company. Her father was an aerospace draftsman before starting a large family and has shared his passion for design with the family for as long as Ann can remember. On vacations, he routinely took 100-mile detours to visit Frank Lloyd Wright homes, sculpture exhibits and art museums. She never felt pressured to

have a design career, but she and each of her sisters followed creative paths as architects, artists or automobile designers.

The duo met on a remodel which resulted with an ecstatic client who remarked, "I love this apartment so much that I don't ever want to leave!" Principal of the project, Linda cleverly maximized the 3,600-square-foot apartment's lakefront view. She incorporated the client's love of organization by designing custom pieces with the company for which Ann was working. The property, which eventually sold for a million dollars more that the owner had paid, was the first of his seven properties which Linda and Ann would be commissioned to design.

ABOVE:
The formal entry and stair hall leads to the open double height living room and master suite above.
Photograph by Scott McDonald © Hedrich Blessing

FACING PAGE:
A suburban Chicago residence, with a two-story living room space, takes advantage of views to the large open space of the large wooded rear yard.
Photograph by Scott McDonald © Hedrich Blessing

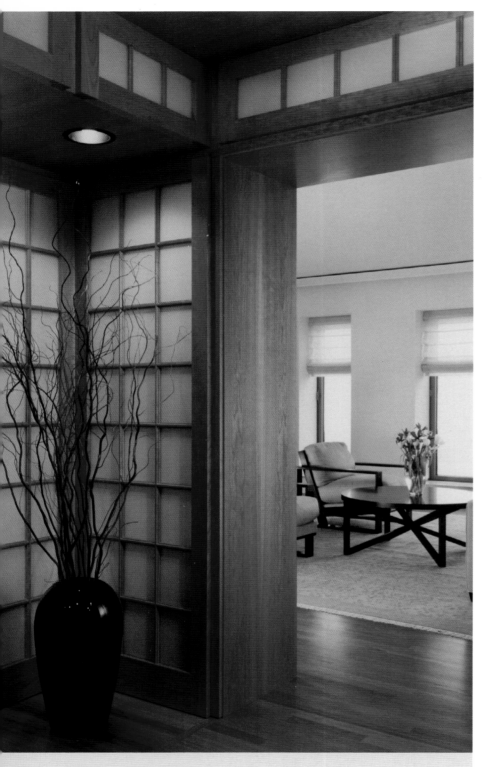

Distinctive woodwork truly sets the company apart. The partners both favor the architectural element of wood for its universal applicability; it works equally well in modern and vintage settings. In the octagonal foyer of a Chicago residence, Ann and Linda collaboratively redesigned the awkward space. They created a niche of custom wood panels accented with translucent glass and a large decorative floor vase, resulting in a very welcoming entryway.

In addition to custom architectural elements, they have designed shoji screens, moveable panels, sofas and even dining room tables out of petrified wood. Linda and Ann make a conscious effort to reuse existing materials whenever possible. Architecturally, it helps to maintain the integrity of a space, and from an interior design perspective, using clients' previously purchased items helps to blend personal taste with fresh style.

The integrity of a 1920s house in Palm Beach was maintained by incorporating the existing stucco and tile roof with a modern open-room layout. Linda and Ann respected the architecture, but still provided a relaxed atmosphere for the laid-back clients. Always up for a good challenge, they jumped at the opportunity to design a 56-story condominium, with almost 300 residences, mindful of the location in a traditional neighborhood, just a block from Michigan Avenue.

ABOVE:
Home furnishings are a carefully selected mixture of contemporary pieces, mission arts and crafts and artifacts.
Photograph by Scott McDonald © Hedrich Blessing

FACING PAGE:
An entry space in a formerly dark entry foyer was transformed using light panels and rich woods to enhance the sequence of spaces as you enter the condominium.
Photograph by Scott McDonald © Hedrich Blessing

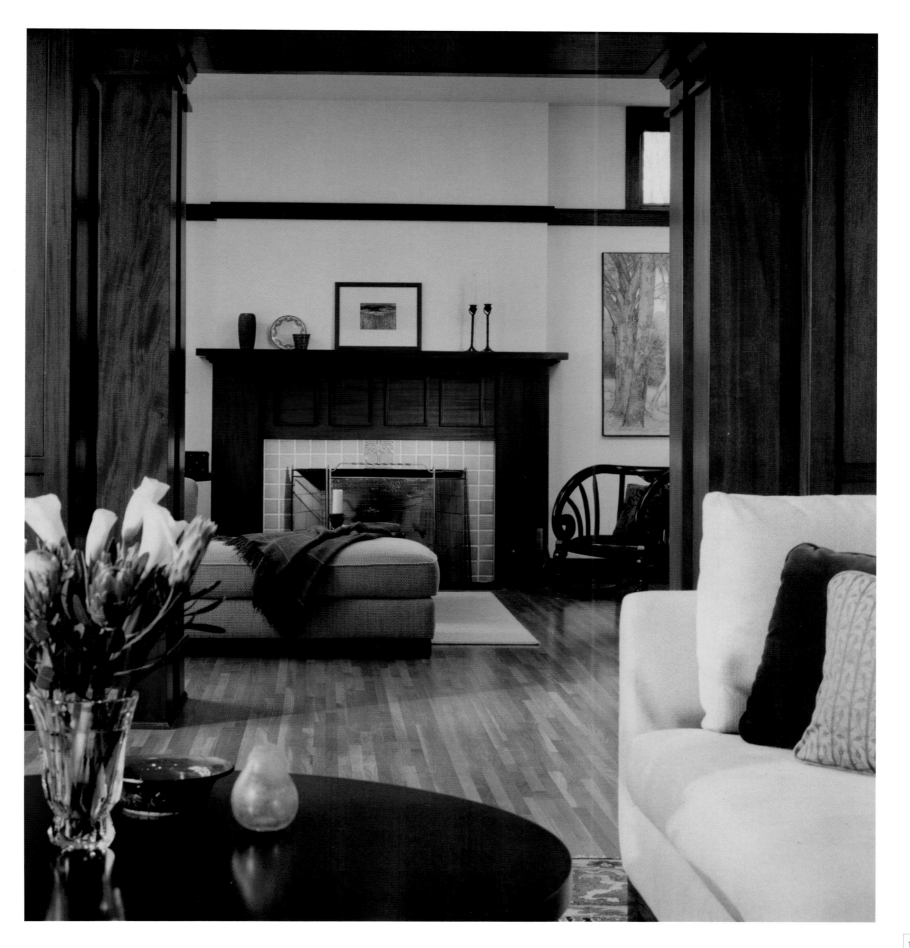

Interiors Group Searl Blossfeld has been featured in over 50 major publications, including *Better Homes and Gardens Remodeling Ideas, Business Week* and the *Chicago Tribune*, and Linda was notably selected for *Architectural Digest's* list of Top 100 architects and designers in 2004. Additionally, they have received Divine Detail, National AIA Interior Architecture and Custom Home Design awards. Frequent compliments, such as "you really listened to me," are relayed from a diverse, discerning clientele.

Linda and Ann have found residential design work to be more challenging than commercial projects, but feel that the knowledge of one informs the other. The collaboration of architect, designer and client provides a beautiful synthesis of creative expression.

Q&A

more about ann & linda ...

WHAT PERSONAL INDULGENCES DO LINDA AND ANN HAVE IN COMMON?

Linda and Ann love to shop in Europe. Linda's husband has relatives in Rome, so they frequently visit fabulous clothing boutiques. Ann likes clothes, but her true passions are shoes, books and classic modern and contemporary Italian furniture.

WHY DO THEY ENJOY LIVING IN CHICAGO?

With great restaurants, a beautiful lake and walking accessibility, Linda has been in Chicago for over 25 years and would not want to live anywhere else. Ann describes Chicago as a "mecca for both good and bad design," and loves the continual learning opportunities.

WHAT ARCHITECTURAL ELEMENTS WOULD LINDA AND ANN LOVE TO ELIMINATE FROM THE WORLD?

Ann has an aversion to poorly constructed condo high-rises, and Linda could certainly live without styles of post-modernism and new urbanism, although the talented team is more than capable of designing in the most difficult of circumstances.

HOW WOULD THEY BRING A DULL HOUSE TO LIFE?

Linda would tear down all unnecessary walls while Ann would work on custom millwork and design details. To really make a statement, they would add interesting color.

WHAT IS THE MOST PROFOUND LESSON THEY HAVE LEARNED?

Ann and Linda have learned that there is nothing wrong with turning down a project that does not feel right. They appreciate challenges, but cannot take on the whole world at once.

INTERIORS GROUP SEARL BLOSSFELD
Linda Searl, FAIA
Ann Frances Blossfeld, Associate AIA
500 North Dearborn Street, 9th Floor
Chicago, Illinois 60610
312.251.9200
f: 312.251.9201
www.searlarch.com

ABOVE:
The bathroom's contemporary details and clean lines open up what was previously a dark, small space.
Photograph by Scott McDonald © Hedrich Blessing

FACING PAGE:
This Chicago lakefront condominium was developed as a series of open rooms for family living and large group entertaining.
Photograph by Scott McDonald © Hedrich Blessing

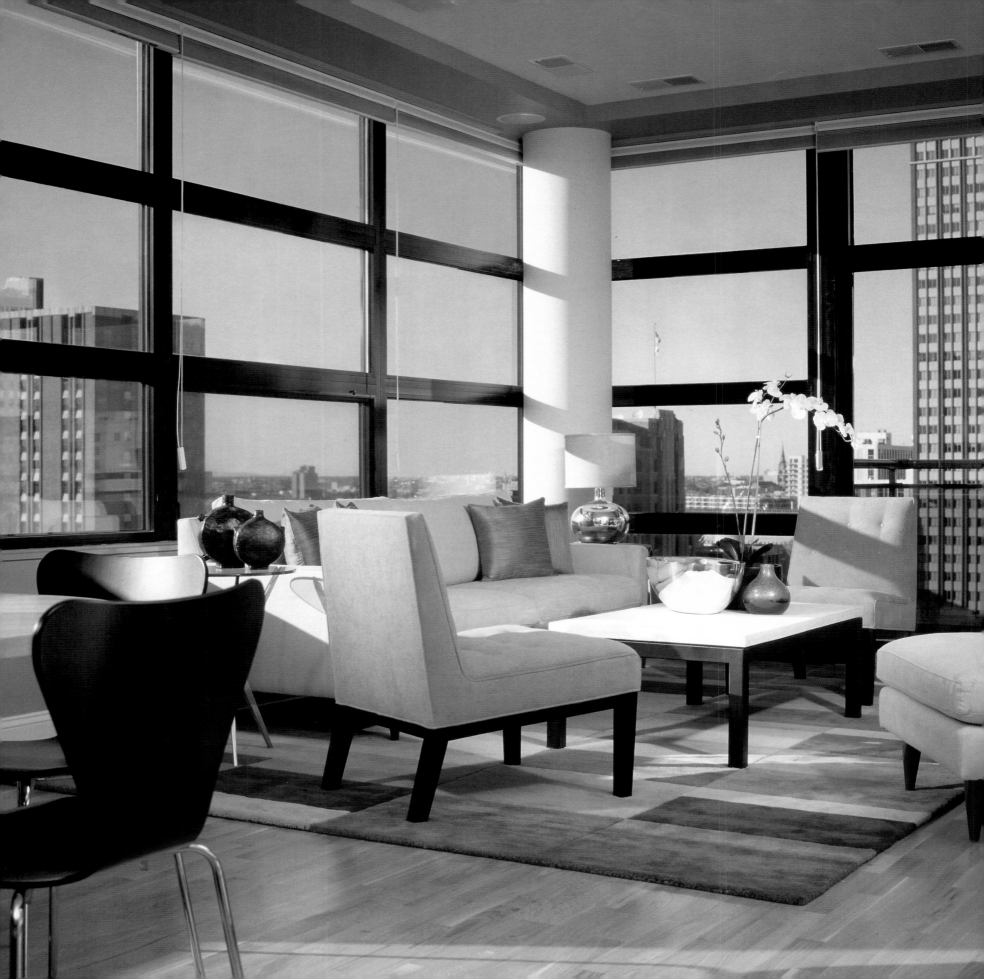

M. GRACE

M. GRACE DESIGNS, INC.

M. Grace Sielaff is the principal of M. Grace Designs, Inc., a Chicago-based interior design firm dedicated to providing customized design solutions for commercial, residential and entertainment clients. The firm's goal is to provide beautiful environments that are graceful and functional.

In an effort to protect the natural environment, Grace practices "Green Design." Therefore, environmentally-friendly materials and products are incorporated in her design whenever possible. Her own goals in practicing Green Design are to increase workplace productivity, enhance energy efficiency through energy-efficient lighting systems and conserve natural resources by educating the client about earth-friendly products. Additionally, Grace is a LEED-accredited professional through the US Green Building Council and does pro bono work for several organizations, including the Heartland Alliance and the Chinese American Service League.

Grace has provided interior design services for a wide variety of clientele. Her fresh style includes elements from traditional to modern-contemporary, with innovative use of color. Her personal style mixes the eclectic and elegant, with unusual color combinations and appealing textures and patterns.

She earned a degree in interior architecture from Mundelein College at Loyola University of Chicago. Grace has been published in various magazines, such as *Fine Furnishings International*, *Chicago Home* and *Chicago Loft*, and was featured on an MTV production. With multiple appearances on HGTV, Home and Garden Television, her designs have earned a permanent place in the online Designers' Portfolio.

M. GRACE DESIGNS, INC.
M. Grace Sielaff, Allied Member ASID, USGBC
1813 South Clark, Suite 32
Chicago, Illinois 60616
312.842.0800
f: 312.842.4399
www.mgracedesigns.com

ABOVE:
M. Grace Sielaff.
Photograph by Calvin Jeng Photography

FACING PAGE:
Urban contemporary design with glass and featured high ceiling, a private balcony and oversized windows frame the dramatic city view. The living room incorporates antique elements with modern-contemporary style and the innovative use of color of gold, sage green, chocolate and creamy yellow.
Photograph by Michael Robinson Photography

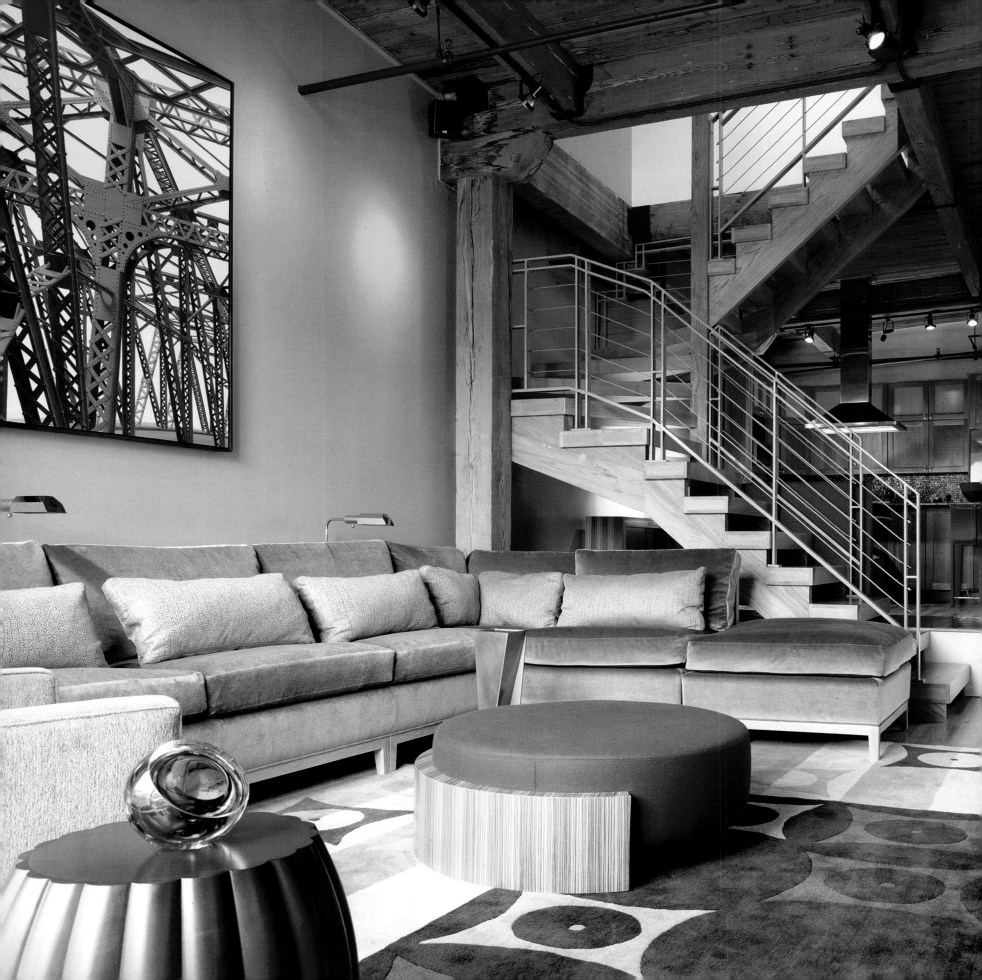

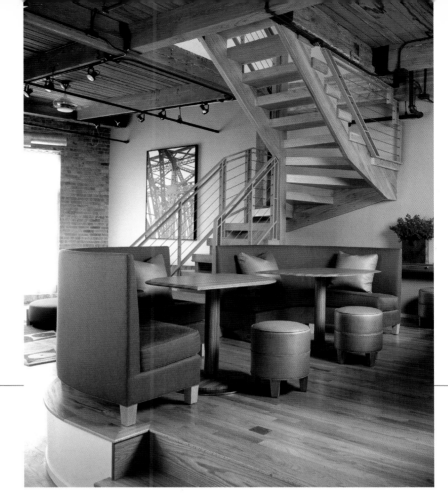

JONATHON G. WELLS

GREGORY JORDAN INTERIORS

Jonathon Wells was one of Chicago's top graphic designers when he decided to use his stunning visual gifts in the field of interior design. His contemporary style with its reliance on traditional elements combines Midwest probity with bi-coastal sophistication.

Jonathon's Chicago Gold Coast home is a few minutes walk to his studio in the trendy River North neighborhood, home of the city's best art galleries and close proximity to the Merchandise Mart, a world-renowned wholesale design center and home to thousands of premier vendors.

Gregory Jordan Interiors, of which Jonathon is the president, is located right in the heart of the haute design community in the "the world's capital for architecture."

He has always admired interior designer Thomas O'Brien for his flawless interiors and his treatment of a room as a work of art, which requires "a skilled hand, perceptive eye, and the experience to know what works and what doesn't."

Jonathon instinctively knew what worked in his design of a famous rock star's Chicago residence and designed a den with 20-foot custom "hot pink" ceilings, French paneled walls, and a massive chandelier above the oversized white Mohair sofa. He also cleverly incorporated the client's impressive collection of music awards into the room's design.

ABOVE:
Banquettes and circular stools show the raised dining area of the open plan drawing room from another surprising angle.
Photograph by Catherine Tighe ©2005

FACING PAGE:
The dramatic diagonal of the Maplewood staircase joins two floors of this duplex in Chicago's first loft conversion. Urban archeology witticism is repeated in a photograph of the Kinzie Street Bridge which can be seen outside the adjacent window. Natural Zebrawood settee does double duty as a coffee table.
Photograph by Catherine Tighe ©2005

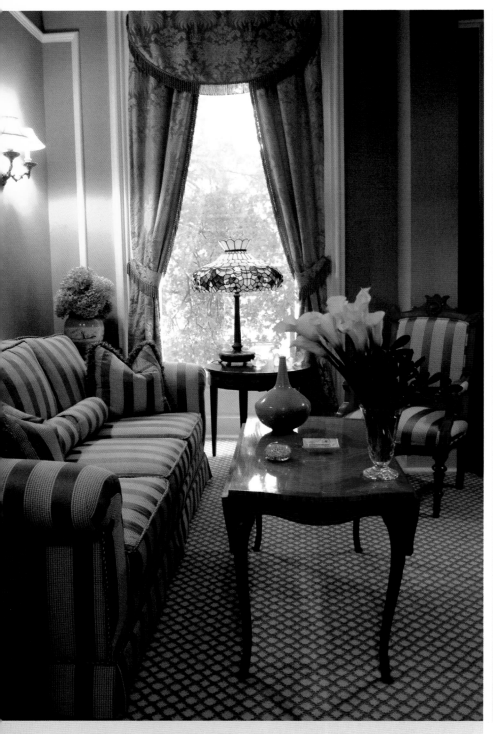

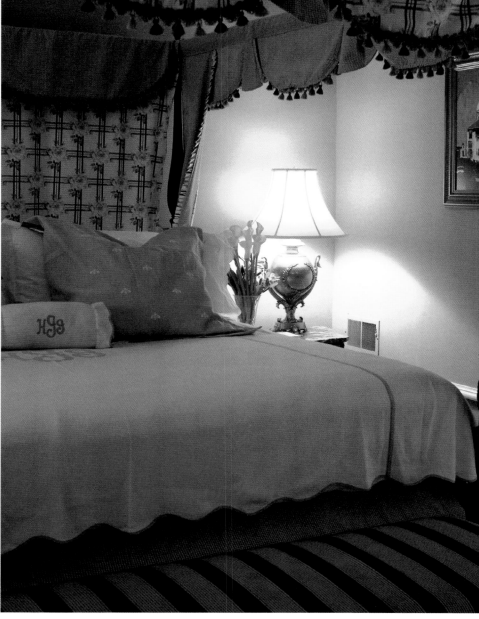

ABOVE LEFT:
French country style is everywhere apparent in blue and white bravura in the silk sofa, draperies, and valence. The Art Nouveau Tiffany lamp provides a touch of color to this beautiful and restful room.
Photograph by Jennifer Wolfe ©2006

ABOVE RIGHT:
Antique fringed tassels on the canopy of this Walnut four-poster are of vintage silk repeated on the headboard of this master bedroom.
Photograph by Jennifer Wolfe ©2006

For yet another local celebrity's home, the look of "70's Park Avenue Chic" combined traditional English furniture with very modern, contemporary fixtures and accents. The office highlighted a series of Andy Warhol-like lithographs created from enlarged photographic images of the on-air radio personality set against stark white walls and exotic wood flooring, to counterpoint the brightly colored art.

Jonathon's own home reflects his love of entertaining, with a gorgeous chandeliered dining room featuring warm colors that are a little bit spicy: pumpkin, russet and persimmon. He enjoys hosting pre-gala events, holds an annual New Year's Eve celebration, and frequently gathers his closest friends for dinner. Jonathon is a connoisseur of French cuisine but also appreciates exotic ethnic foods, especially from Morocco and Algeria.

Numerous travels to foreign lands have provided Jonathon with a unique design perspective, having immersed himself in the cultures of Austria, Italy, France, Israel and Egypt. He is especially fond of Egypt, where he crawled beneath pyramids and communicated with the immense desert's mystical energy, nourishing the creative energy so necessary and vital for interior design. The geometry of ancient structures was another form of inspiration, which he occasionally incorporated into his work.

In the interior design business for 10 years, Jonathon's team works together to create breathtaking spaces for each client.

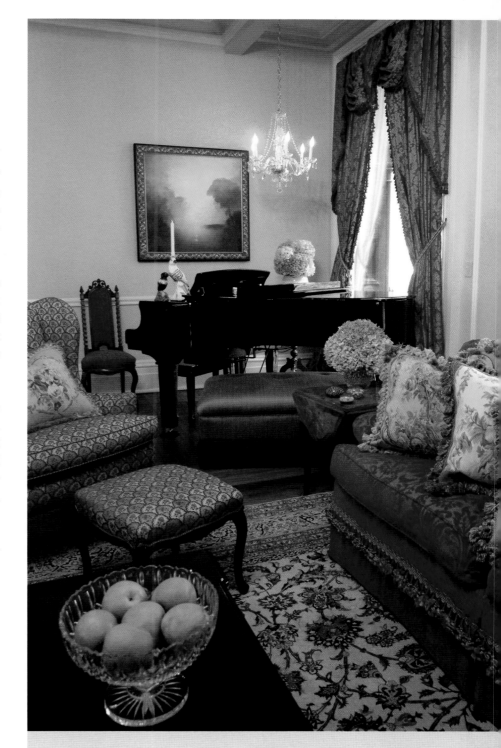

ABOVE:
Antique Aubusson pillows and Belgian carpet create a formal feeling in the drawing room along with the vintage red silk window treatments and period upholstered settee.
Photograph by Jennifer Wolfe ©2006

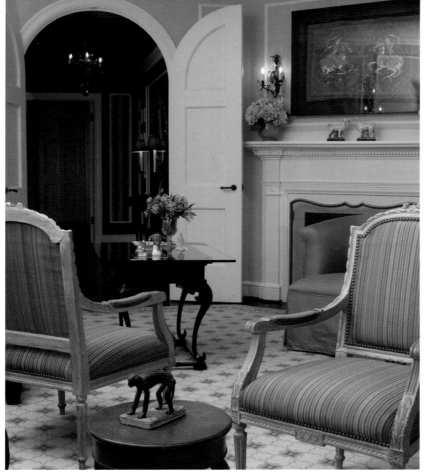

Jonathon has experience teaching graphic design at Columbia College in Chicago. Understanding the roles of both teacher and student has furthered his ability to communicate with his clients.

Through his experiences, he has learned many lessons, one of which will never be forgotten: measure, measure, measure. When a custom 10-foot French sofa would not quite fit into the elevator of a client's Park Avenue pre-war building, it took a tour of New York, traveling through a neighboring church, then a consulate, across a neighbor's backyard, over an 8-foot razor wire fence, and finally it was hoisted off the roof and into the owner's residence through an open window. Jonathon photographically documented the journey and is now able to laugh about the stressful situation, knowing that his ability to overcome that obstacle means that anything is possible.

Jonathon feels that a good designer can do what the client wants, but a great designer can interpret what a client wants and create for them a stunning, livable tableau of timeless beauty. He composes each setting with the utmost attention to detail, colors, patterns, period, and lifestyle and has been featured in both *Chicago Social* and *Chicago Home* magazines for his distinctive flair.

TOP:
Louis Quinze style chairs and a LaForge style fireplace screen give the drawing room a dix-huitieme feel. A glass topped Chinese tea table completes the eclectic presentation of this sophisticated room.
Photograph by Barb Levant ©2006

BOTTOM:
The dining room is inspired by the warm tones of the rolling hills of Tuscany. The Biedermeier dining table and antique porcelain again repeat the eclectic nature of this apartment.
Photograph by Barb Levant ©2006

FACING PAGE TOP & BOTTOM:
Shades of lavender, gray and blue Shanghai silk appear in the gently striated and textured draperies and the upholstery of this tranquil study.
Photograph by Barb Levant ©2006

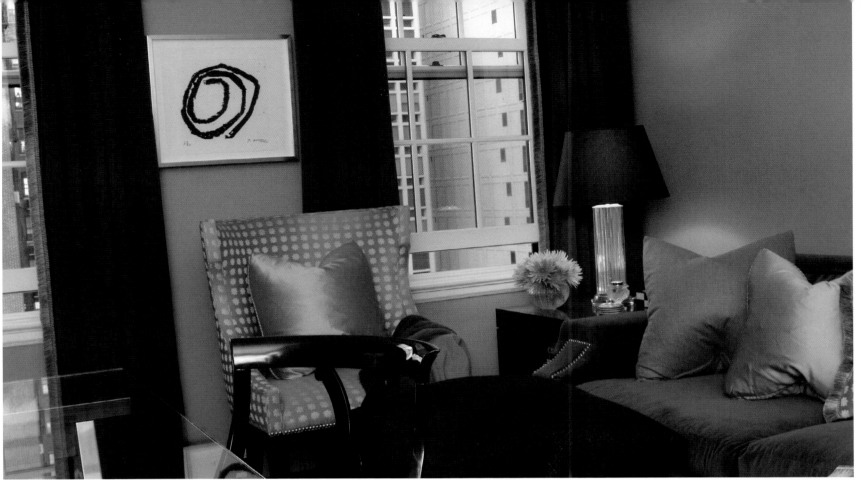

ABOVE:
This sophisticated bachelor apartment sports a perfectly symmetrical layout with leaf green wool Cantonierre window treatments, traditional early Modern furniture, minimal patterns and spare accoutrements, which create a soothing and tranquil living area.
Photograph by Barb Levant ©2006

Q&A
more about jonathon …

WHAT IS ONE THING THAT MOST PEOPLE DON'T KNOW ABOUT JONATHON?

He is a "bit of a handyman," able to change a flat tire, hang a chandelier or use a power drill.

IS JONATHON AN ANIMAL-LOVER?

Dottie Jo, his Pug / Boston Terrier / Cocker Spaniel mix was adopted from a 100% no-kill animal shelter called PAWS (Pets Are Worth Saving). Dottie Jo owns an impressive collection of well-designed and elegant toys.

OF WHICH PIECES IN HIS ART COLLECTION IS HE MOST FOND?

He loves his original Art Nouveau Lalique vase that features female nudes in a beautiful semi-circle, which he bought in Paris.

IF HE COULD ELIMINATE ONE DESIGN STYLE FROM THE WORLD, WHAT WOULD IT BE?

American 'Gold Rush' Victorian.

WHAT IS THE MOST UNUSUAL AND EXPENSIVE DESIGN TECHNIQUE THAT HE HAS USED IN A PROJECT?

The process of gilding is very difficult and he has employed the technique for entire walls, ceilings and also more subtly with accent pieces.

HOW DOES JONATHON BRING DULL HOUSES TO LIFE?

He adds one beautifully appropriate or exotic object d'art, placing it properly to ensure that lighting is balanced and that all artwork is appropriately curated. These accessories may include a gorgeous hand-knotted rug or fresh flowers—never silk.

GREGORY JORDAN INTERIORS
Jonathon G. Wells, Allied Member ASID
Chicago, Illinois
312.337.0428
f: 312.337.0429
www.gregoryjordan.com

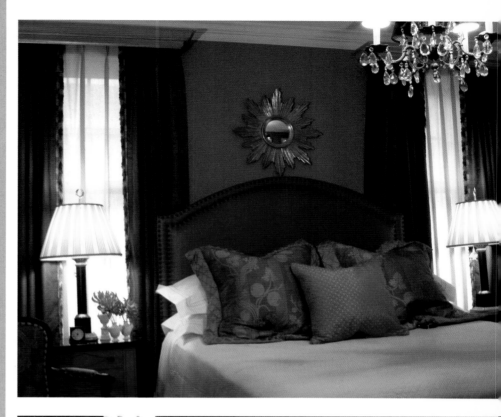

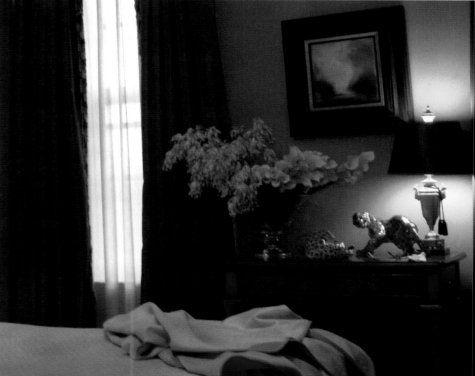

ABOVE TOP & BOTTOM:
Symmetry and a sense of history characterize this bedroom with the gilt Vermeer mirror and chandelier. Soft, yet tailored draperies and bedding add to the intimate cocoon-like aura of the space.
Photograph by Barb Levant ©2006

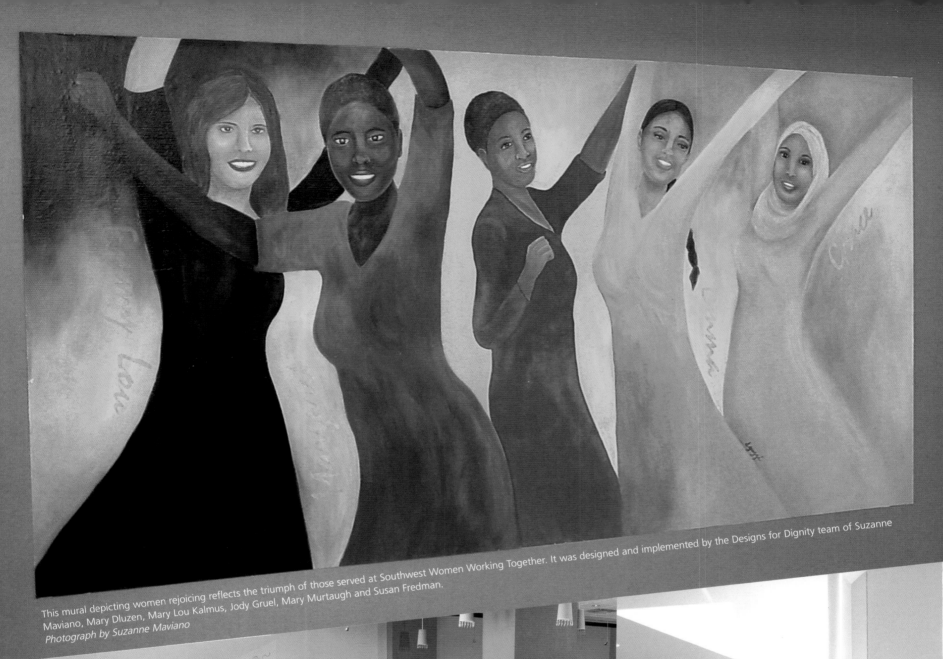

This mural depicting women rejoicing reflects the triumph of those served at Southwest Women Working Together. It was designed and implemented by the Designs for Dignity team of Suzanne Maviano, Mary Dluzen, Mary Lou Kalmus, Jody Gruel, Mary Murtaugh and Susan Fredman.
Photograph by Suzanne Maviano

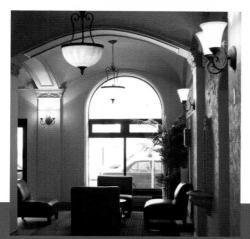

The Leland: Historic renovation into 137 affordable housing units, lobby and community room space. Volunteer designer, David Kaufman of Kaufman Segal, in collaboration with Heartland Housing, Inc.
Photograph by Jill Paider Photography

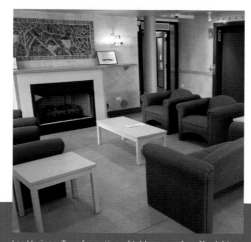

Los Vecinos: Transformation of lobby space for affordable housing site. Designer, Barb Theile, in collaboration with Heartland Housing.
Photograph by Tony Armour Photography

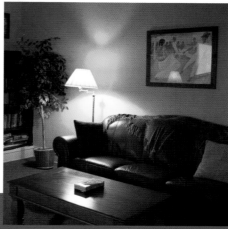

The Antonia: Renovation of community and resident spaces for mentally ill adults. Design Team: Director, Jen Sobecki and Ed Mattingly of Mattingly Custom Finishes.
Photograph by Jill Paider Photography

Designs for Dignity

Aiming to create interiors that reflect dignity, hope and comfort, Designs for Dignity provides *pro bono* design services to nonprofit organizations in the Chicago area. The dedicated board of directors and affiliate volunteers believe that design has the power to nurture, and by beautifying otherwise humble buildings, they improve the atmosphere for recipients of charity and those who caringly serve.

From women's shelters and youth outreach programs to food banks and affordable housing, Designs for Dignity has touched countless lives since it was founded in 2000 by interior designer Susan Fredman. Each project is a group effort to say the least as the organization provides comprehensive interior design and installation services: space planning, flooring, lighting, painting, furniture, window treatments, textiles, artwork and even custom murals—literally whatever the recipient charity needs and Designs for Dignity can prudently accommodate.

Excess tile, stone, carpet squares, unopened gallons of paint, and showroom furniture samples are donated by designers, manufacturers, suppliers and individual contributors. By repurposing these materials, the organization can economically provide pleasing interiors and keep perfectly good supplies out of landfills, in harmony with their new age perspective on sustainability.

Projects run the gamut from single rooms to large renovations such as the 10,000-square-foot LaCASA (Lake County Council Against Sexual Assault) facility, which now functions extremely efficiently with private waiting areas and counseling rooms. The charity's director commented on the welcoming result, "The importance of appropriate space cannot be underestimated."

Designs for Dignity has enriched a multitude of people through over 50 completed projects, but there is more work to be done because everyone has a right to good design. Those interested in giving of time, materials or funds are welcome to submit an application or contact the director, Jennifer Sobecki, for more information. The need is tremendous, the solution, simple.

DESIGNS FOR DIGNITY
208 South LaSalle, Suite 1818
Chicago, Illinois 60604
312.660.1346
www.heartlandalliance.org/designsfordignity

FACING PAGE BOTTOM LEFT:
LaCASA children's playroom. This room incorporates a mural and appropriate toys and furniture for therapy conducted in the facility. Design Team: Susan Fredman and Associates.
Photograph by Jill Buckner Photography

FACING PAGE BOTTOM CENTER:
The Sutherland Ballroom. Design Team: Suzanne Maviano, Jean Alan, and Ed Mattingly in collaboration with Heartland Housing completed a gut rehab of the former ballroom into a community center for the local residents of Drexel Boulevard in Chicago.
Photograph by Jill Paider Photography

FACING PAGE BOTTOM RIGHT:
LaCASA: Lake County Council Against Sexual Assault. Design Team of Susan Fredman and Associates conducted a ground up concept for this facility which serves women and children.
Photograph by Jill Buckner Photography

PUBLISHING TEAM

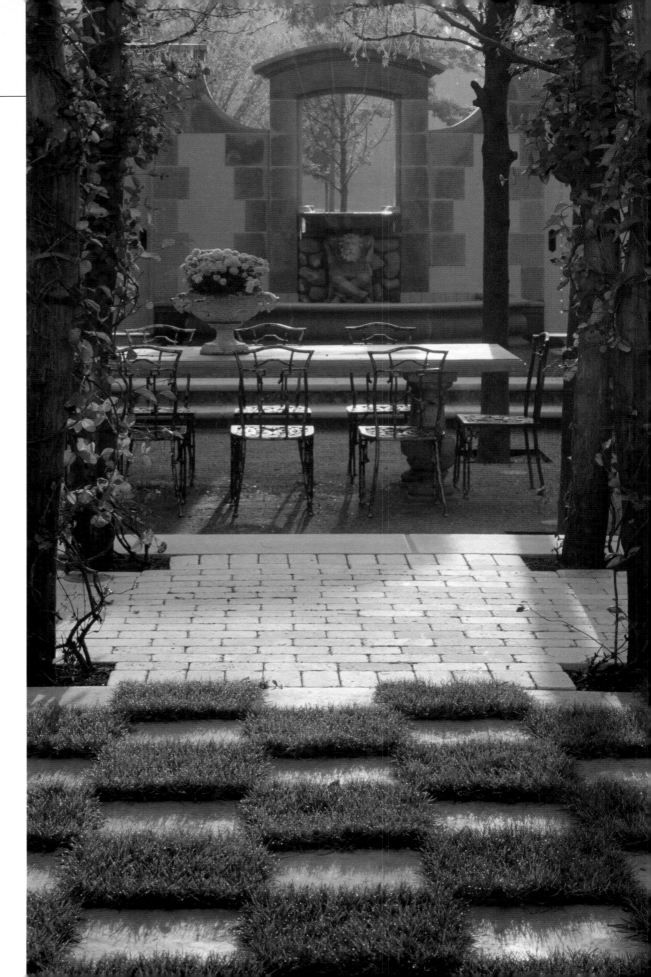

Brian G. Carabet, Publisher
John A. Shand, Publisher
Phil Reavis, Executive Publisher
Chris Miller, Associate Publisher

Michele Cunningham-Scott, Art Director
Mary Elizabeth Acree, Graphic Designer
Emily Kattan, Graphic Designer

Elizabeth Gionta, Managing Editor
Aaron Barker, Editor
Rosalie Wilson, Editor

Kristy Randall, Sr. Production Coordinator
Laura Greenwood, Production Coordinator
Jennifer Lenhart, Traffic Coordinator

Carol Kendall, Project Management
Beverly Smith, Project Management

PANACHE PARTNERS, LLC
CORPORATE OFFICE
13747 Montfort Drive
Suite 100
Dallas, TX 75240
972.661.9884
www.panache.com

CHICAGO OFFICE
312.752.6134

DESIGNER: Tracy Hickman, Hickman Design Associates, Ltd., Page 101

THE PANACHE PORTFOLIO

The catalog of fine books in the areas of interior design and architecture and design continues to grow for Panache Partners, LLC. With more than 30 books published or in production, look for one or more of these keepsake books in a market near you.

Spectacular Homes Series

Published in 2005
Spectacular Homes of Georgia
Spectacular Homes of South Florida
Spectacular Homes of Tennessee
Spectacular Homes of Texas

Published or Publishing in 2006
Spectacular Homes of California
Spectacular Homes of the Carolinas
Spectacular Homes of Chicago
Spectacular Homes of Colorado
Spectacular Homes of Florida
Spectacular Homes of Michigan
Spectacular Homes of the Pacific Northwest
Spectacular Homes of Greater Philadelphia
Spectacular Homes of the Southwest
Spectacular Homes of Washington DC

Other titles available from Panache Partners

Spectacular Hotels
Texans and Their Pets
Spectacular Restaurants of Texas

Dream Homes Series

Published in 2005
Dream Homes of Texas

Published or Publishing in 2006
Dream Homes of Colorado
Dream Homes of South Florida
Dream Homes of New Jersey
Dream Homes of New York
Dream Homes of Greater Philadelphia
Dream Homes of the Western Deserts

Order two or more copies today
and we'll pay the shipping.

To order visit www.panache.com
or call 972.661.9884.

Creating Spectacular Publications for Discerning Readers

index of designers